DYNAMIC SYMMETRY

PUBLISHED UNDER THE AUSPICES OF
THE SCHOOL OF THE FINE ARTS, YALE UNIVERSITY,
ON THE FOUNDATION ESTABLISHED
IN MEMORY OF
RUTHERFORD TROWBRIDGE

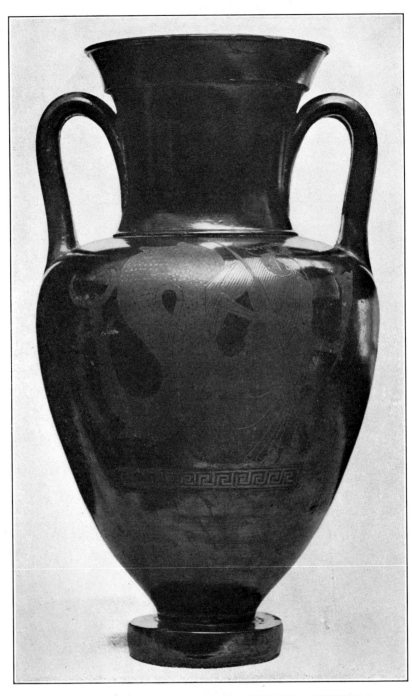

AN UNUSUALLY HANDSOME NOLAN AMPHORA,
FOGG MUSEUM AT HARVARD

A theme in root-two

DYNAMIC SYMMETRY

THE GREEK VASE

BY JAY HAMBIDGE

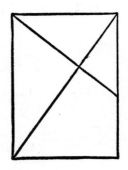

YALE UNIVERSITY PRESS

NEW HAVEN CONNECTICUT

LONDON · GEOFFREY CUMBERLEGE · OXFORD UNIVERSITY PRESS

743
H19

22813

THE RUTHERFORD TROWBRIDGE
MEMORIAL PUBLICATION
FUND

THE present volume is the first work published on the Rutherford Trowbridge Memorial Publication Fund. This Foundation was established in May, 1920, through a gift to Yale University by his widow in memory of Rutherford Trowbridge, Esq., of New Haven, who died December 18, 1918, and who in 1899 had established the Thomas Rutherford Trowbridge Memorial Lectureship Fund in the School of the Fine Arts at Yale. It was in a series of lectures delivered on this Foundation that the material comprised in this volume was first given to the public. By the establishment of the Rutherford Trowbridge Memorial Publication Fund, the University has been enabled to make available for a much wider audience the work growing out of lectures given at Yale through the generosity of one who sought always to render service to the community in which he lived; and, through its university, to the world.

ACKNOWLEDGMENT

TO the School of the Fine Arts of Yale University credit is due for this book on the shape of the Greek vase. When the discovery was made that the design forms of this pottery were strictly dynamic and it became apparent that an analysis of a sufficient number of vase examples would be equivalent to the recovery of the technical methods of Greek designers of the classic age, William Sergeant Kendall, Dean of the Yale School of the Fine Arts, immediately recognized its importance and offered his personal service and that of the University to help in the arduous task of gathering reliable material for a volume.

After the investigation of the shape of the Greek vase was begun the two great American Museums, the Museum of Fine Arts of Boston and the Metropolitan Museum of New York City, through the curators of their departments of Greek art, Dr. L. D. Caskey and Miss G. M. A. Richter, volunteered their services in furthering the work. Most of the vase examples in the book were measured and drawn by the staffs of these Museums, which readily gave permission for their publication. Dr. Caskey, during the past year, has devoted almost all his time to a critical examination of the entire collection of the Greek vases in the Museum of Fine Arts with the result that he now has a book nearly ready for publication. He is especially equipped for a research of this character, because of the fact that in addition to his attainments as a Greek scholar, he has had much archaeological experience in the field at Athens and elsewhere.

<div align="right">JAY HAMBIDGE</div>

TO M. L. C.

CONTENTS

LIST OF PLATES

FOREWORD

SOME twenty years ago, the writer, being impressed by the incoherence of modern design and convinced that there must exist in nature some correlating principle which could give artists a control of areas, undertook a comparative study of the bases of all design, both in nature and in art. This labor resulted in the determination of two types of symmetry or proportion, one of which possessed qualities of activity, the other of passivity. For convenience, the active type was termed dynamic symmetry, the other, static symmetry. It was found that the passive was the type which was employed most naturally by artists, either consciously or unconsciously; in fact, no design which would be recognized as such—unless, indeed, it were dynamic—would be possible without the use, in some degree, of this passive or static type. It is apparent in nature in certain crystal forms, radiolaria, diatoms, flowers and seed pods, and has been used consciously in art at several periods.

The principle of dynamic symmetry is manifest in shell growth and in leaf distribution in plants. A study of the basis of design in art shows that this active symmetry was known to but two peoples, the Egyptians and the Greeks; the latter only having developed its full possibilities for purposes of art. The writer believes that he has now recovered, through study of natural form and shapes in Greek and Egyptian art, this principle for the proportioning of areas.

As static symmetry is more or less known and its principles easily understood, its explanation will be reserved for a chapter at the end of this book. Dynamic symmetry, on the contrary, is entirely unrecognized in modern times. It is more subtle and more vital than static symmetry and is pre-eminently the form to be employed by the artist, architect and craftsman. After an explanation of the fundamental principles of this method of proportioning spaces, the writer will attempt a complete exposition of its application in art through analyses of specific examples of Greek design. He believes that nothing better can be found for this purpose than Greek pottery, inasmuch as it is the only pottery which is absolutely architectural in all its elements. There is no essential difference between the plan of a Greek vase and the plan of a Greek temple or theater, either in general aspect, or in detail. The curves found in Greek pottery are identical with the curves of mouldings found in Greek temples. There are comparatively few temples and theaters, while there are many thousands of vases, many of these being perfectly preserved. Other reliable material for study is furnished by the bas-reliefs of Egypt, many of which, like the vases of Greece, are still intact.

The history of dynamic symmetry may be given in a few words: at a very

early date, possibly three or four thousand years B. C., the Egyptians developed an empirical scheme for surveying land. This primitive scheme was born of necessity, because the annual overflow of the Nile destroyed property boundaries. To avoid disputes and to insure an equitable taxation, these had to be re-established; and of necessity, also, the method of surveying had to be practicable and simple. It required but two men and a knotted rope.

When temple and tomb building began, it became necessary to establish a right angle and lay out a full sized plan on the ground. The right angle was determined by marking off twelve units on the rope, four of these units forming one side, three the other, and five the hypotenuse of the triangle, a method which has persisted to our day. This was the origin of the historic "cording of the temple."[2] From this the step to the formation of rectangular plans was simple. From the larger operation of surveying, and fixing the ground plans of buildings by the power which the right angle gave toward the defining of ratio-relationship, it was a simple matter to extend and adapt this method to the elevation plan and the detail of ornament, in short, to design in general, to the end that the architect, the artist or the craftsman might be able to control the proportioning and the spacing problems involved in the construction of buildings as well as those of pictorial composition, hieroglyphic writing and decoration. At some time during the Sixth or Seventh Century B. C. the Greeks obtained from Egypt knowledge of this manner of correlating elements of design. In their hands it was highly perfected as a practical geometry, and for about three hundred years it provided the basic principle of design for what the writer considers the finest art of the Classic period. Euclidean geometry gives us the Greek development of the idea in pure mathematics; but the secret of its artistic application completely disappeared. Its recovery has given us dynamic symmetry—a method of establishing the relationship of areas in design-composition.

VITRUVIUS ON GREEK SYMMETRY[3]

THE several parts which constitute a temple ought to be subject to the laws of symmetry; the principles of which should be familiar to all who profess the science of architecture. Symmetry results from proportion, which, in the Greek language, is termed analogy. Proportion is the commensuration of the various constituent parts with the whole, in the existence of which symmetry is found to consist. For no building can possess the attributes of composition in which symmetry and proportion are disregarded; nor unless there exists that perfect conformation of parts which may be observed in a well-formed human being. . . . Since, therefore, the human frame appears to have been formed with such propriety that the several members are commensurate with the whole, the artists of antiquity must be allowed to have followed the dictates of a judgment the most rational, when, transferring to the works of art, principles derived from nature, every part was so regulated as to bear a just proportion to the whole. Now, although these principles were universally acted upon, yet they were more particularly attended to in the construction of temples and sacred edifices—the beauties or defects of which were destined to remain as a perpetual testimony of their skill or of their inability."

PREDICTION BY EDMOND POTTIER IN 1906 RELATIVE TO GREEK SYMMETRY

I WILL add that the proportions of the vases, the relations of dimensions between the different parts of the vessel, seem among the Greeks to have been the object of minute and delicate researches. We know of cups from the same factory, which, while similar in appearance, are none the less different in slight, but appreciable, variations of structure (*cf.*, for example, Furtwängler and Reichhold, "*Griechische Vasenmalerei*," p. 250). One might perhaps find in them, if one made a profound study of the subject, a system of measurement analogous to that of statuary. We have, in fact, seen that at its origin the vase is not to be separated from the figurine (p. 78); down to the classical period it retains points of similarity with the structure of the human body (Salle H). As M. Froehner has well shown in an ingenious article (*Revue des Deux Mondes* 1873, c. CIV, p. 223), we ourselves speak of the foot, the neck, the body, the lip of a vase, assimilating the pottery to the human figure. What, then, would be more natural than to submit it to a sort of plastic canon, which, while modified in the course of time, would be based on simple and logical rules? I have remarked ("*Monuments Piot*, IX," p. 138) that the maker of the vase of Cleomenes observed a rule illustrated by many pieces of pottery of this class, when he made the height of the object exactly equal to its width. M. Reichhold (l. c. p. 181) also notes that in an amphora attributed to Euthymides the circumference of the body is exactly double the height of the vase. I believe that a careful examination of the subject would lead to interesting observations on what might be called the "geometry of Greek ceramics." E. POTTIER, Musée National du Louvre, "Vases antiques III," p. 659.

CHAPTER ONE: THE BASIS OF DESIGN IN NATURE

FOR the purpose of the present work, it will be sufficient to deal only with the conclusions obtained by the study of the bases of design in nature. There are so many fascinating aspects of natural form, so many tempting by-paths, that it would be easy to wander far from the subject now under consideration. Moreover, the morphological field has received attention from many explorers more gifted and better equipped to examine and interpret the phenomena of shape from a scientific point of view than the writer, whose training has been, and disposition is, merely that of a practical artist.[4] His working hypothesis, responsible for the material here presented, was formulated upon the assumption that the same curve persists in vegetable and shell growth. This curve is known mathematically as the constant angle or logarithmic spiral. This curiously fascinating curve has received much attention.[5] As a curve form, its use for purposes of design is limited, but it possesses a property by which it may readily be transformed into a rectangular spiral. The spiral in nature is the result of a process of continued proportional growth. This will be clear if we consider a series of cells produced during a period of time, the first cell growing according to a definite ratio as new cells are added to the system. (See Figs. 1 and 2.) The shell is but a cone rolled up. Fig. 1 represents the cone of such an aggregate, while Fig. 2 shows the system coiled.

Fig. 1. Fig. 2.

The curve of the coil is a logarithmic spiral in which the law of proportion is inherent. A distinctive feature of this curve is that when any three radii vectors are drawn, equi-angular distance apart, the middle one is a mean proportional between the other two; in other words, the three vectors, or the three lines drawn from the center or pole to the circumference, equi-angular distance apart, form three terms of a simple proportion; A is to B, as B is to C, and according to the "rule of three" the product of the extremes, A and C, is equal to the square of the mean. A multiplied by C equals B multiplied by itself. The early

Greeks covered the point geometrically when they established the fact that in a right triangle, a line drawn perpendicular to the hypotenuse to meet the intersection of the legs, is the side of a square equal in area to the rectangle formed by the two segments of the hypotenuse. (Fig. 3.)

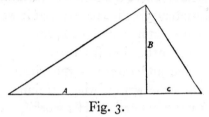

Fig. 3.

These three lines C, B, A, constitute three terms in a continued proportion.

When the three radii vectors are drawn from the center to the circumference of the shell curve, as in Fig. 4,

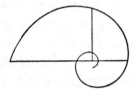

Fig. 4.

and these points of intersection with the spiral are connected by two straight lines, a right angle is created at C and a right triangle formed, ACB. (Fig. 5.)

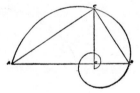

Fig. 5.

If the mean proportional line of this right triangle, ACB, that is, if the line CO be produced through the pole or center of the spiral to the opposite side of the curve, obviously another right angle is created as at B, and by drawing the line BD, the right triangle DBC is formed. (Fig. 6.)

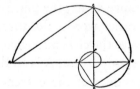

Fig. 6.

The process may be extended until the entire spiral curve has been transformed into a right angle spiral, as shown by the lines AC, CB, BD, DE, EF, etc., a form suggestive of the Greek fret. There now exists in the area bounded by the spiral curve a double series of lines in continued proportion, each line bearing the same relation to its predecessor as the one following bears to it.

As far as design is concerned, we may now dispense with the curve of the spiral. There have been extracted from it all essentials for the present purpose and there remains but the placing of the angular spiral within a rectangle. This may be done in any rectangle by drawing a diagonal to the rectangle and from one of the remaining corners a line to cut this diagonal at right angles. This line, drawn from one corner of the rectangle to cut the diagonal at right angles, is produced to the opposite side of the rectangle. (Fig. 7.)

Fig. 7.

Such a line we shall refer to as a perpendicular, and in all cases it is drawn from a corner. It establishes proportion within a rectangle, and is the diagonal to the reciprocal of the rectangle. In Fig. 8, AB is a reciprocal rectangle and consequently is similar to the rectangle CD.[7]

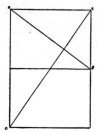

Fig. 8.

There exists a series of rectangles whose sides are divided into equal parts by the perpendicular to the diagonal. Take for example the rectangle in Fig. 9, where the line AB bisects the line CD, at B. In such a rectangle a relationship exists between the end and the side expressed numerically by 1, or unity, and 1.4142 (see Fig. 10) or the square root of two, and a square constructed on the end is exactly one-half, in area, of the square constructed on the side.

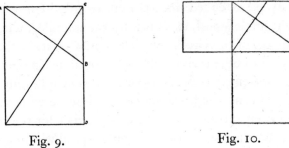

Fig. 9. Fig. 10.

The student may draw all the rectangles of Dynamic Symmetry with a right angle and a decimally divided scale, preferably one divided into milli-meters.

It will be noticed that the number 1.4142 is an indeterminate fraction. In other words, while the end and the side of this rectangle are incommensurable in line, they are commensurable in square.[6] This rectangle we may call a root-two rectangle. It is found to possess properties of great importance to design. It is the rectangle whose reciprocal is equal to half the whole.[7]

Fig. 11a. Fig. 11b.

Fig. 11a shows two perpendiculars in the rectangle, and rectangular spirals wrapping around two poles or eyes. If, as in Fig. 11b, four perpendiculars are drawn to the two diagonals, and then lines at right angles to the sides and ends through the intersections, the area of the rectangle will be divided into similar figures to the whole, the ratio of division being two.

Fig. 12a. Fig. 12b.

If, instead of lines coinciding with the spiral wrapping, as in Fig. 11a, lines are drawn through the eyes, and at right angles to the sides and ends, the rec-

tangle will be divided into similar shapes to the whole, with a ratio of three. (See Fig. 12.) AB is one third of AC, while AD is one third of AE.

A rectangle whose side is divided into three equal parts by horizontal lines drawn through the points of intersection of the perpendiculars and the sides of the rectangle has a ratio between its end and its side of 1, or unity, to 1.732 or the square root of 3. This is a root-three rectangle and has characteristics similar to those of a root-two rectangle, except that it divides itself into similar shapes to the whole with a ratio of 3. AB, BC and CD are equal. (Fig. 13.) Lines drawn through the eyes of the spiral divide this rectangle into four equal parts. The square on the end of this rectangle is one-third the area of the square on the side.

Fig. 13

A rectangle whose side is divided into four equal parts by a perpendicular has a ratio between its end and its side of one to two, or unity to the square root of four. This rectangle has properties similar to those of a root-two or a root-three rectangle, except that it divides itself into similar rectangles by a ratio of four, and the area of the square on the end is one-fourth the area of

Fig. 14a.

Fig. 14b.

the square on the side. This is a root-four rectangle. Lines drawn through the eyes of the spirals of a root-four rectangle divide the area into five equal parts similar to the whole. (Fig. 14*b*.)

A rectangle whose side is divided into five equal parts by a perpendicular has a ratio between its end and its side of one to 2.236, or the square root of five. This area is a root-five rectangle and it possesses properties similar to those of the other rectangles described, except that it divides itself into rectangles similar to the whole with ratios of five and six. A square on the end is to a square on the side as one is to five, that is, the smaller square is exactly one-fifth the area of the larger square. There is an infinite succession of such rectangles, but the Greeks seldom employed a root rectangle higher than the square-root of five.

Fig. 15*a*. Fig. 15*b*.

The root-five rectangle, moreover, possesses a curious and interesting property which intimately connects it with another rectangle, perhaps the most extraordinary of all. To understand this strange rectangle, we must consider the phenomena of leaf distribution. This root-five rectangle may be regarded as the base of dynamic symmetry.[8]

Closely linked with the scheme which nature appears to use in its construction of form in the plant world is a curious system of numbers known as a summation series. It is so called because the succeeding terms of the system are obtained by the sum of two preceding terms, beginning with the lowest whole number; thus, 1, 2, 3, 5, 8, 13, 21, 34, 55, 89, 144, etc. This converging series of numbers is also known as a Fibonacci series, because it was first noted by Leonardo da Pisa, called Fibonacci. Leonardo was distinguished as an arithmetician and also as the man who introduced in Europe the Arabic system of

notation. Gerard, a Flemish mathematician of the 17th century, also drew attention to this strange system of numbers because of its connection with a celebrated problem of antiquity, namely, the eleventh proposition of the second book of Euclid. Its relation to the phenomena of plant growth is admirably brought out by Church,[5] who uses a sunflower head to explain the phenomena.

What is called normal phyllotaxis or leaf distribution in plants is represented or expressed by this summation series of numbers. The sunflower is generally accepted as the most convenient illustration of this law of leaf distribution. An average head of this flower possesses a phyllotaxis ratio of 34 x 55. These numbers are two terms of the converging summation series.

The present inquiry is concerned with only two aspects of the phyllotaxis phenomena: the character of the curve, and the summation series of numbers which represents the growth fact approximately.[9] The actual ratio can be expressed only by an indeterminate fraction. The plant, in the distribution of its form elements, produces a certain ratio, 1.618, which is obtained by dividing any one term of the summation series by its predecessor. This ratio of 1.618 is used with unity to form a rectangle which is divided by a diagonal and a perpendicular to the diagonal, as in the root rectangles. (Fig. 19.)

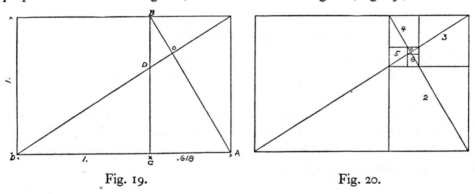

Fig. 19. Fig. 20.

"A fairly large head, 5 to 6 inches in diameter in the fruiting condition, will show exactly 55 long curves crossing 89 shorter ones. A head slightly smaller, 3 to 5 inches across the disk, exactly 34 long and 55 short; very large 11 inch heads give 89 long and 144 short; the smallest tertiary heads reduce to 21 and 34 and ultimately 13 and 21 may be found; but these being developed late in the season are frequently distorted and do not set fruit well. A record head grown at Oxford in 1899 measured 22 inches in diameter, and, though it was not counted, there is every reason to believe that it belonged to a still higher series (144 and 233).

"Under normal conditions of growth the ratio of the curves is practically constant. Out of 140 plants counted by Weisse, 6 only were anomalous, the error thus being only 4 per cent." A. H. Church, "On the Relation of Phyllotaxis to Mechanical Law."[5]

Thus, we may call this "the rectangle of the whirling squares," because its continued reciprocals cut off squares. The line AB in Fig. 19 is a perpendicular cutting the diagonal at a right angle at the point O, and BD is the square so created. BC is the line which creates a similar figure to the whole. One or unity should be considered as meaning a square. The number 2 means two squares, 3, three squares, and so on. In Fig. 19 we have the defined square BD, which is unity. The fraction .618 represents a shape similar to the original, or is its reciprocal. Fig. 20 shows the reason for the name "rectangle of the whirling squares." 1, 2, 3, 4, 5, 6, etc., are the squares whirling around the pole O.

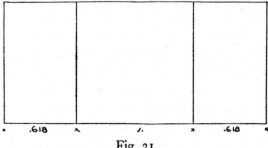

.618 1. .618

Fig. 21.

If the ratio 1.618 is subtracted from 2.236, the square root of 5, the remainder will be the decimal fraction .618. This shows that the area of a root-five rectangle is equal to the area of a whirling square rectangle plus its reciprocal, that is, it equals the area of a whirling square rectangle horizontal plus one perpendicular, as in Fig. 21.

The writer believes that the rectangles above described form the basis of Egyptian and Greek design. In the succeeding chapters will be explained the technique or method of employment of these rectangles and their application to specific examples of design analysis.

CHAPTER TWO: THE ROOT RECTANGLES

THE determination of the root rectangles seems to have been one of the earliest accomplishments of Greek geometers.[9] In fact, geometry did not become a science until developed by the Greeks from the Egyptian method of planning and surveying. The development of the two branches of the same idea went together. Greek artists, working upon this basis to elaborate and perfect a scheme of design, labored side by side with Greek philosophers, who examined the idea to the end that its basic principles might be understood and applied to the solution of problems of science. How well this work was done, Greek art and Greek geometry testify.

As early as the Sixth Century B. C. Greek geometers were able to "determine a square which would be any multiple of a square on a linear unit." It is evident that in order to construct such squares the root rectangle must be employed. We find the Greek point of view essentially different from ours, in considering areas of all kinds. We regard a rectangular area as a space inclosed by lines, and the ends and sides of the majority of root rectangles, because these lines are incommensurable, would now be called irrational. The Greeks, however, put them in the rational class, because these lines are commensurable in square.[6] This conception leads directly to another Greek viewpoint which resulted in the evolution of a method employed by them for the solution of geometric problems, to wit, "the application of areas."[10] Analysis of Greek design shows a similar idea was used in art when rectangular areas were exhausted by the application of other areas, for example, the exhaustion of a rectangle by the application of the squares on the end and the side, in order that the area receiving the application might be clearly understood and its proportional parts used as elements of design. If the square on the end of a root-two rectangle be applied to the area of the rectangle, it "falls short," is "elliptic," and the part left over is composed of a square and a root-two rectangle. (See Fig. 1a.) If the same square be applied to the other end, so as to overlap the first applied square, the area of the rectangle is divided into three squares and three root-two rectangles. (See Fig. 1b.) And, if the square on the side of a root-two rectangle be applied, it "exceeds," is "hyperbolic," and the excess is composed of two squares and one root-two rectangle.[11] (See Fig. 1c.)

This idea is quite unknown to modern art, but that it is of the utmost importance will be shown in this book by the analyses of the Greek vases.

Let us now consider various methods of construction of the root rectangles,

and, of course, the whirling square rectangle. We will commence with the latter, which is intimately connected with extreme and mean ratio, a geometrical conception of great artistic and scientific interest to the early Greeks. Using dynamic symmetry, this problem of cutting a line in extreme and mean ratio may be solved through subtracting unity from the diagonal of a root-four rectangle: the Greek method was not essentially different. To the early geometers it was the cutting of a line so that the rectangle formed by the whole line and the lesser segment would equal the area of the square described on the greater segment.[5]

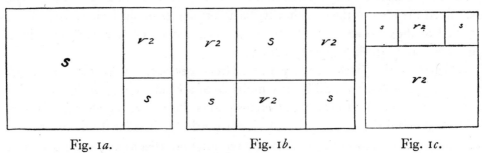

Fig. 1a. Fig. 1b. Fig. 1c.

Euclidean construction furnishes an easy method for describing not only the whirling square, but also the root-five rectangle, after the following manner: A square is drawn and one side bisected at A. The line AB is used as a radius and the semi-circle CBFD described. DE is a root-five rectangle. BC and DF are rectangles of the whirling square, as are also CF and BD. (Fig. 2.)

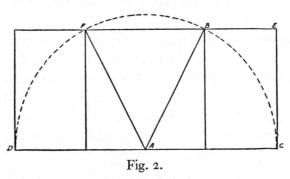

Fig. 2.

The relation of the rectangles, which have been described, to certain compound shapes derived from them will now be shown. If, in a rectangle of the whirling squares mapped out as in Fig. 3, a line parallel to the sides be drawn through the eyes A and B, it cuts from the major shape a root-five rectangle, i. e., a square and two whirling square rectangles, C, D, and E,—D being the square. Fig. 4 shows how a line drawn through the eyes F and G, parallel to

the end, defines also a root-five rectangle, C being the square. Obviously this may be done at either end and side, resulting in the determination of four root-five rectangles overlapping each other within the major shape. In a whirling square rectangle (Fig. *5a*), if lines be drawn through the eyes A, B, C, D parallel to the ends, and A and B connected by another line, an area will be

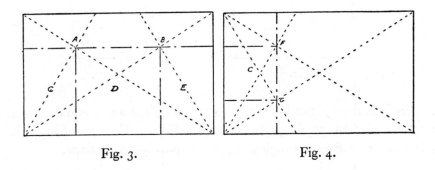

Fig. 3. Fig. 4.

defined, composed of the square E and the rectangle F. This shape, composed of E and F, is numerically described as the rectangle 1.382. The square E is unity. The rectangle F is the fraction .382, this being the reciprocal of 2.618, *i. e.*, it is a whirling square rectangle, 1.618 plus 1. (Fig. *5b*.) If this 1.382 rectangle is divided by 2, the shapes G, H (Fig. *5c*), result and each is composed of a square and a root-five rectangle. 1.382 divided by 2 equals .691, which, divided into unity, proves to be the reciprocal of 1.4472, and .4472 is the reciprocal of root-five and is itself a root-five rectangle. Many Greek vases were constructed according to the principles inherent in this 1.382 shape.

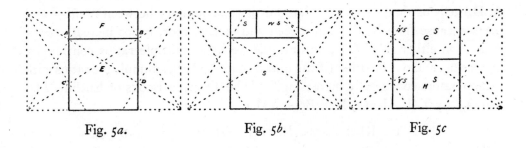

Fig. *5a*. Fig. *5b*. Fig. *5c*

If a whirling square rectangle is subtracted from, or applied to, a square, the defect is .382 or a whirling square rectangle plus a square. (See Fig. 6.) .618 subtracted from 1. equals .382. If, as in Fig. 7, a whirling square rectangle is

placed in the center of the shape 1.382, the "defect" area on either side is composed of a square and a whirling square rectangle.

Fig. 6. Fig. 7.

The reciprocal of 1.382 is .7236; .4472 multiplied by 2 equals .8944, and this result added to .7236 equals 1.618. (See Fig. 8.) The area of Fig. 8 is composed of two root-five rectangles, .4472 x 2, plus a .7236 shape.

Fig. 8.

All of these shapes are found in abundance in both Egyptian and Greek art.

The square is considered the unit form or monad. "Iamblicus (fl. *circa* 300 A. D.) tells us that . . . 'an unit is the boundary between number and parts because from it, as from a seed and eternal root, ratios increase reciprocally on either side,' *i. e.*, on one side we have multiple ratios continually increasing, and on the other (if the unit be subdivided), submultiple ratios with denominators continually increasing." ("The Thirteen Books of Euclid's Elements," by T. F. Heath, Def. Book VII.)

THE RECIPROCAL RATIOS WITHIN A SQUARE

The root rectangles are constructed within a square by the simple geometrical method shown in Fig. 9. AB is a quadrant arc with center D and radius DB. DC is a diagonal to a square and it cuts the quadrant arc at F. A line, parallel to a side of the square, is drawn through F. This line determines a root-two

rectangle and DE is its diagonal. A diagonal to a root-two rectangle cuts the
quadrant arc at H. GD is a root-three rectangle, the diagonal of which cuts the
quadrant arc at J. DI is a root-four rectangle and its diagonal cuts the quad-
rant arc at L. DK is a root-five rectangle and so on. All the root rectangles may
be thus obtained within a square.

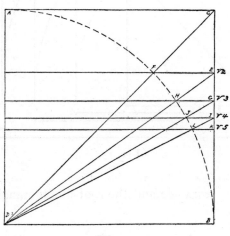

Fig. 9.

The root ratios outside of a square are obtained from diagonals, Fig. 10.

AB, the diagonal of the unit form or square, determines the point C, the side
of a root-two rectangle. The diagonal of a root-two rectangle, as AD, becomes
the side of a root-three rectangle, as AE. AF, the diagonal of a root-three rec-
tangle, becomes the side of a root-four rectangle, as AG. AH, the diagonal of a
root-four rectangle, becomes the side of a root-five rectangle, as AI. AJ, the
diagonal of a root-five rectangle becomes the side of a root-six rectangle, and
so on to infinity. In any of these rectangles a square on the end is some even
multiple of a square on the side. The square constructed on the line AC is dou-
ble the square on AK; the square on AE is three times the area of the square on
AK; the square on AG is four times the square on AK; the square on AI is five
times the square on AK, etc. This was the Greek method of describing squares
which would be any multiple of a square on a given linear unit.[5] The given linear
unit is the line AK. The rectangles inside the square are the reciprocals of the
rectangles outside the square. A root-two rectangle inside the square, for ex-
ample, is one-half the area of the root-two rectangle outside the same square;
a root-three inside, one-third of a root-three outside; a root-four inside, one-

fourth of a root-four outside and a root-five inside, one-fifth of a root-five outside. And a reciprocal to any rectangle is obtained by drawing a perpendicular from one corner.

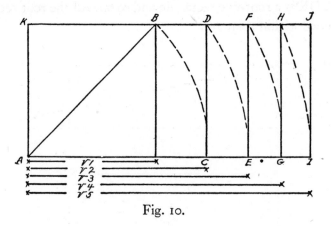

Fig. 10.

The whirling square rectangle and the root-five rectangle are placed within a square thus:

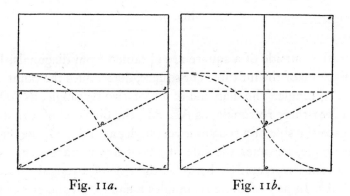

Fig. 11a. Fig. 11b.

The square is first bisected by the line AB, to obtain a root-four rectangle or two squares. From the diagonal of this rectangle CB, unity, or BE, is subtracted to determine the point D, and CD, furnishes the side of the whirling square rectangle FE. See Fig. 11a. A line drawn through the point D, parallel to a side of the square, determines the root-five rectangle GH. Fig. 11b.

In a whirling square rectangle inscribed in a square, if lines be drawn through the eyes and produced to the opposite side of the square, a root-five rectangle is

constructed in the center of the square, see Fig. 12a. The area AB is this area, and if these lines be made to terminate at their intersection with the diagonals of the square, the whirling square rectangle CD, is defined as in Figs. 12b and 12c. That this construction was used by the Egyptians in design is shown by the bas-relief in the form of a square herewith reproduced:

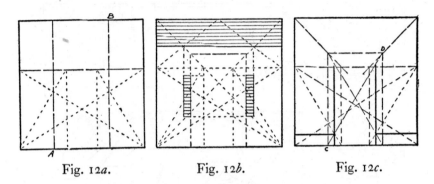

Fig. 12a. Fig. 12b. Fig. 12c.

When, as in Fig. 13, a whirling square rectangle is comprehended within a square, CD, the small square, AB, has a common center with the large square, CK, and if the sides of this small square, AB, are produced to the sides of the large square, CK, four whirling square rectangles, overlapping each other to the extent of the small square, AB, are comprehended in the major square. They are HK, EF, CD, and CJ, and the major square becomes a nest of squares and whirling square rectangles.

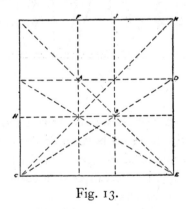

Fig. 13.

Analysis of the Egyptian bas-relief composition (Fig. 14) shows that its designer not only proportioned the picture but also the groups of hieroglyphs by the application of whirling square rectangles to a square. The outlines ot

the major square are carefully incised in the stone by four bars, two of which have slight pointed projections on either end. The general construction was that of *a* in Fig. 12. Spacing for additional elements of the design is shown in *c*, Fig. 12, while *b*, Fig. 12, exhibits the grouping of the hieroglyphic writing.

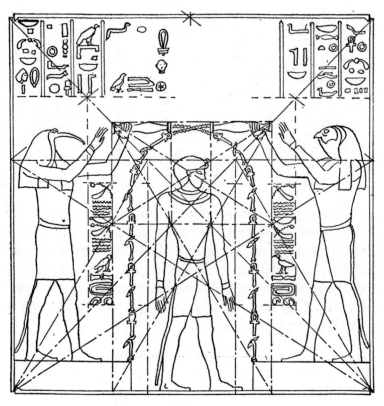

Fig. 14.

Another bas-relief from Egypt shows also how a square which is defined by bars cut in the stone at the top and bottom of the composition has its area dynamically divided for a pictorial composition. In this example the designer has used a root-five rectangle in the center of a square, Fig. 12*a*. The plan of this arrangement is obvious, Fig. 15.

A simple theme in root-two is exhibited in Fig. 16. A goddess is pictured supporting a formalized sky in the shape of a bar. The spaces between the bars on either side of the figure were filled with hieroglyphic writing. These have been omitted in this reproduction. The overall shape of this composition is **a**

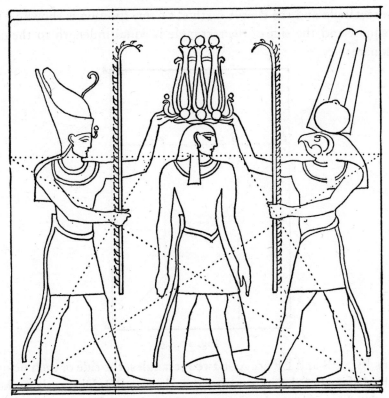

Fig. 15.

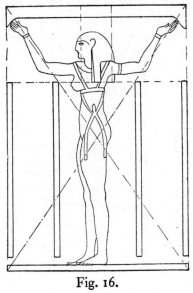

Fig. 16.

root-two rectangle and the simple method of construction is shown in Fig. 17. BC is a square and the side of the rectangle is equal in length to the diagonal of this square:

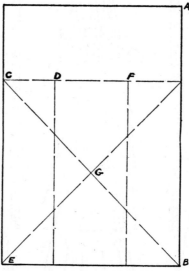

Fig. 17.

AB equals BC. DB and EF are root-two rectangles, the side of each being equal to half the diagonal of the major square, or the line BG. Diagonals to the whole intersect the side of the major square at the points D F.

Another theme in root-two is disclosed in Fig. 18. The general shape is a square, carefully defined by incised lines, as in the other examples.

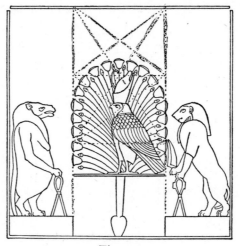

Fig. 18.

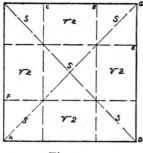
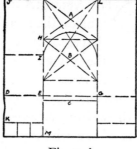

Fig. 19a. Fig. 19b.

The plan scheme of this design is shown in Fig. 19a. AB, CD, AE and FG, are four root-two rectangles overlapping each other in the major square, and the side of each, as CG, is equal to half the diagonal of the major shape. These rectangles subdivide the area of the major square into five squares and four root-two rectangles. In Fig. 19b, the use of this spacing, in its direct application to the design, is shown. The central portion of the major square, composed of the square HG and the root-two rectangle HL, is divided by the diagonals and perpendiculars of this rectangle. B is the center of the semicircle and BC is made equal to BA. This fixes the proportion of space to be occupied by the hawk and the field of formalized lotus flowers. MJ is composed of the two squares MD, DI and the root-two rectangle IJ. The square MD is divided into three parts and one of these parts forms the platform on which stands the hippopotamus god. This god is placed within the space KI. The same construction applies to the other side of the composition.

The examples of Egyptian bas-relief compositions described are, with one exception, arrangements within a square. These are used because of their obvious character. Like Greek temples and vase designs, the best Egyptian bas-relief plans are composed within the figures of dynamic symmetry, both simple and compound.

The Egyptians were regarded by the Greeks as masters of figure dissection. The rational combinations of form, which we may recover from their designs, confirms this and sheds some light on the significance of the ceremonial when "the king, with the golden hammer," drove the pins at the points established by the harpedonaptae, the surveyors or "rope-stretchers," who "corded the temple" and related the four corners of the building with the four corners of the universe.[2]

CHAPTER THREE: THE LEAF

THE rectangles of dynamic symmetry consist of the root rectangles, the rectangle of the whirling squares, and compound shapes derived from subdivision or multiplication of either the square root forms or the rectangle of the whirling squares.

In both Greek and Egyptian design the compound shapes derived from the rectangle of the whirling squares and the root-five shape greatly preponderate. The rectangle of the whirling squares, as a separate design shape, appears, but seldom. This fact suggests that extreme and mean ratio, *per se*, has little aesthetic significance. Its chief feature appears to be its power as a coordinating factor when used with certain of the compound rectangles.

There is unquestionable documentary evidence that the use of the compound rectangles, found so plentifully in Greek art, was not arbitrary. Their bases exist in nature and it is historical that the Greeks thoroughly understood the source from which they are derived. (See the Thirteenth Book of Euclid's Elements.) Their discovery in nature by the writer resulted from examination of the trussing of a maple leaf. The shape of this leaf strikingly resembles a regular pentagon.

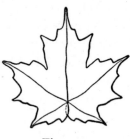

Fig. 1*a*.

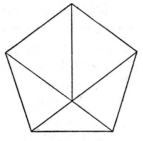

Fig. 1*b*.

The leaf is shown above in Fig. 1*a*, and the resemblance of the shape itself and of its trussing to the regular pentagon and its diagonals, is apparent in Fig. 1*b*. In a regular pentagon inscribed in a circle the relation of the radius of the escribed circle to the radius of the inscribed circle is 1 : .809. The fraction .809 multiplied by 2 equals 1.618, or the ratio of the whirling square rectangle. This means that if we escribe a square to the circle escribing a regular pentagon (Fig. 2), the area shown by the heavy lines is represented by the ratio 1.809. A is a square and B two whirling square rectangles. This is a ratio often found in Greek design, among amphorae and skyphoi especially. The division of the pentagon with its escribed square produces two such areas, as in Fig. 3.

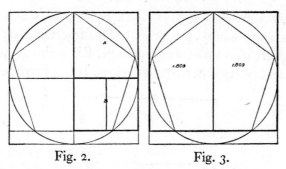

Fig. 2. Fig. 3.

In Fig. 4, the point B in reference to the center A, is eighteen degrees and the natural sine of eighteen degrees or the line AC, is .309. This fraction multiplied by 2 equals .618. The rectangle AB, therefore, is composed of two whirling square rectangles, placed end to end, a common shape in Greek design. The entire area shown by the heavy lines in Fig. 5, is composed of four whirling square rectangles, two perpendicular side by side, and two horizontal end to end.

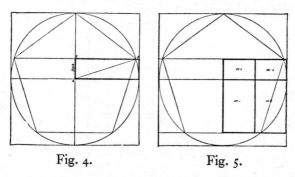

Fig. 4. Fig. 5.

A root-five rectangle is composed of a whirling square rectangle, plus its reciprocal, or 1.618 plus .618. Consequently the area shown by the heavy lines in Fig. 6a is composed of two root-five rectangles, and the area in b, defined by heavy lines, is equal to four root-five rectangles.

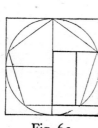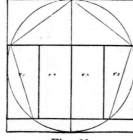

Fig. 6a. Fig. 6b.

The total distance AB in Fig. 7, is 1.809. BC is .809, CD is .309, AC is 1 or unity, and AD is unity minus .309, or .691. This fraction .691, is the reciprocal of 1.4472, or a square plus a root-five rectangle. ED is this shape, the key to the Parthenon plan and many other Greek designs. It is a favorite shape for many vases.[12]

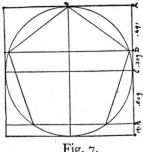

Fig. 7.

The intersection of two diagonals to the pentagon, in Fig. 8, determines the area shown by the heavy lines, which is composed of two squares and two root-five rectangles or the ratio 1.382.

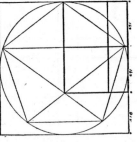

Fig. 8.

The distance AB in Fig. 9, is the difference between 1.809 and 2, or .191, and this fraction multiplied by 2 equals .382, the reciprocal of 2.618. Therefore the area AD is composed of four shapes, two squares and two whirling square rectangles.

Fig. 9.

The radius of a circle escribing a pentagon is 1, and the radius of the inscribed circle is .809. Therefore the area AB, in Fig. 10, is composed of two whirling square rectangles. The area BC plus AD is composed of eight squares and

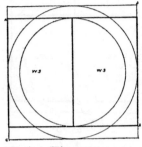

Fig. 10.

eight whirling square rectangles. If these areas BC, AD, are placed one over the other, the area is then expressed as 5.236, *i. e.*, 1.236 plus four squares. The reciprocal of 5.236 is .191. (Fig. 11.)

Fig. 11.
The area 5.236.

The relation of the diameter of the inscribed circle of a pentagon to the diameter of the escribed circle is the ratio 1.236, *i. e.*, root five, 2.236, minus 1, or .618 multiplied by 2 (the reciprocal of 1.236 is .809). When the squares escribing these circles are placed in position, it will be apparent that the larger square is greater than the smaller square by sixteen whirling square rectangles and twelve squares. (Fig. 12.)

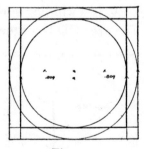

Fig. 12.

When four squares are placed in the pentagonal construction, as AB in Fig. 13, the area shown by the heavy lines is composed of two rectangles, each of

which consists of a square and two whirling square rectangles or the ratio 1.309.

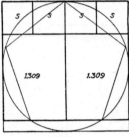

Fig. 13.

The area AB, in Fig. 14, is composed of a square and a root-five rectangle, as is also the area BC. The areas BD, BE, are 1.309 rectangles.

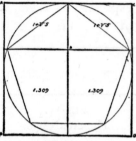

Fig. 14.

The ratio 1.382 is obtained by dividing 1.309 into 1.809. It is represented by the area AB in Fig. 15, and consists of a square plus .382 and this fraction is the reciprocal of 2.618, *i. e.*, a square plus a whirling square rectangle. Also, if this ratio of 1.382 is divided by two, it will be noticed that the area could be expressed by two .691 shapes, each of which is the reciprocal of 1.4472 or a square plus a root-five rectangle. The area BC is a whirling square rectangle, .691 divided into 1.118 producing 1.618. The area CD is a square.

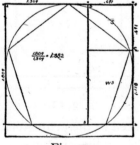

Fig. 15.

A line drawn through the intersection of two diagonals of a pentagon divides the area of the major square as in Fig. 16, into three shapes, two of which are rectangles of the whirling squares and one is composed of a square and a root-five rectangle.

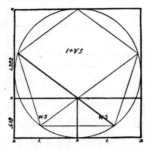

Fig. 16.

When the area of a major square is subdivided, as in Fig. 17, four very interesting shapes result. AB is a rectangle of the whirling squares. BC is represented by the ratio 1.1708, this being composed of .618 plus .5528, the latter ratio being the reciprocal of 1.809 or a square plus two whirling square rectangles. The ratio 1.1708 could be expressed by .4472 plus .7236. The rectangle BD is the ratio 1.7236, a square plus .7236, this fraction being the reciprocal of 1.382. The area BE, representing the ratio 1.099, is a complicated but very important shape. That it was used by the Greeks with telling effect is evidenced by a bronze wine container of the Fifth Century B. C., now in the Museum of Fine Arts in Boston.

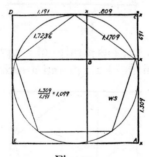

Fig. 17.

Two of the four rectangles in Fig. 18 have been described. The area BD, being 1.0652, consists of a whirling square rectangle plus a root-five rectangle, .618 plus .4472. BE is a 1.382 rectangle.

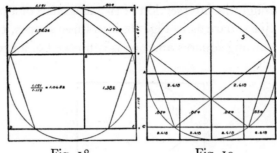

Fig. 18. Fig. 19.

The area of the major square in Fig. 19 is divided into twelve shapes. Two are squares. AB consists of two .382 or 2.618 rectangles, CD four such figures, while BC consists of four .854 shapes. This .854 shape is valuable. It consists of .618 plus .236; the latter being the reciprocal of 4.236 or root-five plus two. The ratio .854 is the reciprocal of 1.1708.

Seven of the thirteen subdivisional figures in Fig. 20 are squares. AB is a square and BC consists of a square plus two root-five rectangles, the ratio being 1.8944, and its reciprocal .528. The area BD is represented by the ratio 2.118, i. e., root five, 2.236 divided by two, 1.118, plus one.

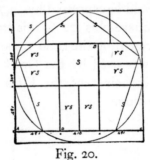

Fig. 20.

The rectangle AB in Fig. 21, has a ratio of 1.4472; a square plus a root-five rectangle, .4472 being one-fifth of 2.236 and a reciprocal of that number.

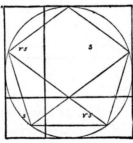

Fig. 21.

The area AB in Fig. 22a is a whirling square rectangle, 1.809 on the side and 1.118 on the end. CB is the major square of this rectangle. The shape DE is the ratio 1.2764, i. e., .691 divided into .882. Of this area .691 by .691 makes a square, and .191, the difference between .691 and .882, divided into .691 furnishes 3.618, i. e., a whirling square rectangle plus two squares. The area BD, .882 by 1.118, supplies the ratio 1.267. This ratio is more easily recognized if we consider its reciprocal .7888. Four root-five rectangle reciprocals equal the ratio 1.7888, .4472 multiplied by four. .7888, therefore, is four root-five rectangles minus one.

It is a beautiful shape and may be obtained readily from the whirling square rectangle. This particular ratio was discovered independently by Wm. Sergeant Kendall, in the form of overlapping whirling square rectangles creating a root-five rectangle by their union as in Fig. 22b.

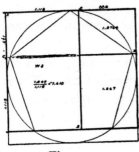

Fig. 22a.

Fig. 22b.

The area AB in Fig. 23 is composed of two squares and two root-five rectangles, or the ratio 2.8944, i. e., 1.4472 multiplied by two; .691 divided into 2.000. The fraction is not quite .691, but this number is sufficiently close for all practical purposes. BC and CD are two equal areas each composed of a square and two whirling square rectangles, i. e., each has a ratio of 1.309.

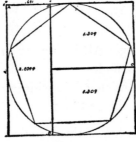

Fig. 23.

In Fig. 24 the area AB, unity on the end and 1.191 on the side, is a square plus .191 and this fraction represents two squares and two whirling square rectangles. The area BC represents four whirling square rectangles; .618 multiplied by four, 2.472 minus one or 1.472. DE is a root-five rectangle.*

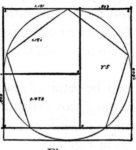

Fig. 24.

The area AB in Fig. 25 is divided into squares, root-five rectangles and rectangles of the whirling squares.

In Fig. 26 the area AB is composed of two rectangles each consisting of a square plus .382, this fraction being the reciprocal of 2.618. The area AB may be expressed also, as a square and a root-five rectangle, 1.4472. The area BC is composed of two whirling square rectangles.

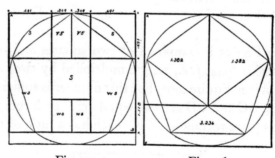

Fig. 25. Fig. 26.

The whirling square rectangle AB in Fig. 27 may also be expressed as two squares and two root-five rectangles.

The area AB in Fig. 28, consists of six whirling square rectangles. The side of this rectangle is 2.000 and the end .927.

* Euclid, XIII, I, in substance proves that a rectangle which is .809 on the end and 1.809 on the side is a root-five rectangle.

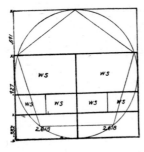 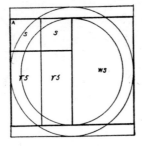

Fig. 27. Fig. 28.

In the thirteenth book of the Elements, Euclid proves the relationship of the end, side and diagonal of the whirling square rectangle. Proposition 8 is devoted to proving that diagonals to a pentagon cut each other in the proportion of the whirling square rectangle. The fact enunciated in this proposition suggests the reason why the Pythagoreans of the Sixth Century B. C. used the Pentagram as a symbol of their school.

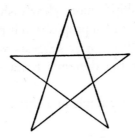

Fig. 29. Fig. 30.

The Pythagorean Pentagram Symbol. Diagram from Euclid XIII, 8.

The first six propositions of the 13th book are devoted to the consideration of the relationships of areas described on lines connected with the whirling square rectangle. In the first proposition the geometrical construction brings out the fact that a rectangle, the end of which is .809 and the side 1.809, is a root-five rectangle. In the 9th proposition proof is furnished that the side of a hexagon and the side of a decagon added, form a line which is cut in extreme and mean ratio, and the side of the hexagon is the greater segment. (Fig. 31.) Proposition 10 furnishes the proof that the square on the side of a pentagon inscribed in a circle is equal in area to the squares on the sides of a hexagon and a decagon inscribed in the same circle. Fig. 31a shows this relationship. This figure is of necessity a right-angled triangle.

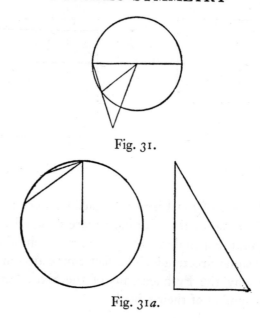

Fig. 31.

Fig. 31a.

Later, in XIII, 18, the rectangular relationship is more clearly shown in a root-five rectangle. The Euclidean diagram of the 18th proposition is peculiarly interesting in the light of dynamic symmetry because it suggests what may have been the Greek method of constructing the dynamic rectangles in a square.

The writer's method of describing a root-five rectangle in a square is shown in Fig. 32.

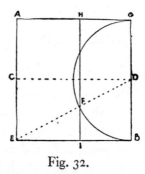

Fig. 32.

In the square AB, Fig. 32, draw the line CD, dividing the square into two equal parts. Draw ED, the diagonal to two squares. On DG describe a semicircle. The arc of this cuts the line ED at F. Through the point F draw the line HI parallel to GB. The area HB is a root-five rectangle within the area of the square AB.

In the 18th proposition of the thirteenth book a diagram is furnished which illustrates the setting out of the "five figures" for the purpose of comparison. The "five figures," of course, mean the five regular solids. These solids were of much interest to the Greeks of the Sixth Century B. C., because it was then thought that the atoms of the elements, which made up the universe, were shaped like the tetrahedron, the octahedron, the cube and the icosahedron. The dodecahedron was regarded as the shape which encompassed all the others.

The basis of the diagram in the 18th proposition of the 13th book is a semi-circle on a given line. In brief the operation is this:

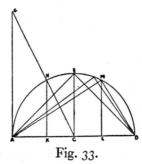

Fig. 33.

AB is the given line and ABE is the semicircle. (See Fig. 33.) Euclid in substance says: at A draw a line equal to AB at right angles to that line and call its point of termination G. The point C is midway between A and B. Connect C and G. In Euclid's diagram the point H is the intersection of the line GC with the arc of the semicircle AEB. From H a line is drawn parallel

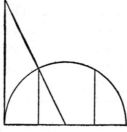

Fig. 34.

to AG to meet AB at K, BL is made equal to AK. From the point L a line is drawn, parallel to AG to meet the arc of the semicircle at M. It is obvious that HLKM is a square and that HA and MB are rectangles of the whirling squares. In other words, Euclid has here constructed a root-five rectangle and defined the square in the center, as is often necessary in the analysis of Greek design.

Euclid further shows in this proposition that the comprehension of the icosahedron in the same sphere with the other four regular solids involves the side of the hexagon, the side of the decagon and the side of a pentagon inscribed in the same circle. AK, BL are two sides of the decagon and KL, KH, LM or HM the side of the hexagon, and MB is the side of a pentagon.

The geometrical constructions used by Euclid for the comprehension of the five regular solids in the same sphere, suggest another method of determining the root rectangles of dynamic symmetry in a square. This method is based upon the fact that an angle in a semicircle is necessarily a right angle.

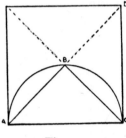
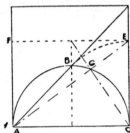

Fig. 35. Fig. 36.

The simplest example of this is shown in Fig. 35, where ABC is a right angled triangle. B is also the center of the square AD.

In Fig. 36 the line CB is revolved until it coincides with the side of the square, to determine the point E. The area AEFC is a root-two rectangle. It will be noticed that the diagonal of the reciprocal of the root-two rectangle AEFC cuts the diagonal of the whole at G, and that this point lies on the arc of the semicircle. If the line GC is revolved until it coincides with CE it will determine the point for a root-three rectangle. The poles or eyes of all the root rectangles, that is, the points where the diagonals of their reciprocals cut the diagonals of the whole will lie on the arc of this semicircle and in each case the lines similar to GC of the root-two rectangle will determine the points on CE for each successive rectangle. Fig. 37 suggests the construction for this.

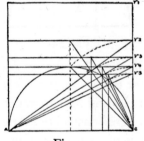

Fig. 37.

The geometrical fact established by Euclid that if a circle is described with a side of a whirling square rectangle as radius, this line equals the side of a hexagon, the end of the rectangle, the side of a decagon and the diagonal of the rectangle, the side of a pentagon, all inscribed in this same circle, suggests the construction of Figs. 39 and 40.

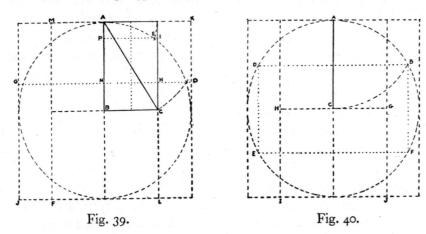

Fig. 39. Fig. 40.

In Fig. 39, AC is the diagonal of a whirling square rectangle, BC the end and AB the side. AD is the side of a pentagon and AE is the side of a decagon. The line DG is a diagonal of a pentagon inscribed in the circle, and it cuts the side of the whirling square rectangle at H. The area BH is equal to two squares and AH is composed of two root-five rectangles, while HM is equal to four such shapes. The line PI passes through the point E of the decagon. AI is equal to two whirling square rectangles, while PC is equal to a 1.309 shape. NL is an area represented by the ratio 2.118 or 1.618 plus .5. This area is also equal to two root-five rectangles plus a square, 1.118 plus 1. JK is a square escribing the circle with radius AB and ML is a whirling square rectangle in the center. The areas MJ and LK are each composed of two whirling square rectangles plus two squares. In Fig. 40 AB is the side of a hexagon equal to AC, the radius of the circle. BD, EF are sides of two equilateral triangles. These two lines divide each of the four whirling square rectangles AH, AG, CI and CJ into two equal parts. The area DF is a root-three rectangle.

CHAPTER FOUR: ROOT RECTANGLES AND SOME VASE FORMS

ANALYSES of Greek and Egyptian compositions show that the artist always worked within predetermined areas. The enclosing rectangle was considered the factor which controlled and determined the units of the form. A work of art thus correlated became an entity, comparable to an organism in nature. It possessed an individual character, instinct with the life of design.

Only such rectangles, simple or compound, were used, whose areas and sub-multiple parts were clearly understood. If the design for a vase shape were being planned the artist would consider the full height of the vessel as the end or side of a certain rectangle, while the full width would be the other end or side. The choice of a rectangle depended upon its suitability for a purpose, both in shape and property of proportional subdivision. A rough sketch was probably made as a preliminary and this formalized by the rectangle. Most Greek pottery shapes, however, were traditional, being slowly developed through a long period of time; consequently, rough sketches of ideas must have been rare. From generation to generation, from father to son, craft ideas were passed along, acquiring refinement gradually.

Modern art, as a rule, aims at freshness of idea and individuality in technique of handling; Greek art aimed at the perfection of proportion and workmanship in the treatment of old, well-understood and established motifs. That this is true is not only proven by the standardized shapes of Amphora, Kylix, Kalpis, Hydria, Skyphos, Oinochoe and Lekythos, but by the accepted forms of temples, theaters, units of decoration, treatment of drapery, grouping of sculpture forms and even the proportions of the figure. The opportunity for individual expression existed only in superlative workmanship, in refinement, precision and subtlety. To win distinction as an artist it was necessary for the Greek to be a veritable master. The danger of overrefinement is feared by the modern artist, for it has become a tradition that this leads to sweetness and loss of virility, because it invariably ends in overwork of surfaces. But this peril was almost unknown to the ancient Greek, his care and energy were devoted largely to the refinement of the structure of his creations.

Analysis of any fine Greek design is sure to disclose an arrangement of area which produces the quality of inevitableness, so conspicuously absent in modern art. An example of such a theme is furnished by a handsome red-figured amphora of the Nolan type, in the Fogg Museum in Boston. Its greatest width divided into its height produces the ratio of 1.7071. This ratio shows that, as

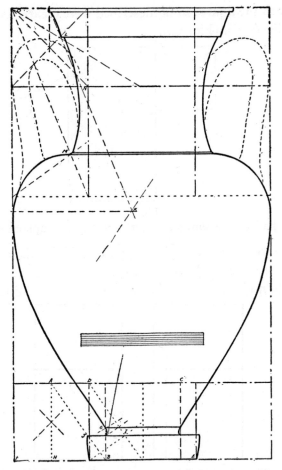

Fig. 1. Nolan Amphora in the Fogg Museum at Harvard.

an area, it is composed of a square plus the reciprocal of a root-two rectangle, *i. e.*, 1. plus .7071, the fraction being the square root of two divided by two.

The amphora is contained within the area of a root-two rectangle plus a square on its side. The width of the lip, in relation to the overall form, shows that it is a side of a square comprehended in the center of the root-two rectangle. When this square is drawn and its sides produced through the major square, an interesting situation exists in area manipulation. The projection of the sides of this square through the major square produces in the center of that square a root-two rectangle so that the shape as defined by the lip is a square plus a root-two rectangle, Fig. 3*a*, but the square is on the end of the rectangle instead of on the side as it is in the major shape. The method of simple con-

struction by which the figures so far described were created is the drawing of a square and its diagonals. (Fig. 3*b*.)

Fig. 2.
The shaded area shows the rectangle of the Amphora design.

The side of the root-two rectangle is equal to half the diagonal of the square. The method of construction by which the secondary square and root two are placed within the major shape, is shown in Fig. 4, *a*, *b* and *c*.

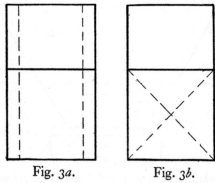

Fig. 3*a*. Fig. 3*b*.

A root-two rectangle, AB, is cut off within the major shape, its side being made equal to the diagonal of the major square. This applied rectangle is in

Fig. 4*a*. Fig. 4*b*. Fig. 4*c*.

"defect" and the area left over is composed of two squares and one root-two rectangle, as shown in *b*, Fig. 4. The same construction is used, working from the other end of the major shape, as shown in Fig. 4*c*.

Fig. 5.

Through the centers of the small squares on each corner, lines are drawn parallel to the sides of the major figure. These lines determine the secondary square and root-two rectangle, shown in Fig. 5. A diagonal to this secondary shape determines the angle pitch of the lip, and its thickness, also the width of its base, and the width of the neck. (See Fig. 1.) LK is this line.

The foot of the amphora is proportioned by the small root-two figure and two squares at the base. DE is the root-two rectangle. A square is placed in the center of this shape, being CB. The width of the ring above the foot is the side of this square. The width of the top of the foot exhibits an interesting manipulation of the square and root-two figures at the base of the design. The line AB in Fig. 1 brings out the point. AB is a derived root-two rectangle, and its diagonal is cut at J by a line through the point I. The thickness of the foot and its width at the bottom are determined by the diagonal and perpendicular of the root-two shape DE. (Fig. 1.)

The thickness of the ring above the foot is established by the line AB, in Fig. 6, a diagonal to a square and a root-two rectangle, intersecting the side of the square at C.

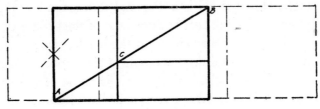

Fig. 6.

Two white pyxides, ladies' toilet boxes, one in the Museum of Fine Arts, Boston, and one in the Metropolitan Museum, New York, furnish examples of Greek design for comparative study. These two examples of the ancient potter's craft are exactly of the same overall shape; the ratio in each case being 1.2071. This is a compound shape composed of the reciprocals of root four or half a square and root two, .5 plus .7071. The reciprocal of 1.2071 is .8284, and this divided by two equals .4142, or the difference between unity and the square root of two, 1.4142, *i. e.*, the square root of two minus 1. When a square is subtracted from a root-two rectangle the excess area is composed of a square and a root-two rectangle.

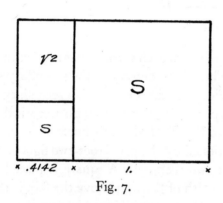
Fig. 7.

Fig. 8.

The containing rectangle of each pyxis design, therefore, is composed of two .4142 figures, *i. e.*, two squares plus a root-two rectangle. (Figs. 7 and 8.)

The details of the two designs, however, are proportioned or themed differently. In the Boston example the line AB of the analysis passes through the center of the root-two shape. (Fig. 10.) The line AB is the top of the pyxis.

The width of the bowl at its narrowest point is equal to the end of the major root-two rectangle, *i. e.*, it is the side of the square CD constructed in the center of this rectangle. (Fig. 9.) HI is a diagonal to a .4142 rectangle, *i. e.*, half the composing shape. This line cuts the diagonal of the square CD at J. Therefore the rectangle JK is a similar shape to the whole, two squares and a root-two rectangle, and is the containing rectangle of the knob. LK is composed of a square and a root-two rectangle. The line MN is a side of the square MNOP.

When unity is applied to a 1.2071 rectangle the excess area is composed of two squares and two root-two rectangles. This is the elevation area of the foot.

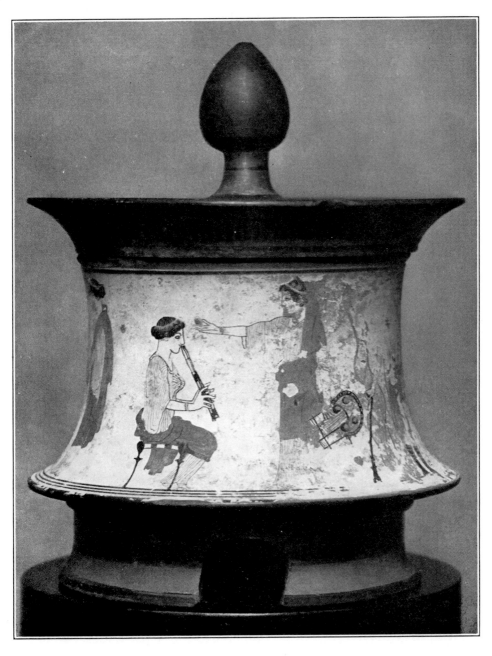

A WHITE-GROUND PYXIS, MUSEUM OF FINE ARTS, BOSTON

(*Compare with White-Ground Pyxis from New York*)

A theme in root-two

Fig. 9. Drawing by Dr. L. D. Caskey of the Pyxis in the Boston
Museum of Fine Arts.

R is the center of the two squares of the base. S is the center of the square MP.
A further refinement in the design is shown by the sinking of the handle below
the outer rim of the cover. The only variation from extraordinary exactitude
is at the juncture of the lid shown by the line EF. This is worn at the edges so
that it is difficult to determine this line precisely. The error, however, is so small
that it cannot be shown in the drawing.

This pyxis was measured and drawn by Dr. L. D. Caskey, of the Boston
Museum of Fine Arts.

The analysis of this vase shows a consistent Greek theme in area and it may
readily be seen that not only the content of the design itself but the excess area
not occupied by the design, may be expressed in terms of the whole and the two
composing shapes, namely, the root-four and root-two reciprocals. HQ is a

square, HL two squares and a root-two rectangle. The application of this area to the square HQ leaves the area CL, a root-two rectangle. HA is a root-two rectangle. The application of the square HQ leaves the area CA, a square and a root-two rectangle.

Fig. 10. Fig. 11.

The design plan of the pyxis in the Metropolitan Museum, New York, depends upon a manipulation of the diagonal to the overall shape and to the two composing figures, the root-four and root-two reciprocals. The manner in which this is done discloses an interesting feature of Greek design practice. It seems to have been recognized early that diagonals were the most important lines in the determination of both direct and indirect proportions. In the present example diagonals of the whole intersect diagonals of the root-two rectangle at A and B, Fig. 10. Through these points are drawn the lines HF, EG, IJ and LK, through the points C and D. These lines subdivide the area of the root-two rectangle into squares and root-two shapes. CE, AG are squares, MC, DN, AP and BO are root-two rectangles. AI and BJ are two root-four rectangles, i. e., shapes of two squares each. IJ is the top of the pyxis, DH the square enclosing the handle or knob.

AB in Fig. 11, is a square, one side of which is the width of the bowl at the narrowest point. The sides of this square produced, determine the root-two rectangle BC and fix the line of the base by their intersection with the diagonals of the whole at the points D and E.

The intersection of the diagonals of the whole with the diagonals of half the major shape, at AB in Fig. 12, determine the thickness of the lid.

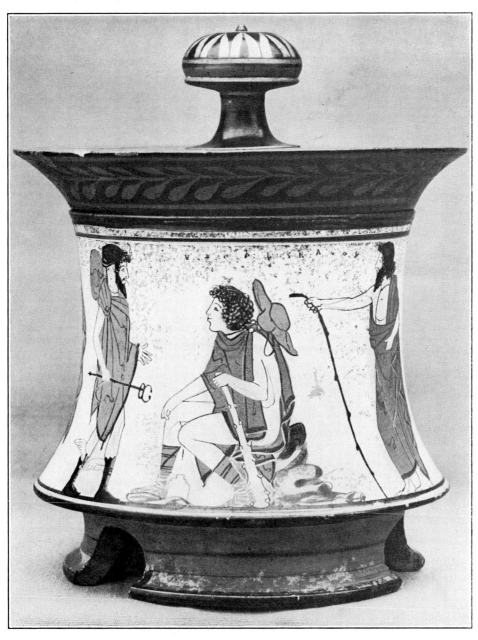

A WHITE-GROUND PYXIS, METROPOLITAN MUSEUM, NEW YORK

(*Compare with the Boston White-Ground Pyxis*)

A theme in root-two

Fig. 12. Drawing of Pyxis in the Metropolitan Museum, New York.
(Measurements checked by member Museum Staff.)

The Fifth Century B. C. bronze oinochoe, Fig. 13, 99.485 in the Museum of
Fine Arts, Boston, in its plan scheme, is another admirable illustration of the
Greek method of arranging a theme in area. The jug was measured and drawn by
Dr. Caskey, before an analysis of the shape was made. The containing rectangle
is a root-two shape, and all details are determined by a consistent arrange-
ment of the elements of this figure. The diagonals and perpendiculars are drawn
to the overall shape and a square described in the center of the root-two figure
AB. This square is CD, the side of which is equal to the width of the lip of the
vase. The diagonals of the whole cut the sides of this square at E and F. This
determines the area CF, equal to two squares, EG, FH, and the root-two figure
HI. A line drawn from J to C cuts the side of the square GE at K. The line
KLM divides the area of this square into two squares, CL, LI, and two root-
two figures, GL and LE. The center of the square CL, fixes the top of the lip;

Fig. 13. Bronze Oinochoe in the Boston Museum.

(Measured and drawn by L. D. Caskey.)

the base of this square, ML, establishes the bottom of the lip. Diagonals and perpendiculars to the root-two figure HI, determine other proportions of the lip and handle juncture. A line drawn through the center of the root-two figure BO, establishes the two root-two figures PO, PQ. The width of the vase, at the base, is fixed by the centers of the two squares SO, RQ. The sides of these squares produced, as from T to I, cut the diagonals of the whole and perpendiculars, as at T and U. This fixes the figure UV, of which TW is a square. Diagonals to half the area of this square, as WX, determine the triangle in which the goats' heads are drawn. The beard of one of these heads is shorter than that of the other, probably due to the molten bronze not entirely displacing the wax in the casting. If a square is applied to the other end of the shape occupied by the heads of the goats, other details are obtained. This design may now be understood as a theme in root-two and square. The drawing was made exactly the size of the original and no other analysis is possible.

A black-figured kylix, 98.920 in the Boston Museum (Fig. 14), fills an area composed of three root-two rectangles, and the width of the foot is the end of one of these shapes. AB is a root-two rectangle, BC is a square applied to it, CE is a diagonal to the excess area or to a square plus a root-two rectangle. AF is a root-two rectangle and its diagonal intersects CE at D, and fixes the width of the bowl. The depth of the bowl is determined by the point G, the intersection of a diagonal of the square BC with the diagonal of the root-two rectangle AB. (Compare with Yale Skyphos, p. 62.)

Fig. 14.

(Measured, drawn and analyzed by L. D. Caskey.)

The ratio of a black-figured kylix from Yale, Fig. 15, is that of a square plus a root-two figure or 1.4142 plus 1. In this case the square is drawn in the center and a reciprocal root-two figure on either end. AB is the side of the square. C and D are the intersections of diagonals of squares and root-two rectangles. I and J are the intersections of diagonals to two figures, each composed of a root-two rectangle plus the large square, with a line drawn through the middle of the large square, and G and H are the intersections of these same diagonals with the diagonals of the major square. The consistency of the proportions of the foot in relation to the width of the bowl is now apparent. The point K is the intersection of the diagonal of the whole with the diagonal of a square.

An Attic black-figured hydria, 95.62 in the Boston Museum (Fig. 16), is a vase form of unusual distinction. The plan is a theme in root-two. The vessel is a splen-

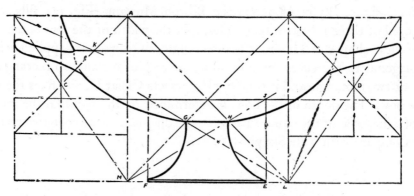

Fig. 15. Black-figured Kylix in the Stoddard Collection at Yale.

did example of Greek craftsmanship. If the width of the bowl is taken as the end and the total height as a side of a rectangle the ratio is 1.2071, the reciprocal being .8284. This is the same rectangle as that of the pyxides in this chapter. The overall ratio obtained by including the handles, is 1.0356. This rectangle is simply .8284 plus .2071, a rather ingenious manipulation of shapes. If the fraction .2071 be divided by two .10356 is the result. This means that the area of the overall rectangle AB is the 1.2071 shape which is composed of the two squares CD and DJ and the root-two rectangle is AJ. The lines IJ and IC are diagonals to the reciprocals of AJ. These diagonals intersect the diagonals of the 1.2071 form as at H. The line OM is a side of the root-two rectangle MN. The line ST bisects the areas of the two squares CD, DJ, and the root-two diagonals, as MN, cut this bisecting line of the two squares at S and T. This fixes the proportions of the foot. The width of the lip is the side of a square, PQ, in the center of the root-two rectangle AJ. The handle extends above the lip and the root-two rectangle XY, with its included square XZ, shows the proportional relationship. The diagonal GF cuts the side of the square PQ at A′. The area FA′ is a 1.2071 shape and H′ is its center. FF′ equals two squares and G′ is the center. The square A′B′ is described on the side of A′F; C′ is its center. B′D′ is a root-two rectangle with a square applied to the end to establish the point E′. The base of the pictorial composition is the line CJ, the top of the two squares CD, DJ. The painted rays at the foot terminate at the line L′M′. This line fixes the side of a square applied to AB, *i. e.*, the line L′M′ is distant from the top of the containing shape an amount equal to GB. The point K′, which marks the line separating the two pictorial compositions, is obtained by diagonal to the shapes PP′ and O′N.

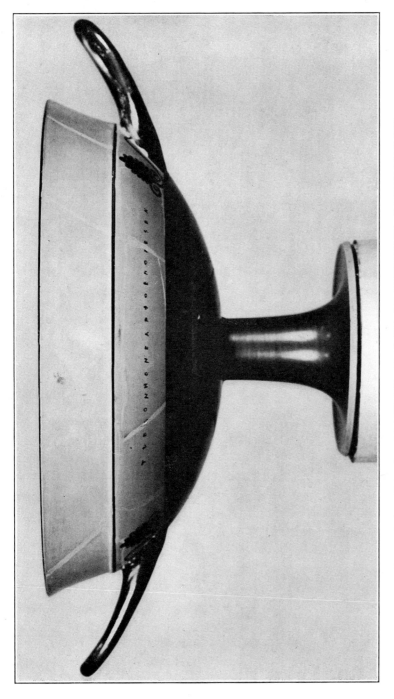

AN EARLY BLACK-FIGURED KYLIX OF UNUSUAL DISTINCTION,
BOSTON MUSEUM OF FINE ARTS

A theme in three root-two rectangles

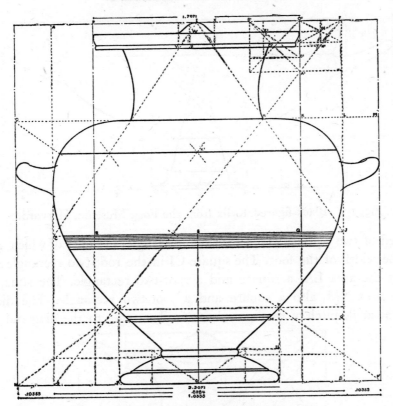

Fig. 16. Boston Black-figured Hydria 95.62.
(Measured and drawn by L. D. Caskey.)

If the width of the foot is considered as the end, and the full height, AG, as the side of a rectangle, it will be a 2.2071 shape, *i. e.*, two squares plus .2071. The area value of this fraction is two squares plus two root-two rectangles. That the designer of this vase must have known something of this value is evidenced by the fact that the rectangle J'U is a .2071 shape and the height of the vase, minus the foot, is equal to twice the width of the foot.

If the width of the lip is considered as the end and the full height, AG, as the side of a rectangle the ratio for the shape is 1.7071, the scheme of the Fogg amphora of this chapter.

An early black-figured kylix in the Fogg Museum, at Harvard, has the same ratio as the kylix from Yale (see Fig. 15), *i. e.*, 2.4142, a square and a root-two figure. The method of subdivision however is quite different. The square AB is applied to the root-two figure AC and its base line produced to D. This determines the root-two figure DE in the square EF. The excess area FB is

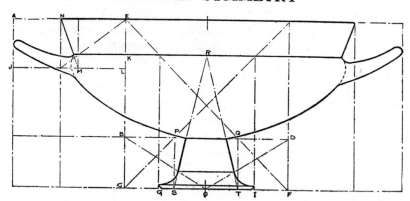

Fig. 17. Black-figured Kylix from the Fogg Museum, Harvard.

composed of two squares and a root-two rectangle, the sides of which, added, equal the width of the foot. The square CJ in the root-two rectangle AC determines the area LA, a square and a root-two rectangle. The square EM fixes the area NM, also a square and a root-two rectangle. The diagonal NM is the angle-pitch of the lip and is a similar angle to the diagonal of the

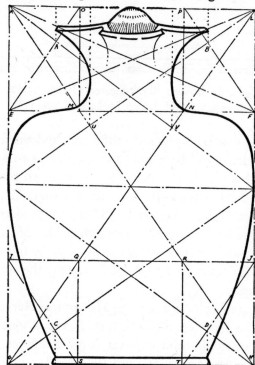

Fig. 18. A root-two Oinochoe from the Boston Museum.

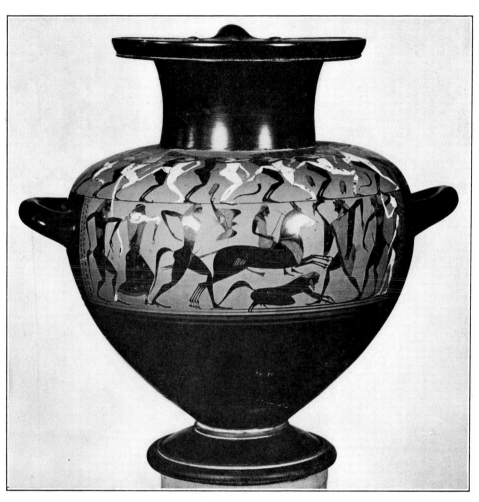

A BLACK-FIGURED HYDRIA, MUSEUM OF FINE ARTS, BOSTON

A theme in root-two. There is no break in the sequence of the theme

entire figure. The area KD is composed of two squares. BO, OD are diagonals to squares and root-two rectangles. OPOQ is a root-two rectangle. RS and RT determine the angle pitch of the foot.

A red-figured oinochoe in the Boston Museum, Fig. 18, is a simple root-two rectangle. A and B are poles or eyes of the two root-two figures MK and NL. U and V are eyes to the major or overall shape. C and D are eyes to the two root-two rectangles GQ and HR. GF is a square, JK is a square. The decorative band at the base of the figure composition passes through the center of the square RS while a side of the square GF passes through the compositional band at the top of the figures.

A Nolan amphora in the Stoddard Collection at Yale, Fig. 19, duplicates the ratio 1.7071 of the amphora of the Fogg Museum at Harvard. The division of

Fig. 19. Nolan Amphora from Yale.

the area however is somewhat different. AB is the major square and AC the root-two rectangle. CD is a square in the root-two rectangle and DE is the excess area equal to a root-two shape and a square. EF is this square and EG is a root-two rectangle within it. The center of the root-two area HG is the point which fixes the proportions at the juncture of lip and neck. EI is a similar shape to the whole. AX is a diagonal to a square and it cuts the diagonal of the whole at J. EM is a root-two rectangle and the area MN is composed of two squares and a root-two rectangle. The side of this root-two form is the width of the foot at its top. OP is a diagonal of a shape similar to the whole, *i. e.*, a square, RN plus a root-two figure, OR. The point S is the eye of the area OR. The relation of the point T to the foot is apparent. The angle pitch of the foot is fixed by the lines KV and KW. The point L is the center of the major square and a factor in the proportions of the meander band under the picture.

CHAPTER FIVE: PLATO'S MOST BEAUTIFUL SHAPE

THE Nolan type amphora, here illustrated, 13.188 in the Museum of Fine Arts, Boston, is an example of a vase design correlated by a root-three rectangle. It is remarkable that this shape is not more often met with in Greek design, for we know that it was regarded as a beautiful shape. It is mentioned by Plato, who makes the Pythagorean Timaeus explain: " 'Each straight lined figure consists of triangles, but all triangles can be dissected into rectangular ones, which are either isosceles or scalene. Among the latter the most beautiful is that out of the doubling of which an equilateral arises, or in which the square of the greater perpendicular is three times that of the smaller, or in which the smaller perpendicular is half the hypotenuse (in length). But two or four right-angled isosceles triangles, properly put together, form the square; two or six of the most beautiful* scalene right-angled triangles form the equilateral triangle; and out of these two figures arise the solids which correspond with the four elements of the real world, the tetrahedron, octahedron, icosahedron and the cube.' " (Quoted by Allman, "History of Greek Geometry from Thales to Euclid," p. 38.) Classic art was practically over by Plato's time.

The relation of the square on the end to a square on the side of a root-three figure is as one to three, while the end is one-half the length of the diagonal. The Greek artists do not seem to have agreed with Plato concerning the beauty of this rectangle, for we find it but seldom. It appears occasionally in vases; and the double equilateral triangle or hexagon appears in important Greek architecture only in the Choragic Monument of Lysicrates. The equilateral triangle is one of the two fundamentals of static symmetry and as a correlating form was used lavishly in Saracenic and Gothic art. (See chapter on Static Symmetry.)

Certainly a root-three rectangle cannot be said to be more beautiful than any of the other shapes of dynamic symmetry. In fact, there is little ground for the assumption that any shape, *per se*, is more beautiful than any other. Beauty, perhaps, may be a matter of functional coordination.

In the analysis of the amphora 13.188 in the Boston Museum, Fig. 1, perpendiculars to its diagonals indicate the divisions of a root-three rectangle into three similar shapes to the whole. AB is a root-three rectangle and a reciprocal of the major shape, as are also AC, CD, EF, and G is the center of the rectangle CD.

H is the center of the rectangle AI. JK is a root-three rectangle and L and

* The "most beautiful" oblong, here referred to, is the root-three rectangle.

Fig. 1. Nolan Amphora 13.188 in the Boston Museum.
(A theme in root-three.)

M are its eyes. The width of the lip is fixed by the points O and P, intersections of the sides of the two squares, NK, with the diagonals of the root-three rectangle JK. A very slight error exists at Q, the juncture of the neck and bowl.

Nolan Amphora 01.8109 in the Boston Museum, Fig. 2, picture by "the Pan Master," is a root-three rectangle. AB is a root-three rectangle, as are also AC and CD. The point E is the eye of the root-three rectangle AB. The point F is the center of the root-three rectangle AE, and P is the center of the root-three shape CD. In the root-three rectangle at the base of the overall shape the point K is the eye. A line through this point parallel to the base line determines the four root-three rectangles IJ. The area HM is a root-three rectangle, as is also

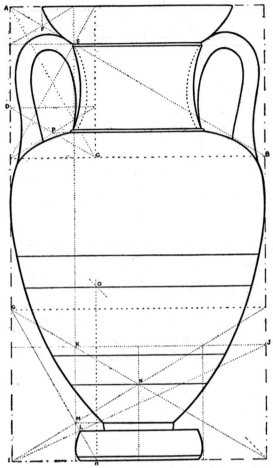

Fig. 2. Nolan Amphora 01.8109 in the Boston Museum.
(Measured, drawn and analyzed by L. D. Caskey.)

HL. The point O is the intersection of the diagonal of a square on the base
line with the side of a root-three rectangle. N is the center of the root-three
rectangle at the base and fixes the base of the meander band.

A small cup in the Stoddard Collection at Yale is a simple root-three rec-
tangle divided dynamically, but use was made of the equilateral triangle in
the arrangement of the three feet. These feet, however, follow the diagonal
of the secondary root-three forms. The width of the base is the end of a root-
three rectangle and the proportions of the painted bands near the top of the
bowl are clearly shown in the diagram. (Fig. 3.)

Skyphos 160 in the Stoddard Collection at Yale, Fig. 4, is a root-three shape
and the detail is correlated by the application of squares on either end of the

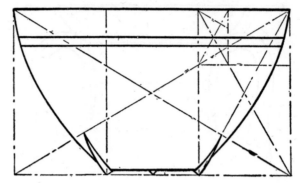

Fig. 3. Small Cup in the Stoddard Collection at Yale.
(A theme in root-three.)

rectangle. The width of the bowl is determined by the intersection of the side of the square AB with a diagonal of the square CD, see point H. The width of the foot is fixed by the intersection of diagonals to the squares AB and CD, as at I. A line from I to C intersects a side of the square CD at G to place the compositional line under the picture. The height of the foot is the intersection of a diagonal to half the entire shape as FC intersecting the diagonal of a square.

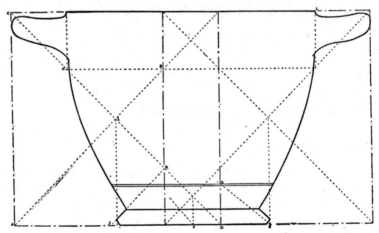

Fig. 4. Skyphos 160 in the Stoddard Collection at Yale.

An early black-figured hydria, 108 of the Stoddard Collection at Yale, Fig. 5, is a theme in root-three and squares. The overall plan is composed of two root-three rectangles, one on top of the other, AB and BC. Squares, as CD, AD, BO and FE, are applied to the two root-three shapes from either end. They overlap in the center to the extent of FD. The overlapping of these squares has the

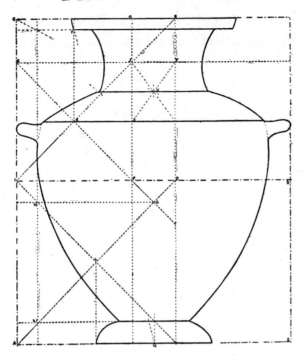

Fig. 5. Black-figured Hydria 108, Stoddard Collection at Yale.
(Theme in root-three with the application of squares.)

effect of dividing the entire area into a rectangular pattern or mesh propor-
tioned by root-three rectangles. This is a remarkable pattern form and it is
strange that no attempt was made to use the equilateral triangles which are
inherent in the root-three shapes. The center, L, of the square AD fixes the
width of the foot. The side of the square AG cuts the diagonal of the square
AD at N. This establishes the width of the bowl and also the height of the foot,
as is apparent at M. The area of the foot elevation is composed of two squares
and two root-three rectangles, and the width of the lip at its base is fixed by a
line drawn from Q, the center of the base of the foot, to the point P. It seems to
have been intended that the angle pitch of the lip should fall outside the point
P because the full width of the lip at its base is equal to one-half the height of
the vase, that is, it is the side of a square placed in the center of the root-three
rectangle BC. The point K is the center of the square IJ. This point has two
functions; it establishes the line which separates the two pictures and is im-
portant in fixing the lip proportions.

 If the width of the foot is considered as an end and the full height as the side

of a rectangle, the ratio is 2.732, *i. e.*, a root-three rectangle, 1.7321, plus 1. The area made by the width of the bowl and the full height has the ratio 1.366. The fraction .366 is equal to .732 divided by two. The point U, through which passes the juncture of neck and bowl, is the center of the rectangle ST. The lip thickness is fixed by a line from C to U and the width of the neck at its juncture with the bowl by a line from C to S.

CHAPTER SIX: A BRYGOS KANTHAROS AND OTHER POTTERY EXAMPLES OF SIMILAR RECTANGLE SHAPES

A STRIKINGLY beautiful kantharos of the Fifth Century B. C., now in the Museum of Fine Arts at Boston, furnishes an admirable example of the use of a compound shape derived from a root-five rectangle. The area of the enclosing shape has an end to side relationship of 1: 1.118. The ratio 1.118 multiplied by two equals 2.236, the square root of five. The ratio may be stated as root-five divided by two. A root-five rectangle divided by two, or cut in half, is composed of two root-five rectangles one over or one beside the other. The heavy lines of the diagram define this shape. The area AB is the overall rectangle of the kantharos.

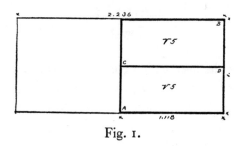

Fig. 1.

This area is that part of a square defined by the pentagon and shown in Fig. 6*a*, Chapter III.

The double root-five shape may be subdivided in many ways to produce themes in abstract form. The primary subdivision would be that of each composing rectangle into a square and two whirling square rectangles. And, because this is a vase elevation design with elements symmetrically disposed, the two squares would be constructed in the center as in Fig. 2. The entire area

W S	S	W S
W S	S	W S

Fig. 2.

would be divided into two squares and four whirling square rectangles. The designer of the kantharos, however, used but one element of this arrangement.

This element is the side of one of the squares, which is employed to establish the strongly emphasized line AB. (See Fig. 3.)

Fig. 3.

The arrangement of the area which constitutes the selected theme, depends upon the application of four whirling square rectangles constructed upon the four sides of the rectangle. These applied rectangles overlap and produce the pattern shown in Fig. 4.

Fig. 4.

The whirling square rectangles are AB, CD, DE and BF. The areas AC, FE, are the important features of the design. The area AC determines the width of the bowl and FE the width of the stem at its juncture with the bowl.

Fig. 5.

In Fig. 5, AD is the containing rectangle of the kantharos. The lines AB and BC, at the points of their intersection with the side of a whirling square rectangle, fix the width of the bowl. These lines are the diagonals to the two halves of the major shape, consequently the elevation of the kantharos, either with or without its handles, is a double root-five rectangle.

Fig. 6.

AD is a double root-five rectangle, as is also FE. And either of these shapes will furnish an analysis of the design. When a whirling square rectangle is applied to the side of a double root-five rectangle, the area on the line AB, as in Fig. 6, is composed of two squares and a whirling square rectangle. The reciprocal of 1.118 is .8944; this is the line CB. CA equals .618 and AB, .2764. AB is the difference between .618 and .8944 or .2764; this fraction .2764 divided into unity equals 3.618. AB is the reciprocal of two squares plus a whirling square rectangle, 2 plus 1.618. Within the major rectangle, therefore, the excess area, at both the top and the bottom of the bowl, is composed of two squares and a whirling square rectangle (see Fig. 7), and AB is a whirling square rectangle and C is its eye.

Fig. 7.

This point C fixes the width of the foot. The analysis is now complete, or is carried as far as is necessary.

Dr. Caskey shows in his drawing of the kantharos, Fig. 8, the exact error in the handle adjustment. The adjustment of these delicate handles must have been a problem because, even if the vase left the potter's hand perfectly fixed,

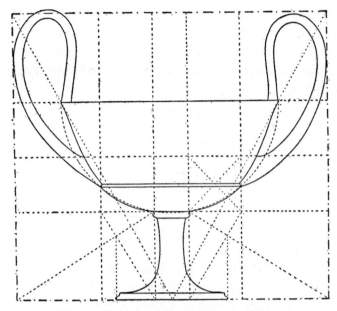

Fig. 8. Kantharos in the Boston Museum.
(Measured and drawn by L. D. Caskey.)

he could never tell how much shrinkage in baking would disorganize his plans. In this case, however, the error of the handles makes no difference because the bowl is a similar shape to the whole. The writer has found that the small errors found in Greek pottery, except in few cases, are practically negligible. This is true for the reason that a part of a design which has been dynamically proportioned is always some recognizable submultiple of some recognizable rectangle. Therefore it is really better to make the small corrections necessary to true up an example. In his drawing of this kantharos, the actual discrepancy appears at the top of the drawing. The width of the handles is correct, and when the double root-five rectangle is drawn, its side is the mean between the handle heights. The writer's drawing of this vase is shown in Fig. 9 with the handle discrepancy corrected.

When two whirling square rectangles are applied to the sides of a double root-five rectangle, as in the case of this Brygos kantharos, they overlap. The area of the "overlap" is determined thus. If the side of this shape is used as unity then the end is .8944, the reciprocal of 1.118. The reciprocal of a whirling square rectangle is .618. This, subtracted from .8944, leaves .2764 which, again, is the reciprocal of 3.618 and is the area on either side of the "overlap." The reciprocal .2764 subtracted from .618 equals .3416. This represents the overlap

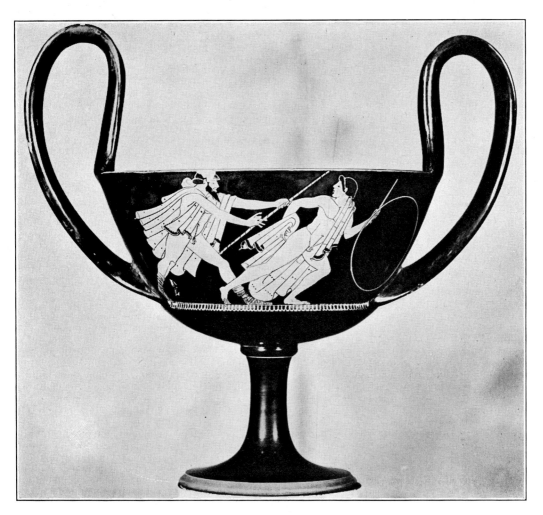

IN THE WRITER'S OPINION THIS KANTHAROS IS ONE
OF THE FINEST OF GREEK CUPS

A theme in double root-five

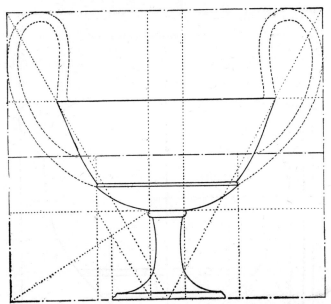

Fig. 9. Drawing of the Boston Kantharos with Handles Corrected.

and is the reciprocal of 2.927. This ratio is compound and consists of two rec-
tangles, as 1.118 plus 1.809. It is now clear that this overlap area consists of a
double root-five rectangle and a square plus two whirling square rectangles.
The ratio 1.809 is one of the basic shapes of the pentagonal form and consists
of a square plus a whirling square rectangle divided by two.

Again, this "overlap" area may be considered as 1.618 plus 1.309, *i. e.,* a
whirling square rectangle plus a square and two reciprocals of such a shape,
.618 divided by two equalling .309.

Fig. 10. Fig. 11.

The area of the elevation of Kalpis G. R. 591, Fig. 12, Metropolitan Museum,
New York, is composed of two root-five rectangles, of which AB is one. The width
of the lip is fixed by the point F, the intersection of a side of the square BC
with the diagonal ED of the root-five shape. By construction the area FD is a
root-five rectangle, while AF is composed of two 1.382 shapes or the ratio 2.764 in

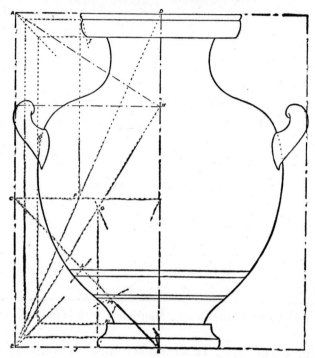

Fig. 12. Kalpis G. R. 591, Metropolitan Museum, New York.
(A double root-five theme.)

the two whirling square rectangles AH and CH. The point G, fixing the width of the foot, is the intersection of a diagonal to the whirling square rectangle HE with the diagonal of the root-five rectangle. The angle pitch of the lip is a line drawn from I to B. The angle pitch of the foot is shown at K, which is found by a line drawn to one corner of the square BC. It will be noticed in this example that the lines showing the subdivisions of the foot and lip are projected until they meet diagonals to certain shapes drawn from the corners A and E. This procedure is one which enables the eye to grasp quickly the proportional relationship which exists in the composing units of a Greek design. The projection of the first subdivision of the lip intersects the diagonal of a whirling square rectangle drawn from the corner A. From this intersection the line turns at right angles and is carried downward until it intersects the diagonal of a square drawn from the corner E. Here it meets the projection of the first division of the foot. This tells us that the first division of the lip is related to the first division of the foot on the proportion of a whirling square rectangle to a square, a fact which is not immediately obvious by construction. Again, the base of the

lip is projected until it meets the diagonal of a square drawn from A. From this point, at right angles, it is carried until it intersects the diagonal of a square drawn from the corner E, where it meets the projection of the top of the foot. We may see by this that the lip and foot are the same thickness because their projections both meet the diagonal of a square. Also it is apparent that the width of the bowl is related to both foot and neck on the proportion of a square.

The two bands at the base of the pictorial composition are determined by the points L and M. The diagonal of the square BC meets the diagonal of the whole at L. The diagonal of the square BC meets the diagonal of two squares at M.

This kalpis shows, unmistakably, that the picture is secondary. The shape of the vessel is determined with great care while the picture is ordinary. Even the height of the male figure is miscalculated, as he is not standing on the same level with the female figure. The hands of the female figure and the right arm and hand of the male figure are badly drawn.

Two root-five rectangles furnish the overall shape for Kalpis 08.417 in the Boston Museum, Fig. 13. The width of the bowl as an end and the height of the

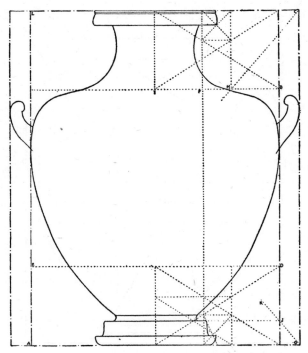

Fig. 13. Kalpis, 08.417, Boston Museum.

vase as a side supplies a 1.309 rectangle, *i. e.*, a square and two whirling square rectangles. AB, CE are squares and AD, BL are double whirling square rectangles. When the .309 shape as AD is applied to the square AB the excess area BE is a square plus a root-five rectangle or the ratio .691. EF is the square and FD is the root-five rectangle. The relation of the double root-five shape to the 1.309 rectangle is shown by the lines CH and GK, which are diagonals to the whole. The points H and J show this connection. The point J is connected with an important element of the foot of the vase.

When a whirling square rectangle is applied to the end of a double root-five rectangle the excess area consists of the reciprocal of a root-four rectangle, *i. e.*, .5 or two squares, .618 plus .5 equals 1.118.

Whirling square rectangles applied to both ends of a double root-five rectangle, overlap. The area of this "overlap" is the difference between .5 and .618 or .118 plus. This fraction will be recognizable as an area if we consider it as .236 divided by two. .236 is the difference between root-four and root-five,

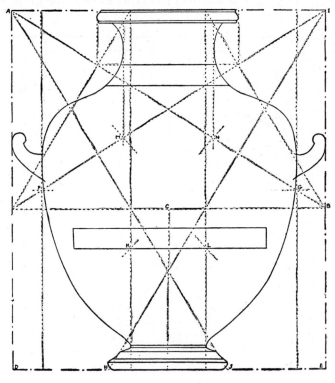

Fig. 14.

i. e., 2.236 minus 2. It is the reciprocal of 4.236 or two whirling square rectangles plus a square, 1.618 multiplied by two plus one. .118 is the reciprocal of two such shapes lying end to end or 8.472 or four whirling square rectangles plus two squares.

It must be stressed repeatedly that these curious areas which are found so abundantly in nature and in Greek art, cannot be too carefully studied. And for that purpose it is necessary to have recourse to arithmetic. We must remember that we are dealing with forms of design used by the best artists and craftsmen the world has known, who worked without stint of labor for generations. If we followed the steps of the Greeks and acquired our knowledge of these shapes entirely by geometrical construction, the labor would be too great for an ordinary lifetime. By using arithmetic in conjunction with geometrical construction, an ordinary student may acquire a working use of dynamic symmetry in a few months.

The double root-five rectangle is found in two kalpides in the Boston Museum, Nos. 91.224 and 91.225. The plan scheme of the first, 91.224, Fig. 14, is simple. AB is a whirling square rectangle applied to the end of the shape and CD, CE are two squares. AJ and HI are two whirling square rectangles which overlap to the extent of the width of the foot. The lip width is clear. FG is a line

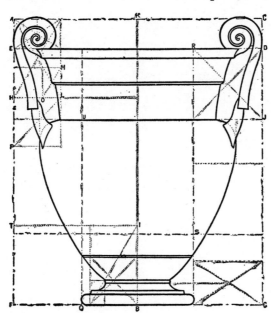

Fig. 15. Drawing of large Volute Krater in the Boston Museum.
(Measured, drawn and analyzed by L. D. Caskey.)

through the center of the overall shape. The points K and L lie on the diagonals to the two squares CD and CE. The points M and N are intersections of the diagonals of the whole with the diagonals of the whirling square rectangle.

The arrangement and proportioning of detail in kalpis 91.225 differs but little from that of 91.224 except in size, the latter being slightly larger.

A large volute krater in the Boston Museum, 90.153, is composed in a double root-five rectangle. AB, BC are the two root-five shapes and GE is a square. A slight error is shown at the top where the handle volutes exceed the containing area. The large square, however, and the complete theme in the arrangement of detail, justify the analysis. The width of the foot as end and the height of the bowl furnish another root-five rectangle of which SU is the square and QS, UR are two whirling square rectangles.

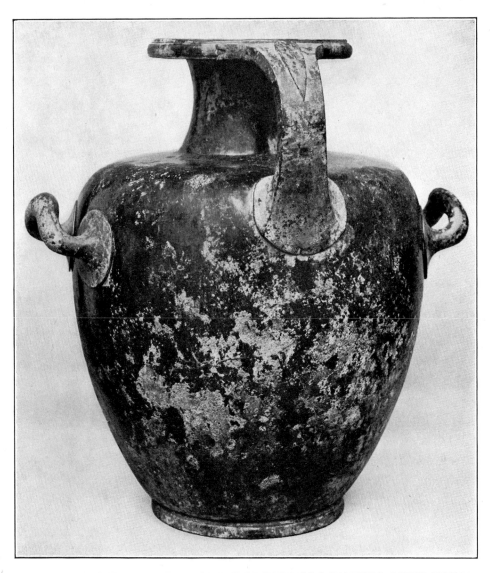

LARGE BRONZE HYDRIA, METROPOLITAN MUSEUM, NEW YORK

One of the most carefully worked designs in existence

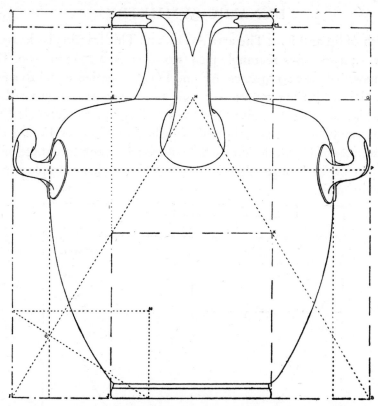

Fig. 1. Bronze Hydria, Metropolitan Museum, New York.
(Measured and drawn by the Museum Staff.)

CHAPTER SEVEN: A HYDRIA, A STAMNOS, A PYXIS AND OTHER VASE FORMS

A BRONZE hydria, 06.1078 in the New York Museum, Fig. 1, supplies a ratio of 1.045. The ratio 2.045 appears in a handsome bronze oinochoe in the Boston Museum. The 1.045 area occurs frequently in Greek pottery. It is composed of a whirling square rectangle, .618 plus .427. The fraction .427 appears in the pentagon form (see Chapter III as .854, *i. e.*, .427 multiplied by two). .809 plus .236 also equals 1.045. In this example it is clear that the designer had this subdivision in view because the area BD is this ratio, *i. e.*, two whirling square rectangles. BC is a square and JM is a root-five rectangle in the center of this square; that is, the vase without the lip is a square. The end of this root-five rectangle

is the width of lip and foot. The area AG is .236. This fraction is the reciprocal of 4.236, *i. e.*, a root-five rectangle plus two squares, 2.236 plus two. The area EF is composed of the two squares. AE and FG are together equal to a root-five rectangle. IP is a whirling square rectangle and the construction for the width of the bowl is shown at the point O in the whirling square rectangle IN.

This vase and the root-two themed oinochoe of Chapter IV are the only bronze examples of Greek design used in this book. The percentage of error is much smaller in the bronzes than in the pottery. In this example the error is astonishingly small.

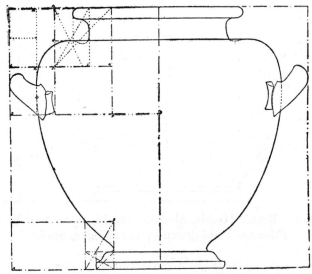

Fig. 2. Large Stamnos 10.210.15 in the Metropolitan Museum.
(Measured and drawn by the Museum Staff.)

A beautiful large stamnos, 10.210.15, Metropolitan Museum, New York, Fig. 2, has a ratio of 1.1826. This is a shape which is not uncommon. It is a compound form of two elements, each of which is .5913, this ratio being the reciprocal of 1.691. AB is a square, the side of which is equal to half the overall shape. BC is a square and CD is a root-five rectangle. AE is a root-five rectangle. The relation of the details of the foot to the whirling square rectangle in AE is apparent. The square CG is divided into the root-five GH and the whirling square rectangle CI. KD is a whirling square rectangle in the square JD. In the double whirling square rectangle CL the sides of the two squares ML produced through K determine the whirling square rectangle in the square JD. This line fixes the width of the bowl.

The area .382 plus two whirling square rectangles (.809), that is, 1.191, is found

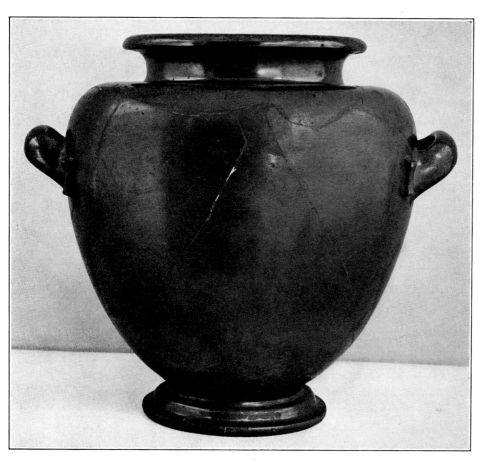

A LARGE STAMNOS, METROPOLITAN MUSEUM, NEW YORK

A vase showing unusual design power

in a pyxis 92.108 in the Boston Museum. AB, or the vase without its cover, is the .809 ratio. AC, or the area of the cover, is the .382 shape. The point H is the eye of the whirling square rectangle AJ. Consequently, the area of half the foot is a root-five rectangle and the whole area of the foot is equal to two such shapes or a root-twenty rectangle. F is the eye of the whirling square rectangle KE. DE is a whirling square rectangle. AM is a whirling square and N is its center. Dr. Caskey's small drawing shows clearly the composing units of the area.

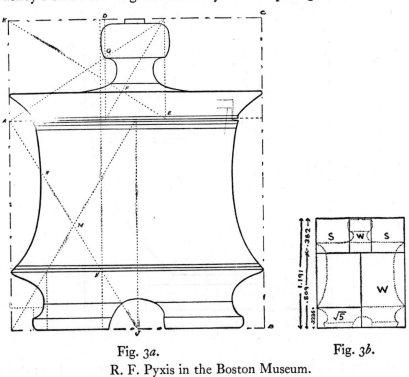

Fig. 3a. Fig. 3b.

R. F. Pyxis in the Boston Museum.

(Measured, drawn and analyzed by L. D. Caskey.)

Nolan amphora 10.184, Boston Museum, has an area ratio 1.691, Fig. 4. This is a shape which appears in the angle column adjustment of the Parthenon. AB and AC are squares. CD is a root-five rectangle. CO is a whirling square rectangle in the root-five shape CD. EB and GF are two root-five rectangles. FI is a 1.809 shape and HI is its major square. GK is a 2.618 shape. The line which marks the juncture of neck and bowl is equal in length to the width of the foot. The diagonal to the square AC is used to fix the length of this line. Its relation to the root-five shape GF is shown at U.

Nolan amphora 136 in the Stoddard Collection at Yale, Fig. 5, has an overall

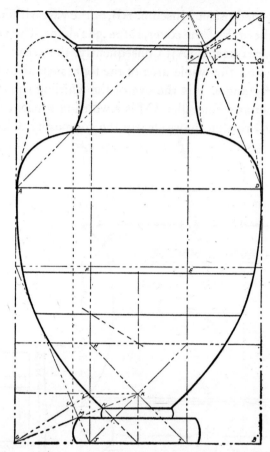

Fig. 4. Nolan Amphora 10.184, Boston Museum.

shape of 1.809 and the bowl width is exactly one half the height. The meander at the base of the composition is placed on the half division of the square AB. The foot is exactly one-half the width of the square AB. The whirling square rectangle intersection of the diagonal of AH with the diagonal of LM determines the juncture of neck and body. The rectangle NO, which encloses the foot, is composed of two root-five shapes. IJ is equal to the width of the foot.

Nolan amphora 01.18 in the Boston Museum apparently has the same ratio as 01.16, Fig. 6, *a* and *b*. The paintings seem to be by the same hand. In this example, however, there is a slight error as shown by the handles. The two vases have exactly the same height but the bowl of 01.18 is wider than 01.16. Otherwise the proportions are nearly the same.

The ratio 1.809 appears in amphora 01.16. This area is composed of a square

plus two whirling square rectangles. FD is a square and DE two whirling square rectangles. AB is a whirling square rectangle, as is also HL. The subdivision of HL and its relation to the proportions of the lip and neck are clear. The point C is on the diagonal to the area DE. The point M is on the diagonal to the square LB. The proportions of the foot in relation to the whirling square area PQ are also clear. The width of the bowl in this example is just half the height of the vase, *i. e.*, minus the handles the area of the vessel is exactly two squares. Compare the Nolan amphora, Metropolitan Museum, New York, Fig. 8, in this chapter.

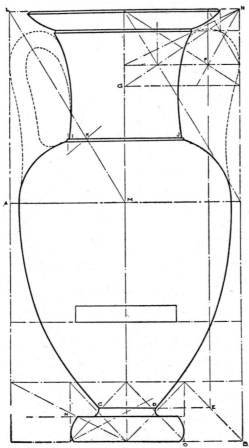

Fig. 5. Nolan Amphora 136 at Yale.

Nolan Amphora 12.236.2, Metropolitan Museum, New York, Fig. 7, has an overall shape of 1.764. The fraction .764 is the reciprocal of 1.309. In the arrangement of the units of the composition AB is a square, DC is a square, and BC is

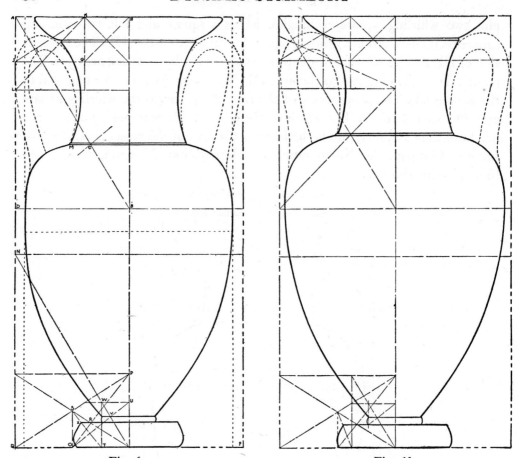

Fig. 6a. Fig. 6b.
Two Nolan Amphorae in the Boston Museum, 01.16 and 01.18.
(Measured, drawn and analyzed by L. D. Caskey.)

.309 or two rectangles of the whirling squares. EI is 4.236, or two rectangles of the whirling squares plus a square. The bowl juncture with the foot is a side of this small square. The area GH equals the area BC. The proportions of the neck and lip are apparent. The width of the bowl, with the total height is the ratio 1.927, the fraction .927 being .309 multiplied by 3. The ratio 1.764 may also be considered as .882 multiplied by two, and also as the ratio 2.764 minus one. The ratio 2.764 is equal to a square plus root-five multiplied by four, i. e., .691 x 4.

Nolan Amphora 12.236.1, Metropolitan Museum, New York, on page 82, Fig. 8, is the rectangle 1.854 (see various skyphoi). This ratio is obtained by multiplying .618 by 3. The proportional details are so clear that explanation is

unnecessary. The point A is the intersection of a diagonal of the whole with the diagonal of a whirling square rectangle. The line DE cuts a rectangle of the whirling squares from the square BC.

The width of the bowl divides the total height into two squares, *i. e.*, the width of the bowl is half the height of the vase. The point F, the base of the meander band under the composition, is the center of one of these squares. The error, due to distortion, is shown by the lip at the top of the rectangle.

The scheme of the large dinos and stand, page 83, is a square plus a root-five rectangle, the ratio being 1.4472, the reciprocal .691. This is a monumental piece of pottery and the theme of the design is worth careful study. The general shape appears repeatedly in both archaic and classic Greek art and is the basic motif in

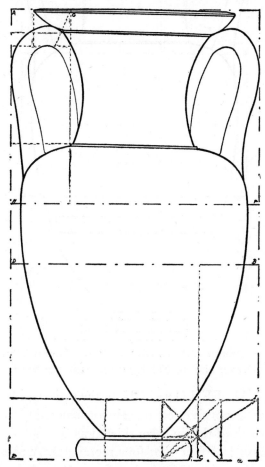

Fig. 7. Nolan Amphora 12.236.2 Metropolitan Museum, New York.
(Measured and drawn by the Museum Staff.)

the plan of the Parthenon. The general theme in this case is a division of 1.4472 by four. One-fourth of 1.4472 is .3618. This ratio of .3618 is the reciprocal of 2.764. One-fourth of 2.764 is .691, which is the reciprocal of 1.4472, *i. e.*, a square and a root-five rectangle. If the area of 1.4472 is divided by four, both side and end, sixteen squares and sixteen root-five rectangles result. If the width of the foot is considered as the end of the rectangle AB, this rectangle is composed of four

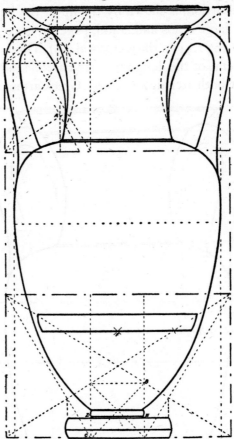

Fig. 8. Amphora 12.236.1 Metropolitan Museum, New York.
(Drawn and measured by the Museum Staff.)

root-five rectangles, AE, EF, FG and GH, or the ratio 1.7888, *i. e.*, .4472 multiplied by four, and each root-five rectangle is constructed in the center of a 2.764 rectangle. If the width of the lip is considered as the end of the rectangle CD, this shape is composed of four root-four rectangles. A root-four rectangle is composed of two squares, and each root-four rectangle is constructed in the center of a root-five rectangle and a 2.764 rectangle. If the bowl of the dinos is

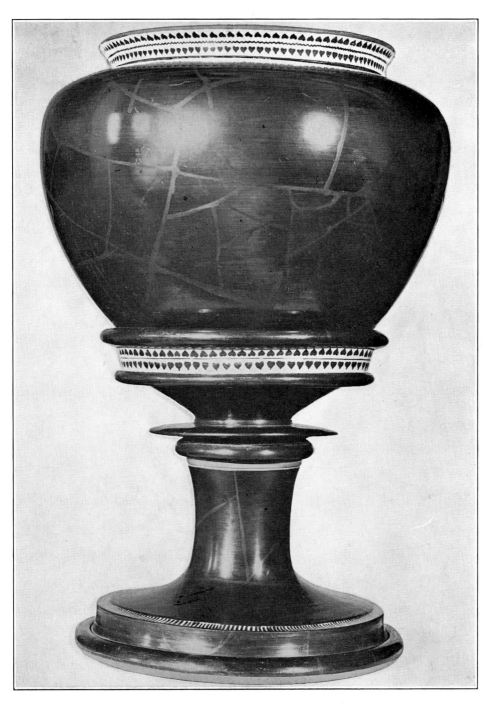

A DINOS AND STAND, MUSEUM OF FINE ARTS, BOSTON
A design theme in square and root-five

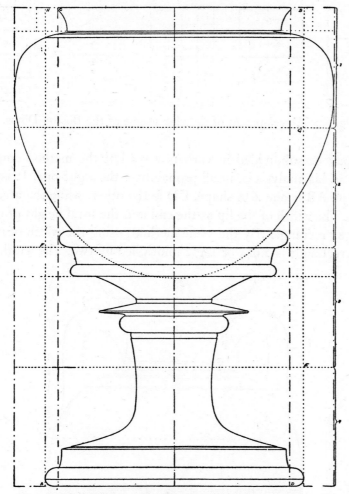

Fig. 9. Large Dinos and Stand in the Boston Museum.
(Measured and drawn by L. D. Caskey.)

considered as a rectangle, apart from the pedestal, this shape is composed of two whirling square rectangles. If the pedestal is considered as an area it is the rectangle 1.045, a fairly common shape in classic art. The combinations of proportions in this vase might be amplified to cover the entire fabric of Greek design. This is also a good example of the free use of ornament within the severe limits of a general shape. The decorated bands on the bowl and pedestal are loosely rendered.

A ratio which frequently appears directly or indirectly in Greek vase designs is 1.472, as in this example of an amphora from the Boston Museum, Fig. 11.

Fig. 10. Development of the plan theme of the Boston Dinos.

This area may be subdivided in various ways but the method employed by Dr. Caskey in his analysis is, in all probability, the right one. It is .618 plus .618 plus .236. AB is one .618 shape, CD is the other, while the area AD represents .236. The width of the lip as the end and the total height of the vase as side is a 2.382 rectangle. By the same method, using the width of the foot as an end, the rectangle is 2.944 or 1.472 multiplied by two. The width of the lip

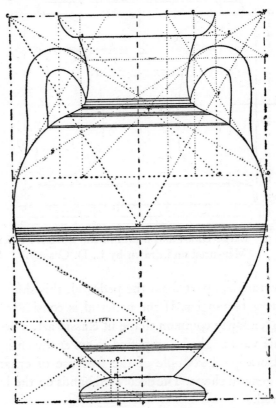

Fig. 11. Amphora from the Boston Museum.
(Drawn, measured and analyzed by L. D. Caskey.)

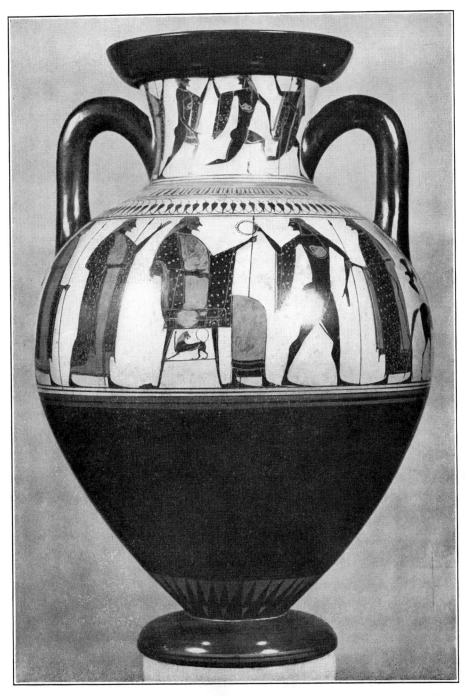

A BLACK-FIGURED AMPHORA FROM THE BOSTON MUSEUM

These early black-figured vases rank among the best designs the Greeks ever
made. The adjustment of the human motif to the shape theme is superb

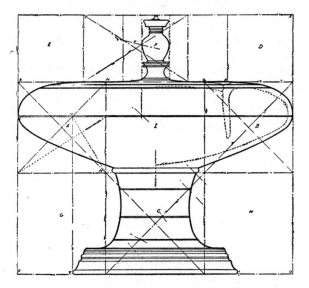

Fig. 12. A Perfume Vase in the Boston Museum.
(Measured and drawn by L. D. Caskey.)

is also the side of a square constructed in the whirling square rectangle CD. This is shown by the point F, the center of the whirling square rectangle DE. The effect upon the proportions of the top of the vase of the diagonal to this square QR is shown by the points S and T. The whirling square rectangle LP, by construction, establishes the proportions of the foot.

The shape of a perfume vase, Fig. 12, is interesting because it shows that the design of the bowl and lid was planned by two separate, but proportional, rectangles. The area occupied by the bowl and foot is shown by the rectangle RO, and consists of the square NO, plus the square RM and the rectangle MP, which is composed of two root-five rectangles. The ratio is 1.472. The fraction .472 equals .236 x 2 and is the reciprocal of 2.118 or root-five divided by two plus one. The shape of the rectangle of the lid and handle is 4.236, the reciprocal of which is .236 or two squares plus a root-five rectangle. This shape equals half of the area NP. A, C, B, E, D are squares. NO is a square and PQ is a square. G, H and I are areas represented by root-five, 2.236 divided by two. JK is a root-five rectangle. LM is a whirling square rectangle in the square RM. Every detail of the vase may be expressed in terms of the major shape.

An early black-figured krater, 07.286.76, Fig. 13, in the Metropolitan Museum, New York, is an illustration of extreme distortion in a classic shape. One side of

the lip is much higher than the other and this irregularity exists also in the neck and top of the bowl. Otherwise the vase is normal. This distortion, probably,

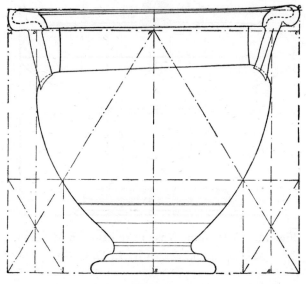

Fig. 13.

happened in baking. The widths at all points are true with a center line. If the width of the bowl be taken as the side of a square, this square is shown in the drawing as DE, and if the sides of the square be produced to the extremities of the handles, as A and C, then the areas AB, BC, become two whirling square rectangles. The analysis need not be further extended as here exists evidence that the design is dynamic and the general distortion is shown at G, where one side of the lip extends outside the encompassing rectangle. The other side of the lip is correct and the overall shape is 1.1382. Without the lip it is 1.236. The lip therefore represents the difference between these two ratios. The decimal fraction .1382 appears in the Parthenon, where the overall rectangle of the ground plan is 2.1382.

The area of Kalpis 90.156, Fig. 14, *a*, *b*, *c*, Boston Museum, is composed of a whirling square rectangle and a root-five rectangle. Dr. Caskey's two small diagrams, 14*b* and 14*c*, show the general proportions.

Greek symmetry, as has been pointed out, is connected with the geometrical properties of the five regular solids (see Chapter V), and the proportions of these solids are associated with the phenomena of leaf distribution in Nature, therefore it is not unreasonable to expect to find in examples of that sym-

metry, such as are furnished by temple plans, decoration, bronzes and pottery, areas and subdivisions of areas which echo and re-echo the shapes derivable from the regular solids and the summation series of phyllotaxis. That this is so the pottery designs alone abundantly show. The area of the elevation of a Greek vase of the first class, that is, the area obtained by the full height and width of such a vessel, and the secondary areas obtained by subdivision of details, such as width of foot, neck, lip and bowl and the height of such members, produce a series of shapes which could not be obtained accidentally. This is clearly disclosed by the analysis of a large krater, 10.185 in the Boston Museum

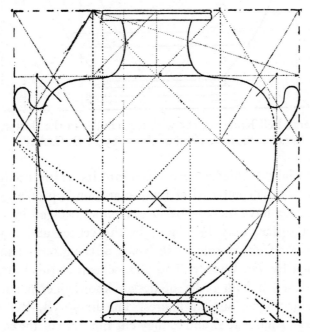

Fig. 14a. Kalpis in the Boston Museum, showing a theme in whirling
square and root-five.
(Measured, drawn and analyzed by L. D. Caskey.)

Fig. 14b. Fig. 14c.

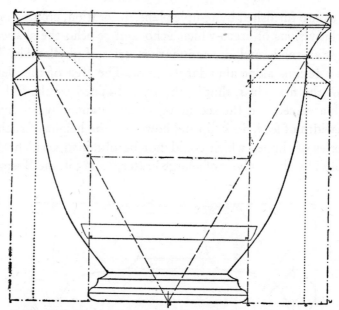

Fig. 15. Large Bell Krater 10.185 with lug handles in the Boston Museum.
(Drawn, measured and analyzed by L. D. Caskey.)

(Fig. 15). The height of this krater divided into its width, produces the ratio .882. The ratio .882 is composed of two squares on top of a .382 rectangle. The .382 ratio may have its composing elements arranged in various ways. For example, a square may be placed in the center and double whirling square rectangles on either side as in No. 3 of the group of small diagrams of the vase made by Dr. Caskey. The plan scheme of this krater shows that its maker possessed a high order of design knowledge, particularly in determining and arranging similar figures. The lines AB, BC are diagonals to half the overall shape; at D and E they cut the sides of the square FG, this square being obtained in the analysis by the width of the bowl. The rectangle DG, that is, the vessel without its lip, is a similar shape to the whole. At H and I these two diagonals cut a line drawn through the center of the major shape. The area HQ is a similar shape to the whole. HI is also the width of the foot. The area QJ is a shape similar to double the shape of the whole, and the width of the foot is one half the width of the whole, that is, the area QJ is expressed by the ratio 1.764, this being .882 multiplied by two. The square FG bears a ratio relationship to the width of the vase of 1.1708, the reciprocal of this being .854. The line KQ, divided into the height, also produces the ratio 1.1708 and LQ is the square on the end of this shape. If two squares are defined in the

.882 shape HQ, the base of the meander band MN is fixed and the area NQ is a .382 rectangle. The points O and P are intersections of the diagonals of the square FG with the sides of the rectangle QJ. This rectangle is also connected

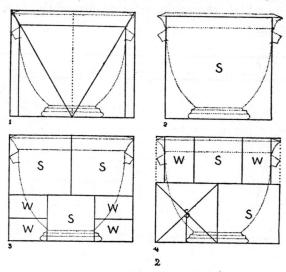

Fig. 16. Dr. Caskey's analysis of the Bell Krater, showing the composing units of form.

with the 1.309 rectangle because the fraction of the ratio 1.764, *i. e.*, .764, is the reciprocal of 1.309. If a square on the end be applied to the area QJ the excess would be a 1.309 shape. The area of an .882 rectangle, as subdivided by the details of a well-known and high-class Greek vase, is now sufficiently clear for the artist and designer.

For the benefit of the reader unskilled in the technique of design the point is stressed that the basic facts pertaining to the area occupied by a composition are paramount. The average layman, when analyzing a design, almost invariably looks for an aesthetic motive, some arrangement of elements which creates a pattern or movement for example. This is a fallacy, for the reason that such effects are always due to personal selection or disposition and consequently cannot be taught except superficially. The facts connected with areas and volumes, however, are impersonal, are general, may be exhaustively analyzed and successfully taught.

Red-figured Krater 07.286.81, Fig. 17, Metropolitan Museum, New York, a large vase, furnishes the same ratio as the two pyxides described in Chapter IV, *i. e.*, 1.2071, the comprising figures being two squares plus a root-two rectangle, .5

plus .7071. In the root-two rectangle, AB, DC are squares; AC, DB, are rec-
tangles, each consisting of a square plus a root-two rectangle. The two small
squares and their subdivisions which fix the proportions of both foot and neck,
and the dotted line which shows the relationship of the foot to the neck, do
not need explanation.

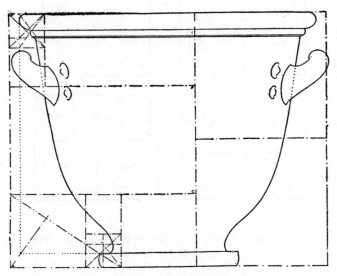

Fig. 17. A Bell Krater 07.286.81 in the Metropolitan Museum, New York.
(Measured and drawn by the Museum Staff.)

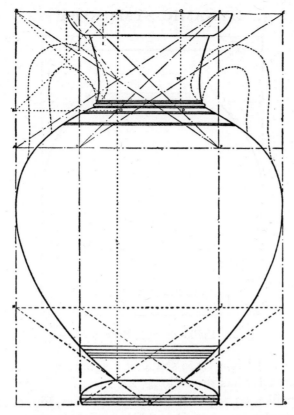

Fig. 1. Black-figured Amphora in the Boston Museum.
(Measured and drawn by L. D. Caskey.)

CHAPTER EIGHT: FURTHER
ANALYSES OF VASE FORMS

A HANDSOME black-figured amphora, 13.76 in the Boston Museum, Fig. 1, has a ratio of 1.528 (compare Lekythos G. R. 589 New York Museum, page 137). The fraction .528 equals a square plus two root-five rectangles. AC is the .528 shape. This fraction is the reciprocal of 1.8944. The square is DE. GD and CF are two root-five shapes. The diagonals to a square and a root-five shape intersect at L and M. The area OQ is a whirling square rectangle and KN, PC are two squares. The centers of these squares fix the width of the lip. The area KC is a .382 shape and GK is one-fourth of CB. AB is the major square. HB is a similar shape to KC. The areas HI, JB are two whirling square rectangles and

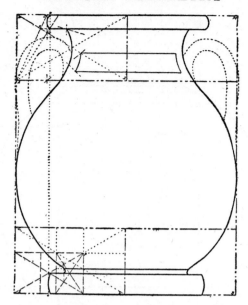

Fig. 2. Pelike 03.793, Boston Museum.

IJ is a 1.382 shape. HR is a 1.309 shape or a square plus two whirling square rectangles. The area JD has the ratio .472.

A red-figured pelike, 03.793 in the Boston Museum, Fig. 2, furnishes a ratio of 1.309. AB is a major square. CD and HI are whirling square rectangles. The points of construction in these shapes are clear. The width of the foot in relation to the height is 1 : 1.854. .618 x 3 = 1.854. The relation of this foot to the lip is shown by the line NO.

Attic red-figured pelike, G. R. 580, Metropolitan Museum, New York, Fig. 3.

This vase furnishes a ratio of 1.309, a square plus two whirling square rectangles, .309 being .618 divided by 2. The design is unusually simple and it supplies an excellent example for detailed inspection.

The 1.309 shape is subdivided by two whirling square rectangles overlapping, as AE, GD, so as to produce an area in the center of the major form the side of which is equal to the width of the lip of the vase. The relation of the width of the foot to the lip is apparent. This area in the center of the 1.309 shape is expressed by the ratio 2.118, a fairly common form in Greek design. Arithmetically, this ratio may be written 2.236, or root-five, divided by 2, or 1.118; to this ratio a square or unity is added, making 2.118. This area may also be described as two squares, or 2 plus .118. In the analysis of the vase it will be observed that this arrangement of two squares plus a small fraction was

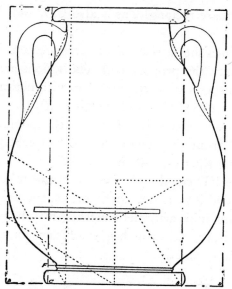

Fig. 3. Red-figured Pelike G. R. 580, Metropolitan Museum, New York.

actually used because the fraction .118 expresses the area of the elevation of the foot; the area FE in the analysis being root-four or two squares.

Consider the rectangle 1.309, divided as described, and without reference to the vase. Draw a rectangle of the whirling squares as in Fig. 4.

AB is the reciprocal of the shape. AC is a square in this reciprocal and a diagonal of this square cuts the diagonal of the whole at D, this being the point which determines the overlap of the whirling square rectangles, as in the analysis. See Fig. 5.

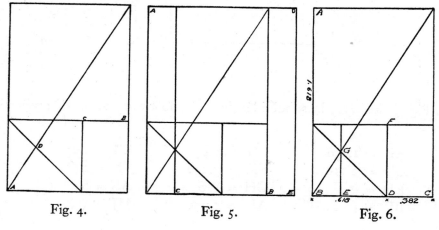

Fig. 4. Fig. 5. Fig. 6.

AB is a whirling square rectangle, as is also CD, and AE is a 1.309 shape, Fig. 5.

This construction furnishes a remarkable arrangement in proportion as will be seen in Fig. 7, where the proportional subdivisions are briefly indicated.

This vase also furnishes a good example for arithmetical analysis. In Fig. 6, the length AB equals 1.618, BC 1, DC .382, BD .618.

By geometrical construction a line through the point G cuts the whirling square rectangle EF from the square BF; consequently there are two rectangles of the whirling squares, side by side, EF and FC. But the length DC equals .382, therefore ED equals .382 and .382 multiplied by two equals .764 and this fraction divided into 1.618 equals 2.118, the area of the shape CE in the analysis of the vase. This arithmetic method may be readily applied to any construction or analysis, provided the larger units are known, as, of course, they always are in dynamic symmetry.

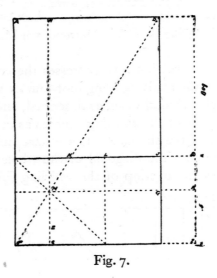

Fig. 7.

In Fig. 7 the 1.309 is subdivided into the following series of proportional areas:

AB = 1.236	CG = $\sqrt{4}$	CJ = 1.236
CD = 2.118	FK = 3.236	IJ = 2.618
ED = $\sqrt{4}$	GH = WS	AK = Sq.
BF = $\sqrt{4}$	AI = 1.309	HJ = 1.309, etc.

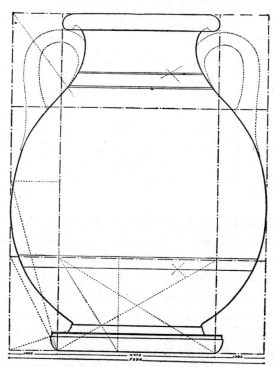

Fig. 8. Pelike 06.1021.191, Metropolitan Museum, New York.

A large simple pelike, 06.1021.191 in the Metropolitan Museum, New York, Fig. 8, is a theme in the often occurring rectangle 1.382. This vase supplies material which sheds considerable light on Greek design practice.

The width of the lip considered as the end of a rectangle, of which the full height of the vessel is the side, defines the area of a root-five shape. The end of this rectangle is also the width of the bottom of the foot of the vase. At some stage of development the design probably looked like the diagram in Fig. 9.

AB is a 1.382 rectangle, CD is a root-five rectangle in the center of the major shape. The short curved lines inside this latter rectangle at the top and outside at the bottom, suggest respectively the lip and foot.

The direct subdivision of a 1.382 rectangle is shown in Fig. 10 where AB and CD are the two squares described on the ends of the shape. AD and CB are two .382 shapes and AE is a rectangle of the whirling squares.

When a root-five rectangle is applied to the center of this containing shape, as in Fig. 11, the major area is subdivided in an interesting manner. AB, CD are two whirling square rectangles, AE, BF, CG and DH are each composed

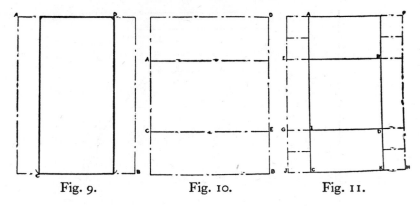

Fig. 9. Fig. 10. Fig. 11.

of two squares, while EI, and the similar shape on the other side of the square BI are each double whirling square rectangles. BI is a square in the center of the whirling square rectangle AE, Fig. 10. Considered arithmetically the major area, as affected by the root-five shape, is as follows:

The reciprocal of 1.382 is .7236. If the side FH, Fig. 11, represents unity, then the end HJ represents .7236. In relation to this fraction, the end of the root-five rectangle CK is expressed by .4472, and this fraction subtracted from .7236 leaves .2764. Dividing this by 2 the fraction .1382 is obtained. Thus the areas AJ and KF are each composed of ten similar shapes to the whole, or ten 1.382 rectangles. The ratio of the ground plan of the Parthenon is 2.1382, *i. e.*, it is composed of two squares plus a rectangle similar to AJ or KF of this pelike design. The fraction .1382 may be further identified as the difference between .309 and .4472 or a root-five shape minus two whirling square rectangles. The diagram, Fig. 12, shows this relationship.

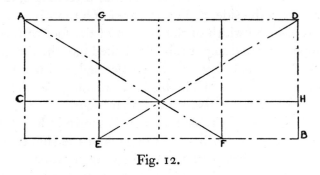

Fig. 12.

AB is a root-five rectangle with the square FG in the center. AF, ED are two whirling square rectangles, as are also AE, FD. The shape CB is a .1382 rec-

tangle and represents the difference between the root-five rectangle AB and the double whirling square area AH. The meander bands, which define the limits of the pictorial composition, are related to the general proportion of the 1.382 rectangle.

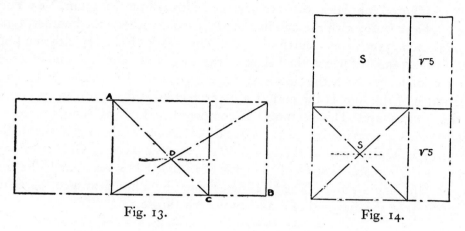

Fig. 13. Fig. 14.

When a 1.382 rectangle is divided into two parts, as in Fig. 14, each half is composed of a square plus a root-five figure. The bottom of the meander band at the base of the figure composition passes through the center of this square. The .382 area of a 1.382 rectangle is composed of a square plus a whirling square rectangle, see Fig. 13.

AB is the whirling square rectangle. AC is its major square and D is the intersection of diagonals to these two shapes. This point marks the top of the mean-

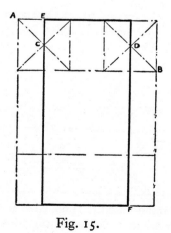

Fig. 15.

der band above the figure composition. Fig. 15 shows the geometrical method for constructing a root-five shape in the center of a 1.382 rectangle. AB is a .382 figure and C and D are the centers of the two squares. EF is a root-five rectangle.

Black-figured Amphora 06.1021.69 in the Metropolitan Museum, New York, Fig. 16, has a ratio, with the handles, of 1.3455 and without the handles, 1.382. The fraction .3455 is one-fourth of 1.382. The width of the lip is the end of a root-five rectangle of which the height of the vase is the side. The end of a root-five rectangle, of which the side is 1.382, is represented numerically by .618. The width of the foot is the end of a 2.472 rectangle described in the center of the 1.382 shape. This rectangle is composed of four whirling square rectangles; .618 multiplied by 4 equals 2.472. CG is one of these .618 rectangles. The compositional band at the base of the panelled picture, GH, is midway between the top and bottom of the vase. The line EF is one-fourth the total height. The angle pitch of the lip is determined by a line drawn to the center of the foot, or the diagonal of a root-twenty rectangle.

Fig. 16. Black-figured Amphora 06.1021.69, Metropolitan Museum, New York. (Measured and drawn by the Museum Staff.)

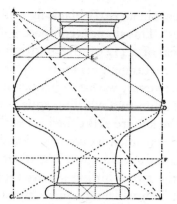

Fig. 17. Psykter in the Boston Museum.
(Measured, drawn and analyzed by L. D. Caskey.)

A psykter in the Boston Museum, Fig. 17, has a 1.2764 shape. (See kalpis in this chapter.) The fraction .2764 is the reciprocal of 3.618. In Dr. Caskey's analysis AB and CD are whirling square rectangles. AE is also one and CF is the 3.618 and AF a square.

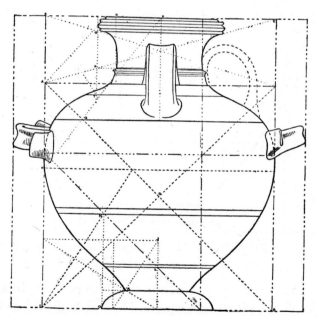

Fig. 18. Black-figured Kalpis 06.1021.69 in the Metropolitan Museum, New York.
(Measured and drawn by the Museum Staff.)

The ratio of 1.0225 appears in an early black-figured kalpis, 06.1021.69 in the New York Museum, Fig. 18. This shape is composed of .618 plus .4045, the latter fraction being the reciprocal of 2.472 or .618 multiplied by four. The rectangle contains a whirling square rectangle plus four such shapes standing on top of it. The width of the bowl, however, with the height of the vase is a 1.309 rectangle, *i. e.*, a square AB plus two whirling square rectangles, AC. It will be noticed that the side of the square AB coincides with the neck and bowl juncture. T, QN and L are points which fix compositional divisions in the painting. SR, RC are two whirling square rectangles. The diagonal SR cuts GF produced at T. The diagonals of the two whirling square rectangles AC proportion the lip and neck at F and G. The whirling square rectangle IJ fixes foot proportions at K. The line NO relates the foot to the painted band under the picture. AD is a square.

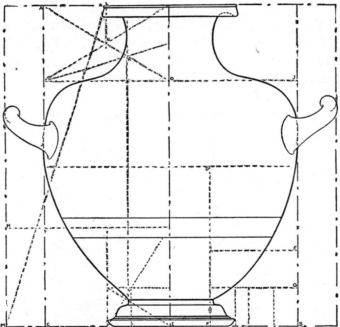

Fig. 19. Kalpis in the Metropolitan Museum, New York.
(Drawn and measured by the Museum Staff.)

The red-figured kalpis, 06.1021.190, Fig. 19, Metropolitan Museum, New York City, has a major shape of an exact square. The width of the bowl divided into a side of the major form produces, exactly, a 1.309 rectangle. The simple geometrical constructions incident to the comprehension of a 1.309 figure in the cen-

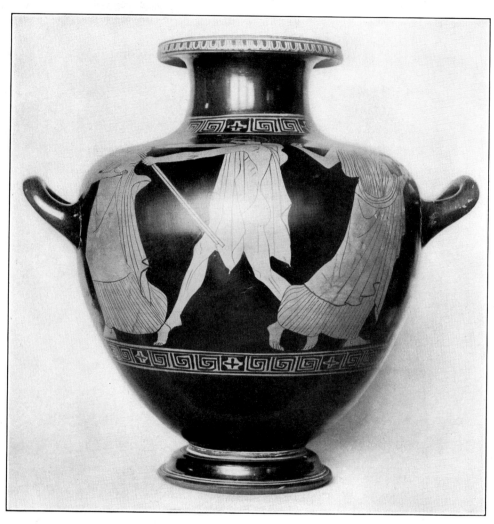

A RED-FIGURED KALPIS IN THE METROPOLITAN MUSEUM,
NEW YORK

A handsome design within a square

ter of a square and the resultant combinations of form are shown in the small diagrams. It is significant that the angle pitch of the lip is the diagonal of a .309 rectangle, *i. e.*, ML, Fig. 19, is a .309 rectangle. The width of the lip as shown by NL is one-half the width of the bowl. The width of the neck at its narrowest point is equal to the width of the juncture of the foot with the body.

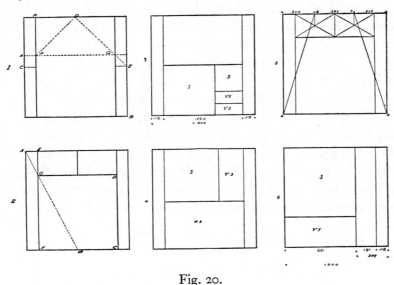

Fig. 20.

Fig. 1 shows the geometrical method of constructing a 1.309 shape in the center of a square. AB is a whirling square rectangle comprehended in a square. The diagonals of two squares, CD and DE, cut the side of the whirling square shape AB at F and G.

Fig. 2. EC is a 1.309 rectangle. AB is the diagonal to two squares. DF is a square and DE two whirling square rectangles. The point G fixes the two composing elements of the 1.309 rectangle.

Fig. 3. A 1.309 rectangle is divided into two parts. Each part is composed of a square plus a square and two root-five shapes.

Fig. 4. A whirling square rectangle applied to a 1.309 rectangle leaves a square plus a root-five shape.

Fig. 5. The construction for the lip angle of the kalpis, AB and DC are .309 shapes. The remaining area in the center of the square is a .382 shape.

Fig. 6 is a .691 shape applied to a square. The .309 remainder is divided into two shapes, one being .191 and the other .118.

Analysis of design for symmetry is slow and often difficult. Especially is this

true of Greek designs. The first step is the approximate determination of the containing rectangle. This is done arithmetically from direct measurement. The rectangle thus obtained may, frequently, be verified arithmetically by measurement of details. If a root-two rectangle be obtained, for example, *i. e.*, a rectangle whose ratio is some recognizable one connected with the root-two series, and the width of the foot, lip or neck either divided into, added to or subtracted from this ratio, or divided into the width or height of the whole, produces other ratios recognizable as belonging to the root-two series, a theme in root-two is almost sure to be found. Usually root-two and root-three are easier to recognize than themes in the compound forms. This is due to the fact that root-two and root-three do not modulate or unite with other shapes. Comparatively, the synthetic use of symmetry is simple; the artist, however, must understand basic principles and be familiar with simple geometrical construction or the use of a scale. The scale to use is one with units divided into tenths because the ratios may be read off directly as numbers. The technique of area or figure dissection is based upon the diagonal not only to the major shape but to its composing elements. The relation of the foot and lip of a stamnos of

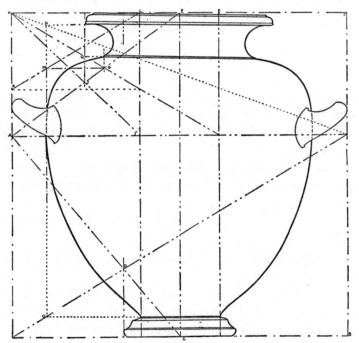

Fig. 21. Stamnos 06.1021.176, Metropolitan Museum, New York.
(Measured and drawn by the Museum Staff.)

this chapter, Fig. 21, shows clearly the employment of two sub-diagonals. A well-trained designer who understands his symmetry will work rapidly, use a simple machinery and his key-plan will be unintelligible to any inferior in symmetry knowledge to himself. In most cases his working plan will not show more than a few diagonals. Dynamic symmetry produces in a design the correlation of part to whole observable in either animal or vegetable growth. It is a satisfying harmony of functioning parts which suggests a thing alive or a thing which has the possibility of life. Design without an understood symmetry is the negation of this.

Stamnos 06.1021.176, Metropolitan Museum, New York, Fig. 21, is a simple square and the elements of the vase are proportioned by the dynamic subdivision of the containing shape.

AB is a rectangle of the whirling squares. AC is a diagonal to one-half this shape. It cuts the diagonal of the whole at D, which point determines the width of the foot. This foot width is equal to one-third of a side of the encompassing square. AP is a .382 rectangle and AF is the diagonal of half this shape and it intersects the diagonal of the whirling square rectangle AE at G. It

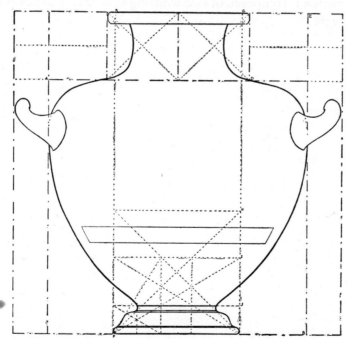

Fig. 22. Kalpis 06.1021.192, Metropolitan Museum, New York.
(Measured and drawn by the Museum Staff.)

also cuts the diagonal of the square HI at J. The line GM cuts the diagonal of the whirling square rectangle KL to determine the line NO, which fixes the width of the bowl. The line NO meets the diagonal of the whirling square rectangle AB at O and the diagonal of the .382 shape at N. This shows that the lip and the foot of the vessel are proportioned respectively in terms of the two main divisions of the overall shape, *i. e.*, .618 and .382, and that both foot and lip are directly proportioned to the width of the bowl. The theme is an arrangement in diagonals of the two main subdivisions of the containing square and diagonals of half these shapes.

Kalpis 06.1021.192 in the New York Museum, Fig. 22, is contained in a square. A small error is shown at the points where the handles do not quite touch the sides of this square. The width of the bowl and the height define a 1.2764 rectangle. The fraction .2764 is the reciprocal of 3.618, *i. e.*, two squares plus a whirling square rectangle. The area of the lip and neck is composed of these two squares, while AC and DE, added, form the whirling square rectangle. AB is a square. The width of the foot is the side of the 2.618 shape FG. FH is a square, and HK is 1.618. FI is a whirling square rectangle. The area of the foot elevation is composed of two whirling square rectangles plus a square or the ratio 4.236.

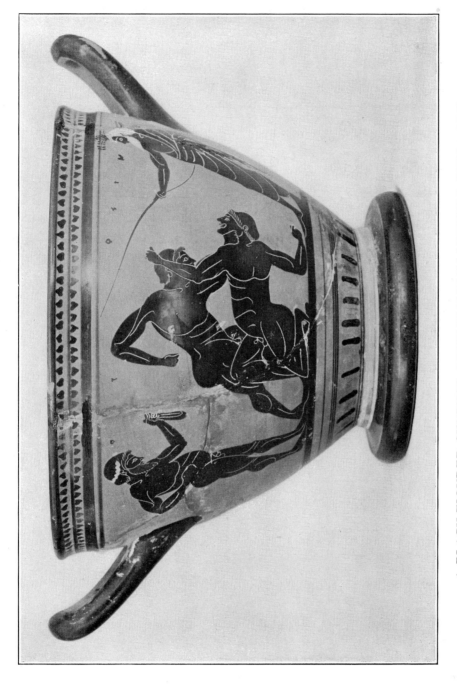

A BLACK-FIGURED SKYPHOS, METROPOLITAN MUSEUM, NEW YORK

(*See Adams Skyphos in the Boston Museum*)

A theme in three whirling-square rectangles

CHAPTER NINE: SKYPHOI

DURING the entire classical period, Greek designers seem to have been searching for certain ideal shapes for certain purposes. The large drinking bowls, which we recognize under the general name of Skyphoi, in their general proportions, illustrate this. The overall shape scheme of these vases approximates a ratio of one and three-quarters. Modern designers would frankly accept this ratio and not trouble themselves about subtle refinements on either the plus or minus side of so obvious, and consequently commonplace, an area.

The employment of ratios either a little less or a little more, than one to one and three-quarters, suggests conscious effort to get away from an ordinary rectangle. Again, the skyphoi shapes curiously parallel the Nolan amphorae forms, the difference of the outstanding or containing rectangle in most cases being simply that of position. The sides of the skyphoi rectangles rest horizontal, the sides of the amphorae shapes, perpendicular. Also, Greek classic artists wasted little design material. This is shown by their use of curves. Practically all convex curves of one design are repeated as concave curves in other creations. For example, the convex curve of the pelike is the concave curve of the pyxis. The convex curves of the lekythos are the concave curves of the calyx krater.

Convex cups have their concave counterparts, a sort of reverse echo in forms which may be termed an inversion of a theme.

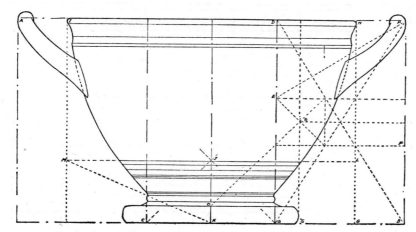

Fig. 1. Black-figured Skyphos in the Metropolitan Museum, New York.
(Measured and drawn by the Museum Staff.)

The two skyphoi, Figs. 1 and 4 of this chapter, should be compared. The elevation of each shows the same rectangle. One vase is in the Metropolitan Museum, New York, the other in the Museum of Fine Arts, Boston. The rectangle was a favorite as it appears repeatedly.

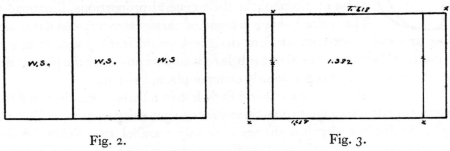

Fig. 2. Fig. 3.

The early black-figured skyphos in the New York Museum, 06.1021.49, Fig. 1, has an overall ratio of 1.854, three whirling square rectangles, .618 x 3, AC, CD and DB. The bowl ratio, however, is 1.382, GI. By construction, as shown by the line GH and the area HB, it will be noticed that the general scheme is that of two overlapping whirling square rectangles, IB and AG, the overlap being the 1.382 shape in the middle.

Fig. 2 shows the three whirling square rectangles. Fig. 3 shows the overlapping whirling square rectangles. A 1.382 shape divided by two equals two square and root-five areas, IK, KH, and IJ, JH in Fig. 1 are squares, MK, KL two root-

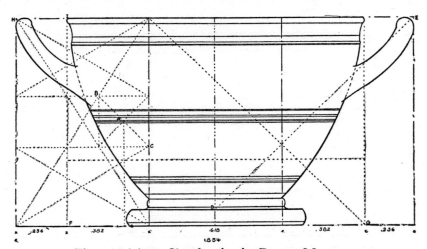

Fig. 4. Adams Skyphos in the Boston Museum.
(Measured, drawn and analyzed by L. D. Caskey.)

five areas. The width of the foot is determined by the point R and SL is a square. OP and OA are squares. Thus the vase without its foot would be a root-four area. HB is composed of two whirling square rectangles plus a square.

A black-figured skyphos loaned to the Boston Museum by the late Henry Adams, Fig. 4, has the same shape as No. 06.1021.49 in the Metropolitan Museum, New York. The overall ratio of 1.854 (.618 multiplied by three) is divided in exactly the same manner as is the one from New York. The Adams vase has a slightly narrower foot as shown by the point A, the center of the small square BC. The bowl is 1.382 and the vase minus the foot equals two squares as shown by the line DE, the diagonal to a square. FE and GH are two whirling square rectangles overlapping to the extent of GI, the 1.382 shape. Dr. Caskey has suggested the sequence of subdivision in the three small diagrams, Figs. 5, 6 and 7. The picture on this vase shows clearly that the Greek artist at the time was incomparably better as a designer than as a figure draughtsman. The figures of the men riding the dolphins are crudely suggested, but the picture as a design composition is superb.

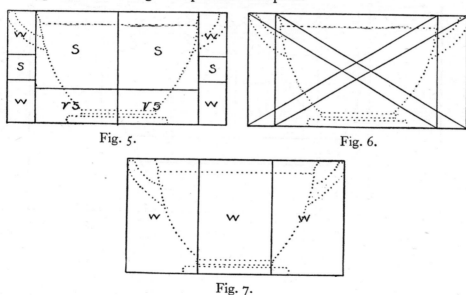

Fig. 5.

Fig. 6.

Fig. 7.

A small black-glaze skyphos at Yale, Fig. 8, has an overall ratio of 2.1213 or three root-two rectangles, .7071 x 3 = 2.1213 (compare Kylix, Fig. 15, Chapter IV), AB, BC, CD are root-two rectangles. AE, BF are squares. These squares divide the area AB into three squares and three root-two rectangles. The general proportions are all obtained by this subdivision of the root-two shape AB.

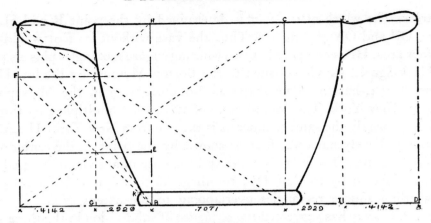

Fig. 8. Black-glaze Skyphos at Yale.

(Measured and curves traced by Prof. P. V. C. Baur.)

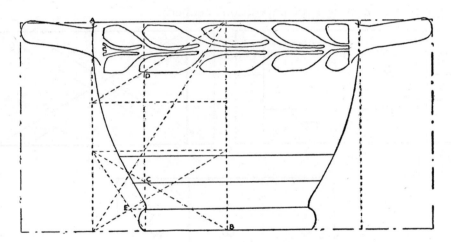

Fig. 9. Skyphos 76.49, Boston.

(Drawn, measured and analyzed by L. D. Caskey.)

Red-figured Skyphos 76.49, Boston, Fig. 9, furnishes an overall rectangle with a ratio of 1.8944. This is a square plus two root-five rectangles. The elevation of the bowl however is 1.236, or two whirling square rectangles, and the logical subdivision of one of these determines the proportionate relation of the details of foot and decorative bands. The points C, D and E in the rectangle AB are clear.

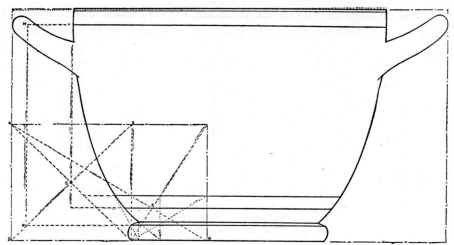

Fig. 10. Boston Skyphos 13.186.

Skyphos 13.186 in the Boston Museum, Fig. 10, has a bowl ratio of 1.309 and an overall area of 1.809. The whirling square rectangle AB is derived from the overall shape. The center of the square DE fixes the width of the bowl. The relation of the bowl to the meander band beneath the picture is shown by C and F. The points G H show that the meander band at the top of the picture is related to the foot.

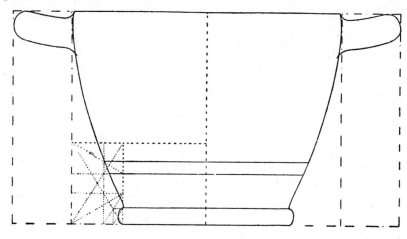

M.F.A. 01.8076

Fig. 11. Boston Skyphos 01.8076.
(Measured, drawn and analyzed by L. D. Caskey.)

Skyphos 01.8076 in the Boston Museum, Fig. 11, has a bowl ratio of 1.236 and an overall area of 1.764. This latter ratio frequently appears in Greek design.

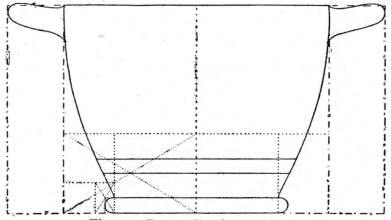

Fig. 12. Boston Skyphos 01.8032.

Skyphos 01.8032 in the Boston Museum, Fig. 12, has a bowl ratio of 1.236, and, apparently, an overall area which is a root-three rectangle. This is the only case in over four hundred examples of Greek design where a root-three figure was apparently used in connection with a whirling square rectangle.

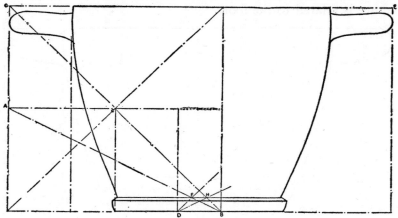

Fig. 13. Yale Skyphos 398

Black-glaze Skyphos 398, at Yale, Fig. 13, has a bowl ratio of 1.236 and an overall area of 1.809. AD is a whirling square rectangle from the 1.809 area. GB is the diagonal to a square and the point H shows that without its foot the vase is a root-four area.

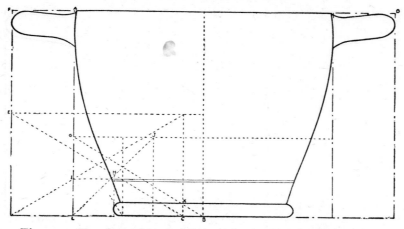

Fig. 14. Skyphos 06.1079, Metropolitan Museum, New York.

A skyphos from the New York Museum, Fig. 14, has a bowl ratio of 1.236 and an overall area of 1.809. AB is a whirling square shape from the bowl while EC is a similar figure from the 1.809 ratio.

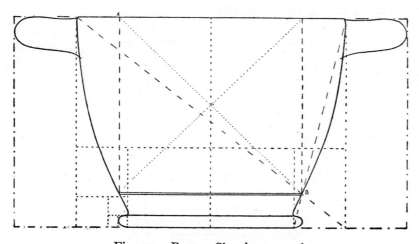

Fig. 15. Boston Skyphos 10.176.

Skyphos 10.176 in the Boston Museum, Fig. 15, has a bowl ratio of 1.236, while over all it is 1.809. The picture composition is placed within the square AB.

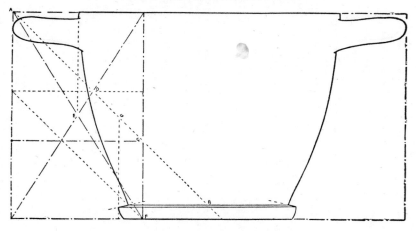

Fig. 16. Yale Skyphos 397.

Black-glaze Skyphos 397 in the Stoddard Collection at Yale, Fig. 16, has a 1.854 ratio. As AB is the diagonal to a square the area of this vase without the foot is equal to a root-four rectangle. The bowl, as shown by E, has a 1.236 ratio or two whirling square rectangles. G is the center of the square DC. (See Figs. 1 and 4, this chapter.)

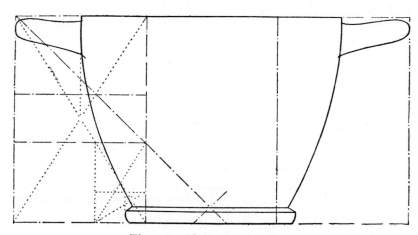

Fig. 17. Yale Skyphos 399.

Yale black-glaze Skyphos 399, Fig. 17, has an overall ratio of 1.854 while the bowl is 1.236, and the vase without the foot is a root-four rectangle.

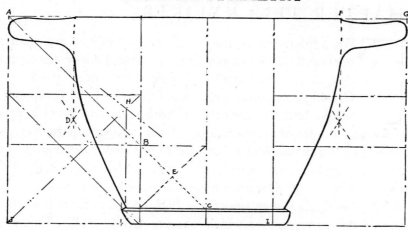

Fig. 18. Yale Skyphos.

A black-glaze skyphos in the Stoddard Collection at Yale, 400, Fig. 18, has a ratio of 1.854 or three whirling square rectangles. The bowl ratio is 1.236 or two whirling square rectangles. AC, CG are two squares. The point H is the intersection of the diagonals of the square HJ and the two whirling square rectangles AI.

CHAPTER TEN: KYLIKES

THE adjustment of the handles on a kylix to maintain a proportional relationship with the bowl and minor elements of the design seems to have been a difficult technical problem to the Greek potter. The great width of the bowl compared to its height and the delicacy of both stem and bowl supplies an uncertain foundation for the attachment of the two, comparatively, heavy handles. When the kylix was first submitted to analysis the varying height of the handles suggested that the pottery designers had frankly met the difficulty of adjustment by making allowance for an error. This was found to be true because, while the handles were sometimes high and sometimes low, there was one feature of this arrangement which was practically stable. This was their width in relation to the bowl. The makers of the kylix, therefore, must have raised or lowered the handles, after they were attached and while the clay was still workable, so the width should remain true.

Of course, the handles of the kylix may be ignored, as they may also be in the skyphoi, and the analysis confined to the bowl, foot and other details; but the Greek, apparently, did not ignore the handle adjustment in any type of pottery when they extended beyond the rectangle of the bowl, a fact clearly shown by the amphorae. In this vase class there are many examples with handles both inside and outside the bowl rectangle; when outside they are almost invariably finely worked and highly finished, when inside the reverse occurs. The Greek pottery collection in the Boston Museum of Fine Arts is unusually rich in kylikes and Dr. Caskey has given them careful attention, as the table in this chapter shows. This table contains seventeen examples of red-figured kylikes completely examined. The complete list comprises fifty-four examples.

This table is interesting. First it shows that five out of the seventeen are themes in root-two while the other twelve are design arrangements in the compound figures derived from the proportions found in the dodecahedron or the icosahedron. The relation of the details to the overall shape as shown in the classification is striking. Of the seventeen there are six where the width of the foot is equal to the height of the bowl, or one side of a square in the overall shape. The reader will recognize the tabled ratios as representing dynamic areas which have appeared frequently in the vases so far described.

In every example the details, as sub-ratios, show a recognizable theme in terms of the overall shape. Of the root-two shapes there are three overall ratios of 3.4142, or two squares plus a root-two rectangle.

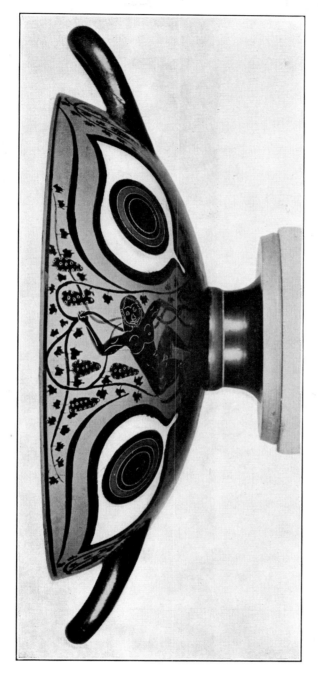

A BLACK-FIGURED EYE KYLIX, MUSEUM OF FINE ARTS, BOSTON

A theme in whirling-square rectangles with a root-five bowl

CASKEY'S TABLE OF R. F. KYLIKES

Museum No.	Overall Shape	Bowl	Foot	Stem	Base of Stem*	Projection of Handles
89.272	3.000	2.382	.8944			.309
95.35	3.090	2.472	.8944	.236	.6552	.309
01.8074	3.090	2.236	1.000	.309		.427
95.32	3.236	2.618	1.000		.691	.309
00.338	3.236	2.528	1.000	.236	.764	.354
01.8020	3.236	2.528	1.146	.236	.691	.354
01.8022	3.236	2.618	.927		.764	.309
10.195	3.236	2.618	1.000	.236	.618	.309
89.270	3.382	2.618	1.000	.309	.545	.382
1353.15	3.382	2.764	1.000		.764	.309
01.8038	3.528	2.764	1.09		.764	.382
01.8089	3.854	2.854	1.545			

ROOT-TWO SHAPES

Museum No.	Overall Shape	Bowl	Foot	Stem	Base of Stem*	Projection of Handles
13.83	3.0606	2.3535	.9393	.3535		.3535
95.33	3.4142	2.4714	1.0672	.4714		.4714
98.933		2.7071	1.000			
00.345	3.4142	2.7071	1.0606		.7071	.3535
13.82	3.4142	2.7071		.2929		.3535

The overall shape of the early black-figured kylix, 03.784 in the Boston Museum, Fig. 1, is represented by the ratio 2.854. The bowl ratio is a root-five rectangle. The width of the foot is a side of the square in a root-five shape. The difference between the square root of five, 2.236, and the ratio 2.854 is .618; consequently, the handles, as represented by AE and DF, are each equal to two whirling square rectangles. The bowl fills two whirling square rectangles as shown by AG, GD, and the area of which the foot is a side is composed also of two such shapes as shown by CG and GB. The scheme of the kylix, therefore, is a theme throughout in double whirling square rectangles.

*Base of stem is the slightly raised ring on top of the foot.

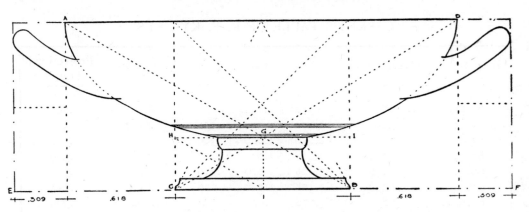

Fig. 1. Black-figured Kylix 03.784 in the Boston Museum.
(Measured, drawn and analyzed by L. D. Caskey.)

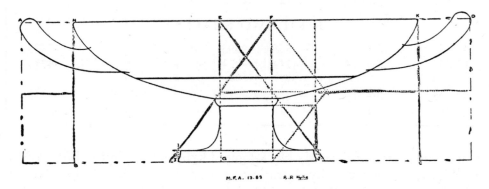

Fig. 2. Boston Eye Kylix 13.83.
(Measured, drawn and analyzed by L. D. Caskey.)

A large Boston eye kylix, Fig. 2, is a theme in root-two. The overall area ratio is
3.0606. The bowl area is 2.3535. The two handle areas, added, represent .7071,
the reciprocal of root-two, and therefore a root-two shape. Each handle area
must then be composed of two root-two areas. The bowl area, 2.3535 is com-
posed of two squares plus .7071 divided by two, or two plus .3535. BE, FC are
the squares and FG is the area composed of two root-two figures. The areas
HI and JK are each a root-two rectangle and JF is the difference between .7071
and unity or .2929.

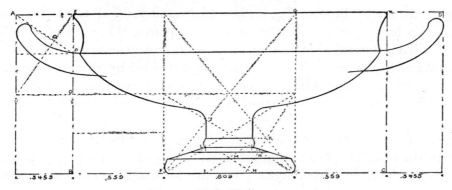

Fig. 3. Yale Kylix 167.

A heavy red-figured kylix at Yale, Fig. 3, has an overall area ratio of 2.618. The bowl ratio is 1.927, the fraction being .618 plus .309. The width of the foot is the end of an .809 shape. The major area is divided curiously. The total area of the handles gives a .691 shape, one-half of which is .3455. The area AO, therefore, is a square and a root-five; AP is also such a figure, consequently it is the reciprocal of AO, and the diagonals to both shapes meet at right angles at Q. EF is composed of four root-five rectangles. FG equals two whirling square rectangles; AH and ID are square plus root-five shapes. The points J, K, L, M, N are clear.

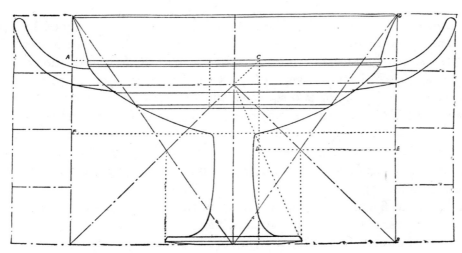

Fig. 4. Kylix 92.2654, Boston.
(Measured, drawn and analyzed by L. D. Caskey.)

Kylix 92.2654 at Boston, Fig. 4, has an overall ratio of 1.882, the bowl 1.382. This leaves for the handles .5 or two squares. When .5 is divided by two it will be noticed that the space on each end in excess of the bowl is composed of four squares. The 1.382 rectangle divided by two furnishes two .691 rectangles, each of which is composed of a square plus a root-five rectangle. The relation of the foot to the bowl is shown by the intersection of diagonals to two squares and the two .691 forms.

The area AB, which is determined by the line formed by the juncture of the lip with the bowl, supplies the ratio 1.7236, *i. e.*, a square plus a 1.382 shape, .7236 being the reciprocal of 1.382. CB is this form and it is divided into two .691 shapes by the line DE.

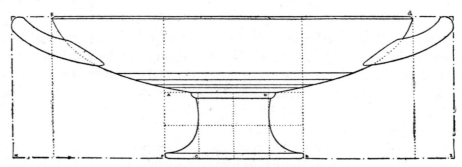

Fig. 5. New York Kylix by Nikosthenes.
(Measured and drawn by the Museum Staff.)

A large eye kylix in the New York Museum, 14.136, Fig. 5, signed by Nikosthenes, has an overall area of three squares. The bowl area however is 2.4472, *i. e.*, two squares plus root-five. The width of the foot in relation to the height is .9472, which is root-five, .4472 plus .5 or two squares, or 1.4472, a square plus root-five, minus .5 or two squares. The foot area AB is composed of two squares, and CD is one square. The areas EF, BG are each one and one-third. The areas EH and GI are each composed of two squares plus a whirling square rectangle. There is much evidence in this vase that the designer had been trained in static symmetry. The method of arranging the units of form have a distinct static flavor.

A large red-figured kylix, 06.1021.167 in the New York Museum, Fig. 6, supplies an overall ratio of three squares. The width of the bowl in relation to the height however is 2.4142, *i. e.*, a root-two rectangle plus a square. The two root-two rectangles AB, CD have ends equal in length to half the diagonal of one of the major squares.

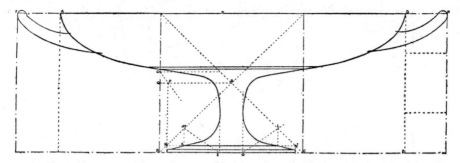

Fig. 6. Kylix 06.1021.167, Metropolitan Museum, New York.
(Measured and drawn by the Museum Staff.)

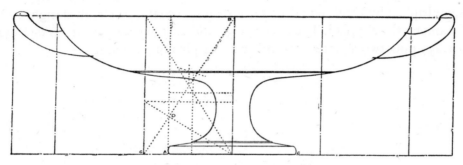

Fig. 7. Boston Kylix 95.35.
(Measured, drawn and analyzed by L. D. Caskey.)

A large kylix, 95.35 in the Boston Museum, Fig. 7, has an overall area of 3.090 or five whirling square rectangles, .618 x 5 = 3.090. The bowl area is four whirling square rectangles or 2.472. This latter fraction subtracted from 3.090 equals .618, therefore the handle areas are each composed of two whirling square rectangles. In the whirling square rectangle BC the line representing the width of the foot passes through the point D. Therefore the foot width is equal to the end of an area represented by two root-five rectangles. AB is one of these.

The overall ratio of the black-figured kylix, 06.1097 in the Metropolitan Museum, New York, Fig. 8, is 2.472 or .618 multiplied by 4. The bowl ratio is 1.854 or .618 multiplied by 3. AB is the major square in the reciprocal BC of the whirling square rectangle BD.

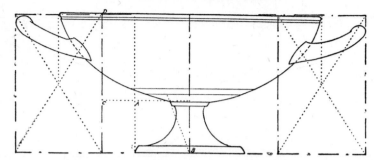

Fig. 8. Black-figured Kylix 06.1097, Metropolitan Museum, New York.
(Measured and drawn by the Museum Staff.)

Ring-foot Kylix 01.8089, Museum of Fine Arts, Boston, Figs. 9*a* and 9*b*.
Overall ratio 3.854, bowl, 2.854. Three whirling square rectangle reciprocals,
.618, multiplied by three, equal 1.854, a common shape in Greek design, espe-
cially among the skyphoi. The ratios 3.854 and 2.854 are apparent. In one case
it is 1.854 plus two squares, the other 1.854 plus one square.

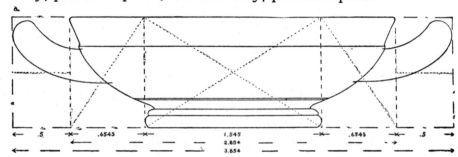

Fig. 9*a*.

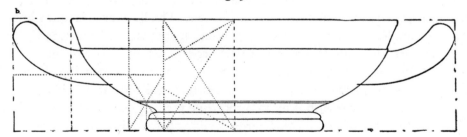

Fig. 9*b*.

Boston Kylix 01.8089.
(Measured, drawn and analyzed by L. D. Caskey.)

The width of the foot is the side of a rectangle composed of two whirling square rectangles and a half. .618 multiplied by two and a half equals 1.545. The area between the handles and bowl, on each side, equals two squares or .5. The area between the foot and the bowl, on each side, is composed of a square plus two whirling square rectangles divided by two, 1.309 divided by two equals .6545 and 1.545 plus 1.309 equals 2.854. Another arrangement, as in *b,* makes clear the relationship of detail in the design.

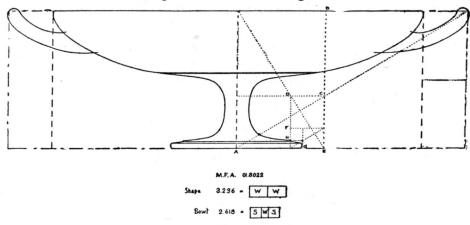

M.F.A. 01.8022

Shape 3.236 = [W | W]

Bowl 2.618 = [S |W| S]

Fig. 10.

(Measured, drawn and analyzed by L. D. Caskey.)

Kylix 01.8022, Museum of Fine Arts, Boston, Fig. 10, has an overall shape of two whirling square rectangles or 3.236, while the bowl proportion is a whirling square rectangle plus a square, or 2.618.

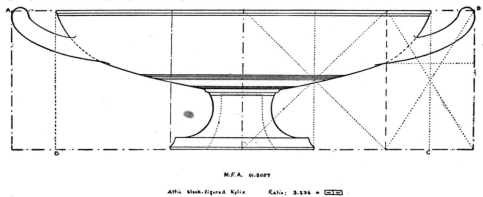

M.F.A. 01.8057

Attic black-figured Kylix Ratio: 3.236 = [⬚ | ⬚]

Fig. 11.

(Measured, drawn and analyzed by L. D. Caskey.)

AB is a whirling square rectangle as are also AC and DE and EF and FG and GH, the detail proportions being simply that of continued reciprocals. The areas of the handles are each two whirling square rectangles.

Black-figured Eye Kylix 01.8057 in the Boston Museum, Fig. 11, has an overall area of 3.236, two whirling square rectangles. The bowl area is 2.618. The difference between 2.618 and 3.236 is .618, therefore the handle areas, AB and CD, are each composed of two whirling square rectangles. The ratio 2.618 is a whirling square rectangle, 1.618, plus a square. The width of the foot is the side of this square, *i. e.*, the width of the foot is equal to the height of the bowl.

Yale Kylix 165, Fig. 12, has an overall ratio of 3.236. AB, CD are whirling square rectangles. E is the intersection of a whirling square diagonal with a diagonal of the whole. The points F, G, H and I are clear.

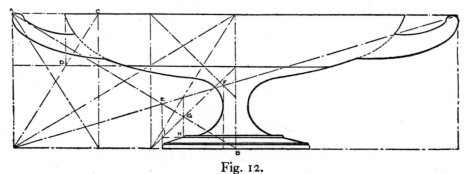

Fig. 12.

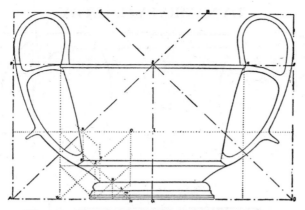

Fig. 1. Kantharos in the Boston Museum.
(Measured and drawn by L. D. Caskey.)

CHAPTER ELEVEN: VASE ANALYSES, CONTINUED

A BLACK-GLAZE Kantharos at Boston, Fig. 1, has an overall ratio of a square plus a root-five rectangle or the ratio 1.4472. AB and CD are the squares applied to either end of the rectangle and their diagonals intersect at E; consequently, the area AF is composed of two squares. GH, the rectangle of the bowl, is a 1.309 area, GI is one-fourth of this, therefore a similar shape composed of a square GO and two whirling square rectangles IN. The square GO is divided into the squares JN, KN, LN and MN. The point R is the center of the square PQ.

The Greek Olpe or Jug 07.286.34, Metropolitan Museum, New York, Fig. 2, is a design within the rectangle 1.9045. The fraction .9045 multiplied by two equals 1.809. The relation of this ratio to the whirling square rectangle and the subdivisions of the square made by the pentagon, is apparent (see Chapter III). The handle of the olpe extends beyond the rectangle made by the bowl far enough to produce an overall ratio of 1.691. The width of the lip with the full height of the jug supplies a 2.618 shape. The width of the foot with the height supplies 2.8944, *i. e.*, two squares and two root-five rectangles. The area AB is .691, a square and root-five shape. The relations of the subdivisions of the whirling square rectangle AC are obvious. The width of the bowl at its juncture with the foot, in relation to the full height, is 3.090 or five whirling square shapes. The rectangle obtained by the full height and the width of the neck at its narrowest point, is 4.618. AD is 1.236.

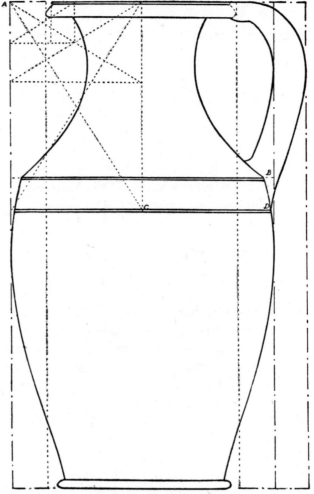

Fig. 2. Olpe from the Metropolitan Museum, New York.
(Measured and drawn by the Museum Staff.)

A theme of root-two and two squares appears in a Sixth Century B. C. leky-
thos, 111 in the Stoddard collection at Yale University, Fig. 3. The vase shape
is two squares, AB and BC in the drawing. AD, the height of the bowl, is a
root-two rectangle. The area CD is composed of the square DS and the root-
two rectangle SN. A side of a square, ES, produced from E to J, determines the
root-two rectangle JS and fixes the juncture of the neck with the body. A diagonal
to the whole cuts a side of a square at G to fix the proportion of the lip. It also
intersects the end of a root-two rectangle at L to determine the width of the

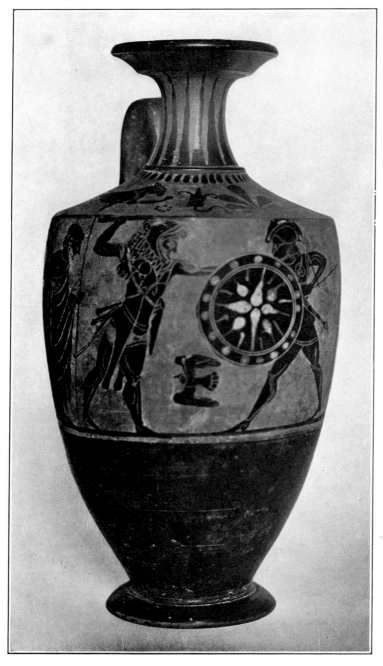

AN EARLY BLACK-FIGURED LEKYTHOS,
STODDARD COLLECTION AT YALE

A theme in root-two within two squares

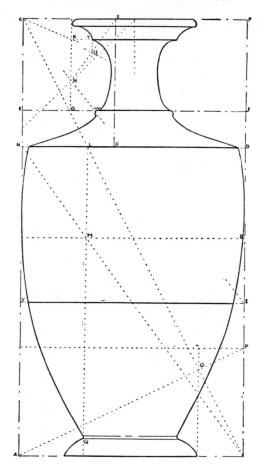

Fig. 3. Lekythos III at Yale.
(Measured by Prof. P. V. C. Baur of Yale University.)

foot at its juncture with the bowl. The line VI is the center of the root-two rectangle AD. This is the line on which the figures of the picture stand. O is the intersection of a diagonal of the whole with the diagonal to the two squares AP. The point U is the intersection of the diagonal to two squares with the diagonal to the root-two rectangle NS. The points H and W are fixed by a line from C to I. The point K is on the diagonal to the area CJ.

The ratio of a small white lekythos, 06.1021.125 in the Metropolitan Museum, New York, Fig. 4, is 2.7071, which is .7071, the reciprocal of root-two,

plus two squares. The coordination of detail to the whole shape is entirely by diagonals of square and root-two.

An early black-figured dinos, 13.205 in the Boston Museum, Fig. 5, is a static example. The curve of this vase, however, is interesting because it shows clearly what, in the writer's opinion, was the Greek method of relating curves to the straight line and area proportion in a work of art. The dinos area is four squares high and five wide. The width of the lip is fixed by the point D, the

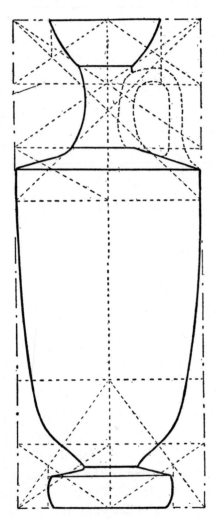

Fig. 4. Lekythos 06.1021.125, Metropolitan Museum, New York.
(Measured and drawn by the Museum Staff.)

intersection of the diagonal to two and one-half squares, AS, with the diagonal
of the square GH. EH and FG are diagonals to two squares, F and E being
midway between AH and AG. In the large square IM the lines ML and IK are
each diagonals to two squares. The point T is the center of the vase at its base
and J the middle of the side of the square IC. The curve touches FG at Q, HE
at P, the point J, IK at O, LM at N and the point T. Artists will appreciate
the quality possessed by a curve of this character, where it is perfectly related
to the composing elements of a theme in design and is not in any way mathe-

Fig. 5. Dinos 13.205, Boston Museum.
(Measured and drawn by L. D. Caskey.)

matical. Curves were, apparently, drawn by tangents in this manner all through
the Greek classical period. Hardly a vase, among the hundreds so far examined,
fails to disclose this method of relating curve to angle, area and line. The con-
structions necessary to show this have been kept out purposely in other
examples to avoid confusion. No mathematical curves have, so far, been found
in Greek art.

The shape of a black-glaze oinochoe in the Stoddard collection at Yale Univer-
sity, Fig. 6, is a 1.4472 rectangle, a square plus root-five. AB, CD are each squares
and CB, AD are each root-five rectangles. A 1.4472 rectangle divided into two
parts produces two 1.382 rectangles. 1.4472 divided by 2 equals .7236 and this
fraction is a reciprocal of 1.382. The lines GM and FL pass through the center
of the two 1.382 shapes. These lines intersect diagonals to the two root-five rec-
tangles at M and L, determining the width of the lip and foot, also the height of
the neck as shown by the square HI. The line JK shows that the height of the

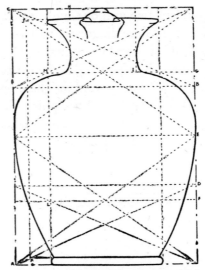

Fig. 6. A Black Oinochoe at Yale.
(Measured by Prof. P. V. C. Baur of Yale University.)

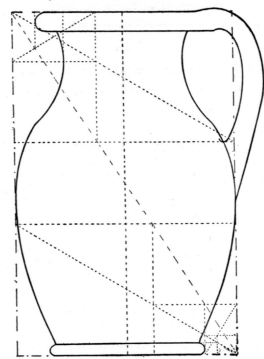

Fig. 7. Olpe from the Boston Museum.
(Measured, drawn and analyzed by L. D. Caskey.)

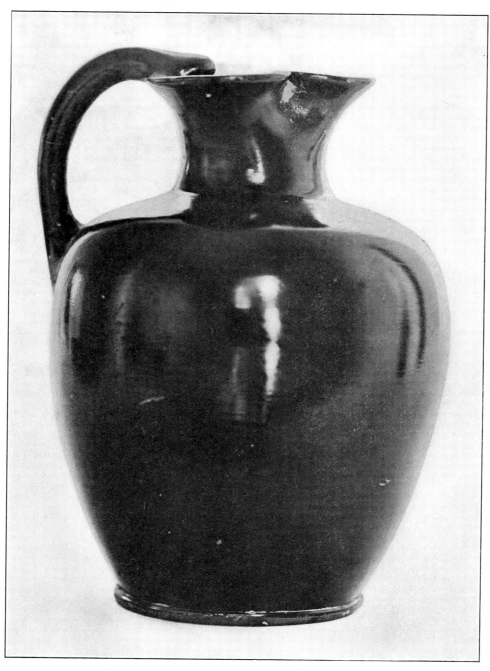

A BLACK GLAZE OINOCHOE FROM THE STODDARD
COLLECTION AT YALE

A theme in square and root-five

vase without the handle is proportioned to the thickness of the foot by the diagonal to a 1.382 shape, as CE, and the diagonal to a root-five rectangle, as AD.

The area of the jug, Fig. 7, is a perfect whirling square rectangle. The details are correlated by reciprocals of the major shape.

Fig. 8. Amphora 01.8059, Boston Museum.
(Measured, drawn and analyzed by L. D. Caskey.)

An early black-figured amphora, 01.8059 in the Boston Museum, Fig. 8, in area, is a whirling square rectangle. The width of the lip is the side of a square in the whirling square rectangle AB. In the whirling square rectangle CD, the line EF is a diagonal to half that shape. G is the intersection of EF with the diagonal of the square HI. The remainder of the analysis is clear.

Boston Amphora 10.178, Fig. 9, is a perfect whirling square rectangle and all its details are consistently correlated.

Fig. 9. Boston Amphora 10.178.

Lekythos 13.195 in the Boston Museum, Fig. 10, has an overall ratio of two and a half and the area is divided in terms of this shape, consequently it is a static example. AB is a diagonal of the whole. It intersects the halfway division of the square IO at H and the side of two squares AC at D. The line DT cuts the diagonal of the square SL at M. A line parallel with the base meets the diagonal of the whole at U. This fixes the foot width. The line FHQ is clear. The width of the lip is the side of the square FG and the entire lip is composed of two squares. The point N is clear, the intersection of diagonals of the half and whole. The three squares LW fix the proportions of the foot. The essential design idea in this example is the use of a series of correlated elements obtained by the diagonal of a rectangle made by two and a half squares cutting the sides of two squares. These two squares are placed at both top and bottom of the rectangle.

An early black-figured lekythos, 95.15, Fig. 11, has an overall ratio of two squares and the method of subdivision shows that this is a static shape. About five per cent, even less, of classic Greek design is static. The Greek designers

Fig. 10. Lekythos 13.195, Boston Museum.
(Measured, drawn and analyzed by L. D. Caskey.)

who used static symmetry possibly were uninitiated in the craft guilds. In the square AB the square CD is equal to one-fourth the AB area, and CE is composed of three squares. O is the intersection of the diagonals of one and two squares. F is the intersection of the diagonals of one and two squares. The area IJ with its diagonal and its influence at KLM is apparent. N is the intersection of the diagonals of one and two squares.

An early black-figured lekythos, 06.1021.60, Metropolitan Museum, New York, Fig. 12, is a simple root-five rectangle. There is a slight error in the width as shown where the containing rectangle does not touch the sides of the

vase. As all the details of the vessel are simple parts of a root-five figure there can scarcely be a doubt but that this rectangle was intended. A is the center of the square BC. F is the intersection of the diagonal of the square BC with the diagonal of the whirling square rectangle BD. E is the intersection of the line FE with the diagonal of the whole. H is the center of a small square and

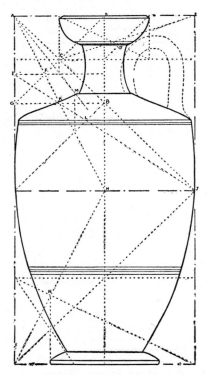

Fig. 11. Boston Lekythos 95.15.
(Measured, drawn and analyzed by L. D. Caskey.)

IJ is an area composed of two squares. G is an intersection of the diagonal of the whole with the diagonal of a square.

The large white lekythos, 12.229.10, Metropolitan Museum, New York, Fig. 13, exhibits the rectangle 3.2764. The fraction .2764 is the reciprocal of 3.618. The general area of this rectangle will be understood if two squares are subtracted. 3.2764 minus 2 equals 1.2764, and this remainder equals .8944 plus .382. This latter fraction, which is composed of two squares and a whirling square rectangle, furnishes the proportional area which defines the details of the lip. The fraction .8944 equals two root-five reciprocals, .4472 multiplied by 2.

One of these root-five shapes fixes the details of the foot. Many other arrange-
ments of the encompassing area could be made. For example; 1.2764 is com-
posed of .7236 plus .5528. .7236 is the reciprocal of 1.382, .5528 is the reciprocal
of 1.809, 1.2764 plus .7236 equals 2. 1.2764 multiplied by 2 equals 2.5528, .7236
plus 2.5528 equals 3.2764. Such combinations of area units as this should prove

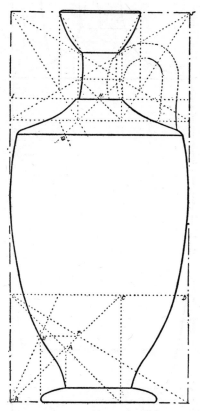

Fig. 12. Black-figured Lekythos 06.1021.60, Metropolitan Museum, New York.
(Measured and drawn by the Museum Staff.)

of the greatest value to designers. All of these areas may be readily determined
with a scale, and after the forms are studied, fixed by construction.

Lekythos G. R. 540 in the New York Museum, Fig. 14, has a ratio of root-
eight, i. e., root-two multiplied by two. The proportional correlation of foot and
neck is by root-two rectangles, diagonals of squares and diagonals of the whole.

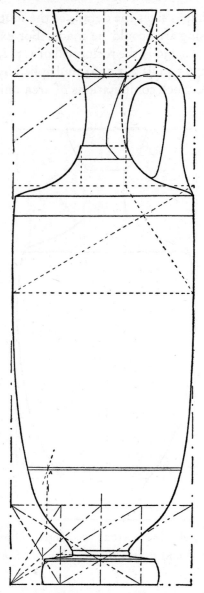

Fig. 13. Lekythos 12.229.10, Metropolitan Museum, New York.
(Measured and drawn by the Museum Staff.)

Red-figured Lekythos 08.258.23, Metropolitan Museum, New York, Fig. 15,
supplies a ratio of 3.236 or two whirling square rectangles, 1.618 multiplied
by 2. The subdivisions of the whirling square reciprocals at the top and bot-

tom of the enclosing rectangle, which proportion the details of the foot and the lip, do not need explanation, beyond mention that AB is a square in the center of CD, this area being a whirling square rectangle.

The red-figured lekythos, G. R. 589, Metropolitan Museum, New York, Fig. 16, supplies the ratio 1.528 (compare Amphora, Fig. 1, page 91, Chapter VIII). This form may be subdivided into two 1.309 shapes, 1.528 divided by two

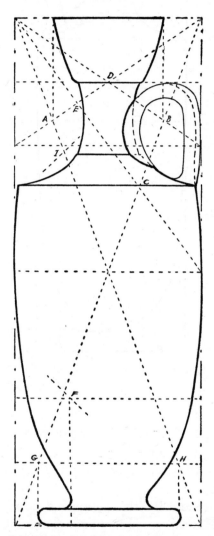

Fig. 14. Lekythos G. R. 540, Metropolitan Museum, New York.
(Measured and drawn by the Museum Staff.)

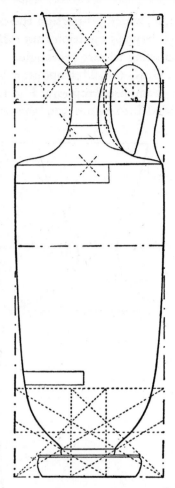

Fig. 15. Red-figured Lekythos 08.258.23, Metropolitan Museum, New York.
(Measured and drawn by the Museum Staff.)

equals .764, the reciprocal of 1.309, or it may be treated as a square plus .528.
This fraction is the reciprocal of 1.8944, i. e., a square plus two root-five rec-
tangles. Analysis shows that the second was the method of subdivision used
by the Greek designer.

AB is the major square and BC the rectangle consisting of a square and two
root-five rectangles. DE is this secondary square and DC, EB the two root-five
shapes. GH are two points obtained by the intersection of the diagonal of the
whole with the side of the major square. The general construction of the lip

and neck follow proportional subdivisions of the secondary square and the two
root-five figures by diagonals to the square, diagonals to the whole and diago-
nals to a square plus a root-five shape. The diagonals of the whole cut the
diagonals of the secondary square and a root-five figure at I and J. These
points fix the width of the lip. The points K and L are intersections of the diag-
onals of the secondary square with diagonals of a square plus a root-five figure.
M and N, two points directly connected with the proportions of the foot, are
centers of the two root-five shapes.

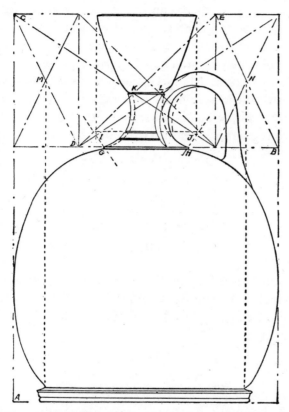

Fig. 16. Red-figured Lekythos G. R. 589, Metropolitan Museum, New York.
(Measured and drawn by the Museum Staff.)

CHAPTER TWELVE: STATIC SYMMETRY

THE basic idea in static symmetry, particularly as it is found applied in Saracenic and in mediaeval art, was stated by the writer in a paper read before the Society for the Promotion of Hellenic Study in London in the autumn of 1902. At that time dynamic symmetry had not been formulated and it was the writer's belief then that the static type would be found in Greek art. Further research proved, however, that this was true only to a small extent.

Static symmetry, as found in both nature and art, often, is radial. In this respect it is a symmetry of focus, an orderly distribution of shapes or composing units of form about a center. Almost invariably these units of form are parts or logical subdivisions of the regular figures, the equilateral triangle, the square and the regular pentagon. The two former predominate. The latter was used generally as a pattern. Many Gothic rose windows furnish examples of pentagonal pattern. Static symmetry of a radial character is regulated by a binary or doubling ratio, which is inherent in the equilateral triangle and the square. These two regular figures in nature may result from cell packing. If a

Fig. 1.

series of circles is considered, as in Fig. 1, and the centers joined, a network of squares is produced. An aggregate of circles, which may be considered as representing spheres, can be placed in contact in but two ways, either as in Fig. 1 or as in Fig. 2.

Fig. 2.

In this arrangement lines drawn through the centers of the circles produce a network of equilateral triangles.

The relation of the diameter of an inscribed to the diameter of an escribed circle of an equilateral triangle, is one to two.

Fig. 3. Fig. 4.

AB in Fig. 3 is one-half CD, and if a series of equilateral triangles be arranged as in Fig. 4 the ratio of the diameters of the circles is binary or doubling. The side of an equilateral triangle compared to the radius of the escribing circle is as one is to the square root of three. Very often both in nature and in art forms, the spaces between the expanding circles in an equilateral triangle pattern, will be occupied by zones of form which are root-three distances from the center of the system; *i. e.*, the radius of a circle represented by such a zone of form units would be equal to the side of an equilateral triangle inscribed in one of the preceding binary circles. But the basic ratio in an expanding system of this type is binary.

The relation between the diameters of circles inscribing and escribing a square is as one is to the square root of two.

This relationship is shown in Fig. 5. CD is to AB as a side is to a diagonal of a square, or unity to root two. But CD is to EF as one is to two.

Fig. 5.

In a system of squares expanding from a center, as in Fig. 6, the relationship of any three consecutive circles, by radius or diameter, is as $1 : \sqrt{2} : 2$. The equilateral triangle produces the relationship $1 : \sqrt{3} : 2$. The square produces the relationship $1 : \sqrt{2} : 2$. In each case the basic ratio is binary. There is no record that this binary ratio was ever understood though there is abundant evidence that equilateral triangles and squares were used consciously in art for the purpose of maintaining definite relationship between the parts and the whole of a composition. These simple figures form the base of most of the

"systems" of proportion which have been produced. Indeed, so many of these "systems" have appeared during the past fifty or seventy-five years that a list of even their names would be wearisome.*

Fig. 6.

The discovery of the design value of the regular figures of area is spontaneous. These shapes appear in the decoration, and often in the building construction, of many peoples. Apparently continued use of these elementary forms inevitably produces a system that is eventually recognizable as a definite art product of a people or an age. This is true of Saracenic, Byzantine, Norman or Gothic art. In decoration, especially, the themes are recognizable by inspection. The student of symmetry can hardly make a mistake in following out the pattern theme in any style of art where the regular figures are used. In many styles of architecture and decoration, other than the Greek and the Egyptian, root-two and root-three rectangles often may be found but they are always used in the static manner. In Greece or in Egypt they were used in the dynamic manner. In static symmetry these two rectangles are produced as logical divisions of some regular figure. The central area of a hexagon, as in Fig. 7, is a root-three rectangle.

The heavy line part of Fig. 8 is a root-two rectangle.

Either of these rectangles would be obtained in a multiplicity of ways from the simple pattern forms made by squares and equilateral triangles.

That squares and equilateral triangles are not found oftener in Greek and Egyptian design is indeed remarkable. The Choragic Monument of Lysicrates is a Greek example of a building in which an equilateral triangle appears and

*The reader is referred to Gwilt's "Encyclopedia of Architecture," section on Proportion, for a fairly complete list, with some detailed explanation, of these "systems." Also Leonardo da Vinci's sketch books, the Note Book of Villars de Honecourt, a Twelfth Century French architect, and the published works of Viollet le Duc.

Fig. 7.

Fig. 8.

the Tower of the Winds is an example of a square used in a static manner to obtain an octagon. Both of these structures are, however, comparatively late. The equilateral triangle appears often in tripod forms and in chariot wheels of six spokes, but the square, as a proportioning factor in decoration or construction, is strangely rare. The Greek and Egyptian methods of using static symmetry are quite different from those of other ages and peoples. In the art of the former it is almost invariably employed as an area in rectangle form, which is subdivided into multiple squares. For example, a Greek design whose greatest width is some even multiple of its greatest length, as 1 : 2, 1 : 1½, 1 : 1. 1/3, 1 : 2½, 1 : 2. 2/3, etc., is almost sure to have its details expressible in logical subdivisions of the containing shape. Any of the static examples of Greek pottery shapes in this book exemplify the idea. The Greeks, however, seem always to have been fond of subtleties. They seemed to enjoy finding hidden squares. In a shape composed of two squares, as in Fig. 9, they would

Fig. 9.

use the diagonals of the whole and the diagonals of the half to obtain the smaller square. Without the construction lines the relation of the small to the two larger squares is not obvious. The early black-figured dinos, page 127, is an example of the subtle use of squares to obtain, not only structural but also curve relationship. Greek practice in static symmetry was not essentially

different from what it was in dynamic. The latter type was simply a more powerful and flexible instrument.

The modern designer is much at fault in failing to realize that unless some type of symmetry is employed in art, design does not exist. Indeed, it is extraordinary that the modern architect almost invariably fails to recognize the part played by the regular figures in Gothic art. For example, he seems to feel that these pattern forms, which are so manifest, are arbitrary and were used because they facilitated tracery and diaper arrangement. As a matter of fact they are invariably the logical outgrowth of a fundamental plan scheme which permeates a structure or design throughout, thus producing that unity and interrelationship of parts and whole which may be compared to a like condition in a snow crystal. The modern designer also fails to realize that formalized art is impossible unless it is schematic. That even realistic representation will lack integrity and force, and become little better than a photograph, unless it is planned in area, *i. e.*, in two dimensions. It is because of this lack of understanding of schematic design that no formalized animals, for example, appear in art today, which can in any way be compared to those of Egypt, Greece or the Middle Ages. Indeed, this is the lesson that modern artists must learn; that the backbone of art is formalization and not realism. Art means exactly what the term implies. It is not nature, but it must be based on nature, not upon the superficial skin, but upon structure. Man cannot otherwise be creative, be free. As long as he copies nature's superficialities he is an artistic slave. No craftsmen ever so thoroughly understood this as the Greeks. When they used a flower or a plant as a design motive the superficial or accidental aspect of the thing was eliminated. They saw that nature was tending toward an ideal, that the principles at work underneath the surface of natural phenomena were perfect, but that material manifestations of the operation of these principles, as exemplified by animal and vegetable growth, owing to vicissitudes of circumstance and the length of time necessary for development, were seldom or never perfect. Realization of nature's ideal, however, and understanding of the significance of structural form should enable the artist to anticipate nature, to attain the ideal toward which she is tending, but which she can never reach. The Greek artist was always virile in his creations, because he adopted nature's ideal. The modern conception of art leads toward an overstress of personality and loss of vigor.

APPENDIX: NOTES

NOTE I.

THE idea that so much care should have been taken to proportion such a commonplace article as a clay pot, will probably strike the average reader as fanciful. And it would be so if ordinary pottery were under consideration. The vases considered here, however, are Greek, and the Greek vase is unique. Nothing like it was made before or has been made since the classic period. Moreover, in spite of the fact that Greek ceramics have received the enthusiastic attention of archaeological and other writers during the past one hundred years, little is known of the subject. Volumes have been written about the pictures found on Greek pottery, but the shape or form of the vase, which is of much greater importance, has been almost entirely neglected. In the light of dynamic symmetry, in the close analytical inspection of the shape which this symmetry makes possible, it is clear that the classic vase has survived, not because of its decoration and picture, admirable as these often are, but because of the extraordinary beauty of its form. Scholars, since the discovery of classic pottery in the Seventeenth Century, have advanced many strange, and sometimes amusing, theories to explain this curious and fascinating product of Greek design. The present situation in regard to the subject is summed up by H. B. Walters, Assistant Curator of Greek and Roman antiquities in the British Museum, who has written a history of pottery: "Any day may bring forth a new discovery which will completely revolutionize all preconceived theories; hence there is the constant necessity for 'being up to date,' and for the adjustment of old beliefs to new." In his introduction to the catalogue of the Rebecca Darlington Stoddard Collection of Greek and Italian vases at Yale University, P. V. C. Baur says: "To the ancient Greek the form of the vase was of vital importance, the vase painting was usually of secondary importance, a fact made clear by the great preponderance of signatures of potters over those of painters."

As a matter of fact, Greek pottery is one of the greatest design fabrics ever created. It is an artistic miracle.

NOTE II.

THE "cording of the temple" was a recognized process among the Egyptians, carried out by professional rope-stretchers and attended with ceremonies somewhat like those seen at our laying of the corner stone.[1] Lockyer quotes several significant descriptions of the process taken from wall inscriptions at Karnak, Denderah and Edfu. The Pharaoh himself was the chief actor and he was supposed to be assisted by a goddess called Sesheta, "the mistress of the laying of the foundation stone." These inscriptions also confirm the importance attached to careful orientation.

"Arose the king," says one, "attired in his necklace and feathered crown; and all the world followed him, and the majesty of Amenemhat. The *ker-heb*, chief priest, read the sacred text during the stretching of the measuring cord and the laying of the foundation stone on the piece of ground selected for this temple. Then withdrew his majesty Amenemhat; and King Usertesen wrote it down before the people." Another inscription represents Sesheta as addressing the king: "The hammer in my hand was of gold, as I struck the peg with it, and thou wast with me in thy capacity of Harpedonapt. Thy hand held the spade during the fixing of its four corners with accuracy by the four supports of heaven." Two more inscriptions directly describe orientation: "The living God, the magnificent son of Asti, nourished by the sublime goddess in the temple, the sovereign of the country, stretches the rope in joy, with his glance toward the *ak* of the Bull's Thigh Constellation, he establishes the temple-house of the mistress of Denderah, as took place there before" and the king says, "Looking to the sky at the course of the rising stars and recognizing the *ak* of the Bull's Thigh Constellation, I establish the corners of the temple of her majesty." Finally, regarding the building of the temple at Edfu, Lockyer remarks; "the king is represented as speaking thus:—'I have grasped the wooden peg and the handle of the club; I hold the rope with Sesheta; my glance follows the course of the stars; my eye is on Meschet; I establish the corners of thy house of God.' And in another place

[1] Sir Norman Lockyer, "The Dawn of Astronomy."

. . . . 'I have grasped the wooden peg; I hold the handle of the club; I grasp the cord with Sesheta; I cast my face toward the course of the rising constellations; I let my glance enter the constellation of the Great Bear; I establish the four corners of thy temple.'"

This laying out of the plan was called by the Egyptians *Put-ser*, which means literally "to stretch a cord." Having obtained a North and South line, says Ball,[1] the rope fasteners found an East and West one by an immemorial geometrical method still in use among engineers and carpenters. It was known that a triangle of which the sides were respectively 3, 4 and 5 units long, was necessarily a right triangle. The Harpedonapt, therefore, took a rope AD with knots tied at B and C so that AB was equal to 4, BC to 3 and CD to 5. Fastening BC with peg along the north and south line, he then rotated BC and CD about B and C until the points A and D coincided to form the vertex of a triangle. BA was then necessarily at right angles to BC.

Clement of Alexandria quotes Democritus as saying: "I have wandered over a larger portion of the earth than any man of my time, inquiring about things most remote; I have observed very many climates and lands, and have listened to very many learned men; but no one has yet surpassed me in the construction of lines with demonstration; no, not even the Egyptian Harpedonaptae, as they are called, with whom I lived five years in all, in a foreign land." Allman, p. 80.

It is worthy of note that about the same time that Greek artists were creating their stupendous masterpieces, and using root rectangles to correlate the elements of their designs, in far India designers of another race were using the same idea in architecture. The Hindus actually worked out the root rectangles up to root six. This is as far as the record goes. There is no indication that they knew anything of the connection between root five and extreme and mean ratio. The Hindu phraseology is suggestive. The record of the fact is contained in the Sulvasutras and is published in a book on Indian Mathematics by George Rusby Kaye (Calcutta and Simla). Mr. Kaye says:

"The term *Sulvasutra* means 'the rules of the cord' and is the name given to the supplements of the *Kalpasutras* which treat of the construction of sacrificial altars. The period in which the *Sulvasutras* were composed has been variously fixed by various authors. Max Müller gives the period as lying between 500 and 200 B. C.: R. C. Dutt gave 800 B. C.: Bühler places the origin of the Apastamba school as probably somewhere within the last four centuries before the Christian era, and Budhayana, somewhat earlier: Macdonnell gives the limits as 500 B. C. and A. D. 200, and so on. As a matter of fact, the dates are not known and those suggested by the different authorities must be used with the greatest circumspection. It must also be borne in mind that the contents of the *Sulvasutras*, as known to us, are taken from quite modern manuscripts; and that in matters of detail they have probably been extensively edited. The editions of Apastamba, Budhayana and Katyayana, which have been used for the following notes, indeed differ from each other to a very considerable extent."

Reference to the root rectangles are:

" 'The chord stretched across a square produces an area of twice the size.' "

The reference here is to the diagonal of a square, probably as the operation would be done by a "rope stretcher," and, of course, would be the first step necessary for the determination of a root-two rectangle. The square on the diagonal of a square is twice the area of a square on the side.

" 'Take the measure for the breadth, the diagonal of its square for the length; the diagonal of that oblong is the side of a square the area of which is three times the area of the square.' "

Here is described the construction of a root-two rectangle and the use of its diagonal to obtain the side of a root-three rectangle. The square described on the side of a root-three rectangle is three times the area of the unit square. And so on.

" 'The diagonal of an oblong produces by itself both the areas which the two sides of the oblong produce separately.

" 'This is seen in those oblongs whose sides are three and four, twelve and five, fifteen and eight, seven and twenty-four, twelve and thirty-five, fifteen and thirty-six.' " Budhayana edition. Translated by Dr. Thibaut.

[1] "Short History of Mathematics."

This last description refers to a geometrical construction which would be equivalent to the forty-seventh proposition of the first book of Euclid. That is, that the square on the hypotenuse is equal to the squares on the two legs of a right-angled triangle. It is noteworthy that here the hypotenuse is called the diagonal of an oblong. This would be an artist's statement of the fact enunciated in the forty-seventh proposition. A right-angled triangle doesn't mean as much to an artist as does a rectangle. The former suggests incompleteness, the latter means finish, an ensemble.

The second part of the last statement refers to the right-angled triangles obtained by the "rope stretchers" when they used the knotted rope to construct a right-angled triangle on the ground. In Egypt, as Cantor says, this operation of rope stretching, as is proven by the bas-reliefs, dates back to a very early period, possibly the first dynasty. This means that rope stretching was an established profession thousands of years before there is an historical reference to the same thing in either India or Greece.

The oblong whose sides are three and four means the celebrated 3, 4, 5 right-angled triangle used for temple cording for ages. Three and four units on a knotted rope represent the two sides of a triangle; the hypotenuse is five units, the squares on the two sides being three times three equalling nine, and four times four being sixteen; and nine plus sixteen being twenty-five, the square of five.

The sides of a triangle which are composed of twelve and five units will have an hypotenuse of thirteen units. $12 \times 12 = 144$, $5 \times 5 = 25$, 144 plus 25 = 169, $13 \times 13 = 169$.

Fifteen and eight units have an hypotenuse of seventeen units, the sum of the squares of fifteen and eight being two hundred and eighty-nine, the square of seventeen, and so on.

Pythagoras, one of the Greek philosophers who brought the knowledge of geometry from Egypt to Greece, has left us a rule for obtaining these right-angled triangles arithmetically, beginning with odd numbers. Later Plato supplied a rule beginning with even numbers. See Allman.

The early development of science in India was apparently slow and was soon tainted with looseness and inaccuracy. See T. L. Heath's "Elements of Euclid," particularly his notes on the forty-seventh proposition of the first book. This element of inaccuracy flavors all Hindu art; indeed, degree of precision and clearness of expression are hall marks for the art of any nation. Hindu art, for example, is much what Hindu science is; the same may be said of Greek art and science.

NOTE III.

THIS quotation from Vitruvius, the Roman writer on architecture, was used by David Ramsey Hay, a Scotch artist and author of the early part of the nineteenth century, who wrote several books upon the subject of symmetry and proportion. Hay's work is noteworthy as he is the only one of the many who have contributed theories to this subject who was attracted to the root rectangles. The idea was suggested to him by a mathematical friend who was conversant with the history of Greek geometry. Hay, however, knew little of the properties of these area figures and missed entirely the rectangle of the whirling squares. It is remarkable, however, that he tried to obtain the design themes of Greek pottery, in spite of the fact that in his day little was known about the vase and he did not have the benefit of first-hand observation. This writer, however, made the mistake of trying to bring design into the domain of music. In this attempt he not only failed utterly, but became so confused that his contribution, except for its historical interest, is valueless.

Modern research has entirely discredited Vitruvius. Not a single Greek example has been found which bears out the Roman writer's theory. As a matter of fact, now that we have dynamic symmetry as a guide, it is clearly to be seen that this writer gives us nothing but the echo of a tradition and his elaborate instructions for constructing buildings in the Greek style constitute nothing more than the Roman method of using static symmetry. The Romans were either intentionally misled by the Greek artists and craftsmen, or, blinded by conceit, they jumped at the conclusion that what was meant by the Greek tradition that the "members of the human

body were commensurate with the whole" was that the length measurements were commensurate. Dynamic symmetry now shows us that not only are the members of a Greek statue of the best period commensurate with the whole, but that the same is true of the human figure. But commensurate means commensurate in area, not in line. If a statue is made wherein the members are commensurate in line a static condition necessarily results. See Note No. 6.

NOTE IV.

THOSE interested in the latest contribution to Morphology should read "Growth and Form" by D'Arcy W. Thompson, Cambridge, 1917. This is an extraordinarily well-written book and the author's treatment of the logarithmic spiral in relation to uniform growth is most able. It may be said in passing, however, that this author has overstressed the value of the "gnomon" in some respects, and understressed it in others. Professor Thompson, however, gives the best general explanation of the proportion or logarithmic spiral in relation to growth phenomena that has yet appeared.

NOTE V.

THE following notes and bibliography are by Professor R. C. Archibald of Brown University. The writer feels that Professor Archibald's contribution is both valuable and timely and that it will do much to clear away the mystic, sentimental and impracticable notions now prevalent among artists and others in relation to the terms "Golden Section" and "Divine Section."

NOTES ON THE LOGARITHMIC SPIRAL, GOLDEN SECTION AND THE FIBONACCI SERIES[1]

I. The Logarithmic Spiral.[2]

THE first discussions of this spiral occur in letters written by Descartes to Mersenne in 1638, and are based upon the consideration of a curve cutting radii vectores (drawn from a certain fixed point O), under a constant angle, ϕ.[3] Descartes made the very remarkable discovery that if B and C are two points on the curve its length from O to B is to the radius vector OB as the length of the curve from O to C is to OC;[4] whence $s = a\rho$,[5] where s is the length measured along the curve from the pole to the point (ρ, θ), and $a = \sec \phi$.[6] This leads to the polar equation (1) $\rho = ke^{c\theta}$, where k is a constant and $c = \cot \phi$. The pole O is an asymptotic point. The pole and any two points on the spiral determine the curve; for the bisector of

[1] Most of the following notes appeared in *The American Mathematical Monthly*, April and May, 1918, but extensive additions, and some corrections, are here introduced.

[2] Historical sketches and some of the properties of the curve are given in F. Gomes Teixeira, *Traité des courbes spéciales remarquables*, tome 2, Coïmbre, Imprimerie de l'université, 1909, pp. 76–86, 396–399, etc.; in G. Loria, *Spezielle algebraische una transzendente ebene Kurven*, Band 2, 2. Auflage, Leipzig, Teubner, 1911, pp. 60 ff.; in *Mathematisches Wörterbuch . . .* angefangen von G. S. Klügel . . . fortgesetzt von C. B. Mollweide, Leipzig, Band 4₁, 1823, pp. 429–440.

[3] The curve arises in the discussion of a problem in dynamics. For references see the next footnote.

[4] *Oeuvres de Descartes*, tome 2, publiées par C. Adam et P. Tannery. Paris, Cerf, 1898, p. 360; also pp. 232–234; (see Montucla, *Histoire des Mathématiques*, nouvelle édition, tome 2, Paris, 1799, p. 45). *Cf.* I. Barrow, *Lectiones Geometricae*, Londini, 1670, p. 124; or English edition by J. M. Child, London, Open Court, 1916, pp. 136–9, 198. From the discussion and figure of Descartes it seems certain that he had no conception of O as an asymptotic point of the spiral. This property of the point was remarked in a letter, dated July 6, 1646, from Toricelli to Robervall (*L'Intermédiaire des mathématiciens*, 1900, vol. 7, p. 95). See also G. Loria, *Atti della accademia dei Lincei*, 1897, p. 318.

[5] The intrinsic equation $s^m R = K$ represents a logarithmic spiral when $m = -1$, a clothoïde when $m = 1$, a circle when $m = 0$, the involute of a circle when $m = -\frac{1}{2}$ and a straight line when $m = \infty$. Haton de la Goupillière remarked, and Allegret proved (*Nouvelles annales de mathématiques*, tome 11 (2), 1872, p. 163,) that the logarithmic spiral may be regarded also as a particular case of the spiral sinusoid.

[6] That is, the length of the arc measured from the pole is equal to the length of the tangent drawn at the extremity of the arc and terminated by the line drawn through the pole perpendicular to the radius vector, that is, "the polar tangent." The logarithmic spiral was the first transcendental curve to be rectified.

the angle made by the radii vectores of the points is a mean proportional between the radii. If $c = 1$ the ratio of two radii vectores corresponds to a number, and the angle between them to its logarithm; whence the name of the curve.

The name logarithmic spiral is due to Jacques Bernoulli.[1] The spiral has been called also the geometrical spiral,[2] and the proportional spiral;[3] but more commonly, because of the property observed by Descartes, the equiangular spiral.[4]

Bernoulli (and Collins at an earlier date) noted the analogous generation of the spiral and loxo-drome ("loxodromica"), the spherical curve which cuts all meridians under a constant angle. Credit for the first discovery that the loxodrome is the stereographic projection of a loga-rithmic spiral seems to be due to Collins.[5]

As the result of Descartes's letters distributed by Mersenne, Torricelli also studied the logarithmic spiral. He gave a definition which may be immediately translated into equation (1), and from it he obtained expressions for areas, and lengths of arcs. These results were rediscovered by John Wallis[6] and published in 1659.[7] Wallis states in this connection that Sir Christopher Wren had written about the logarithmic spiral and arrived at similar results.

During 1691-93 Jacques Bernoulli gave the following theorems among others: (a) Logarithmic spirals defined by equations (1) for different values of k are equal and have the same asymptotic point; (b) the evolute of a logarithmic spiral is another equal logarithmic spiral having the same asymptotic point;[8] (c) the pedal of a logarithmic spiral with respect to its pole is an equal log-

[1] "Specimen alterum calculi differentialis in dimetienda Spirali Logarithmica Loxodromiis Nautarum . . . ," "per J.B.," *Acta eruditorum*, 1691, pp. 282-283; *Opera*, tome 1, Genevae, 1744, pp. 442-443. Loria's references (*l. c.*, p. 61) to Varignon and Bernoulli are distinctly misleading. In 1675 John Collins used, in this connection, the expression "the spiral line is a logarithmic curve," *Correspondence of Scientific Men of the Seventeenth Century*, vol. 1, 1841, p. 219; [Quoted in full in a later footnote, page 150].
In more than one place Bernoulli refers to the logarithmic spiral as the 'Spira mirabilis,' e. g. *Opera*, tome 1, pp. 491, 497, 554; also *Acta eruditorum*, 1692 and 1693.

[2] P. Nicolas, *De Novis Spiralibus, Exercitationes Duae . . . In posteriori autem agitur de alia quadam spirali a prioribus longe diversa, de qua Vvallisius & Vvrenius insignes Geometrae scripserunt; & quae illi non attigere circa Tangentem hujus spiralis, spatiorum illa contentorum, & curvae ipsius dimensionem absolvuntur.* Tolosae, 1693. "Exercitatio II. De spiralibus geometricis" pp. 27-44. Appendix, pp. 45-51. The following quotation from page 27 may be given: "Esto curva BCDEF cujis sit talis proprietas, ut omnes radii AB, AC, AD, AE, AF constituentes angulos aequales in centro A sint inter se in continua proportione Geometrica. Propter hanc insignen proprietatam curvam BCDEF vocamus *Spiralem Geometricam* ut distinguatur à Spirali communi & Archimedea, cujus proprietas est ut radii aequales angulos ad centrum sive principium Spiralis constituentes sese aequaliter excedant, ac proinde servent proportionem Arithmeticam."

[3] E. Halley, *Philosophical Transactions*, 1696. The lengths of segments cut off from a radius vector between successive whorls of the spiral form a geometric progression.

[4] A term originating with R. Cotes, *Philosophical Transactions*, 1714; reprinted after the death of Cotes in his *Harmonia Mensurarum*, Cantabrigiae, 1722 ("Aequiangula spiralis," p. 19). The term was revived more recently by Whitworth in *Messenger of Mathematics*, 1862.

[5] See two letters of Collins, one undated and the other dated Sept. 30, 1675, in *Correspondence of Scientific Men of the Seventeenth Century . . .* Vol. 1, Oxford, University Press, 1841, pp. 144, 218-19. The result was first given in print by E. Halley, in *Philosophical Transactions*, 1696.
Cf. F. G. M., *Exercices de Géométrie Descriptive*, 4e éd., Paris, Mame, 1909, pp. 824-6. Chasles showed (*Aperçu historique*, etc., . . . 2e éd., Paris, 1875, p. 299) that if the logarithmic curve generates a surface by revolving about its asymptote, and if this asymptote is the axis of a helicoidal surface, the two surfaces cut in a skew curve whose orthogonal projection on a plane perpendicular to the asymptote is a logarithmic spiral. See also H. Molins, *Mémoires de l'académie des sciences inscriptions et belles-lettres de Toulouse*, tome 7 (sem. 2), 1885, p. 293 f.; tome 8, 1886, pp. 426. That the logarithmic spiral is a projection of a certain "elliptic logarithmic spiral" was shown in W. R. Hamilton, *Elements of Quaternions*, London, 1866, pp. 382-3. For other quaternion discussion of the logarithmic spiral see H. W. L. Hime, *The Outlines of Qua-ternions*, London, 1894, pp. 171-3.

[6] Cf. Turquan, "Démonstrations élémentaires de plusieurs propriétés de la spiral logarithmique," *Nouvelles annales de mathématiques*, tome 5, 1846, pp. 88-97. "Note" by Terquem on page 97.

[7] J. Wallis, *Tractatus Duo*, 1659, pp. 106-107; also *Opera*, tome 1, 1695, pp. 559-561.

[8] Paragraph 9 of an article in *Acta eruditorum*, May, 1692, entitled "Lineae cycloidales, evolutae, ante-volutae, causticae, anti-causticae, peri-causticae. Earum usus et simplex relatio ad se invicem. Spira mira-bilis. Aliaque per I.B." Cf. *Oeuvres Complètes de Christian Huygens*. Tome 10. La Haye, 1905, p. 119. The center of curvature at a point on a logarithmic spiral is the extremity of the polar subnormal of the point.

arithmic spiral;[1] (d) the caustics by reflection and refraction of a logarithmic spiral for rays emanating from the pole as a luminous point are equal logarithmic spirals.

The discovery of such "perpetual renascence" of the spiral delighted Bernoulli. "Warmed with the enthusiasm of genius he desired, in imitation of Archimedes, to have the logarithmic spiral engraved on his tomb, and directed, in allusion to the sublime tenet of the resurrection of the body, this emphatic inscription to be affixed—Eadem mutata resurgo."[2] The engraved spiral (very inaccurately executed) and inscription, in accordance with Bernoulli's desire, may be seen to-day on his tomb in the cloister of the cathedral at Basel.[3]

The logarithmic spiral appears in three propositions of Newton's "Principia" (1687).[4] From the first there develops that if the force of gravity had been inversely as the cube, instead of the square, of the distance, the planets would have all shot off from the sun in "diffusive logarithmic spirals."[5] In the second proposition Newton showed that the logarithmic spiral would also be described by a particle attracted to the pole by a force proportional to the square of the density of the medium in which it moves, while this density is at each point inversely proportional to its distance from the pole. In the third proposition the second was generalized by the substitution of "inversely proportional to any power of its distance" for "inversely proportional to its distance"—a result which has been attributed to Jacques Bernoulli (for example, by Gomes Teixeira, l. c.).

There is also considerable discussion of the logarithmic spiral by Guido Grandi in various parts of his *Geometria Demonstratio Theorematum Hugenianorum circa Logisticam seu Logarithmicam Lineam* . . . , Florentiae, 1701.[6] A section in the first chapter deals with "spiralio logarithmicae per duos motus descriptio," and points are found (page 8) "in Spirali Logistica, aliis Spiralis Logarithmicae, quibusdam Spiralis Geometricae nomine appellata" (evidently referring to P. Nicolas, l. c.). In a letter to Ceva, printed at the end of the volume, the gauche spiral cutting the generators of a right circular cone under a constant angle was studied for the first time, and it was shown, by purely geometric methods, that this spiral may be projected into a logarithmic spiral.

In a memoir read by Pierre Varignon before the French Academy in 1704[7] he discussed a transformation equivalent to $x = \rho$, $y = l\omega$, where ρ and ω are the polar coordinates of the point corresponding to (x, y), and l is a constant. Varignon found, in particular, that from the logarithmic curve $x^{-h} = e^y$ is derived the logarithmic spiral $\rho = e^{-\frac{l}{h}\omega}$. So also, if $l = 1$, the

[1] The nth positive pedal of the spiral $\rho = ke^{c\theta}$ with respect to the pole is

$$\rho = k\sin^n\phi . e^{cn(\frac{\pi}{2}-\phi)} . e^{c\theta}$$

(J. Edwards, *Elementary Treatise on the Differential Calculus*, 3d edition, London, Macmillan, 1896, p. 167).
[2] *Acta eruditorum*, 1706, p. 44. Cf. *Acta eruditorum*, 1692, p. 212; also *Opera*, tome 1, Genevae, 1744, p. 502, and p. 30 of "Vita."
[3] Cf. L. Isely, "Epigraphes tumulaires de mathématiciens," *Bull. de la société des sciences naturelles de Neuchâtel*, tome 27, 1899, p. 171. See also W. W. Rupert, *Famous Geometrical Theorems and Problems* (Heath's Mathematical Monographs, part 4), Boston, 1901, p. 99.
[4] Book I, proposition 9, and book II, propositions 15 and 16.
[5] The hodograph of an equiangular spiral is an equiangular spiral (W. Walton, *Collection of Problems in Illustration of the Principles of Theoretical Mechanics*, 3d ed., Cambridge, 1876, p. 296). In a chapter on electromagnetic observations in J. C. Maxwell's *Treatise on Electricity and Magnetism* (vol. 2, Oxford, Clarendon Press, 1873, pp. 336–8) the discussion calls for the investigation of the motion of a body subject to an attraction varying as the distance and to a resistance varying as the velocity. This leads to the reproduction of Tait's application (*Proc. Royal Society of Edinburgh*, vol. 6, 1867, p. 221 f.) of the principle of the hodograph to investigate this kind of motion by means of the logarithmic spiral.
"If a particle be describing a logarithmic spiral under the action of a force to the pole, and simultaneously the law of force be altered to the inverse biquadrate and the velocity to $\sqrt{\frac{2}{3}} \times$ its previous value, the particle will proceed to describe a cardioide." Purkiss, *Messenger of Mathematics*, vol. 2, 1864. For other results of this type, involving the spiral, see Newton's *Principia*, first book, sections I–III, with notes and illustrations by P. Frost, London, 1880, p. 203.
[6] Also in *Christiani Hugenii Zuelechemi . . . Opera Reliqua*, tome 1, Amstelodami, 1728, pp. 136–288.
[7] "Nouvelle formation de spirales," *Histoire de l'académie royale des science*, année 1704, Paris, 1706, pp. 69–131; see especially pp. 113f.

sine curve $x = \sin y$ becomes a circle. In recent times this latter transformation has been employed in plotting alternating voltage and current curves.[1]

In 1892 I. Stringham showed[2] that if the logarithmic spiral is properly defined as a geometric locus it may be used for defining the logarithm and demonstrating its properties, which lead to a classification of logarithmic systems. This classification was somewhat modified by M. W. Haskell and I. Stringham.[3]

Cremona's discussion of the logarithmic spiral, and how it may serve, when drawn, for the solution of problems involving extraction of roots[4] (higher than the second) should not be forgotten. Then there is A. Steinhauser's *Die Elemente des graphischen Rechnens mit besonderer Berücksichtigung der logarithmischen Spirale. Eine Einleitung zur Construction algebraischer und transcendenter Ausdrücke für Bau- und Maschinen-Techniker*[5]—Equiangular spirals appear as "tie-lines" and "strutt-lines" in a problem of W. J. Ibbetson's *Elementary Treatise on the Mathematical Theory of Perfectly Elastic Solids*[6]—There is also the little known but notable paper, published by James Clerk Maxwell when only eighteen years of age,[7] which contains several properties of logarithmic spirals. Some quotations follow:

"The involute of the curve traced by the pole of a logarithmic spiral which rolls upon any curve is the curve traced by the pole of the same logarithmic spiral when rolled on the involute of the primary curve." (Page 524 [10].)

"The method of finding the curve which must be rolled on a circle to trace a given curve is mentioned here because it generally leads to a double result, for the normal to the traced curve cuts the circle in two points, either of which may be a point in the rolled curve.

"Thus, if the traced curve be the involute of a circle concentric with the given circle, the rolled curve is one of two similar logarithmic spirals." (Page 529 [16].) (Often attributed to Haton de la Goupillière.)

"If any curve be rolled on itself, and the operation repeated an infinite number of times, the resulting curve is the logarithmic spiral." The curve which being "rolled on itself traces itself is the logarithmic spiral." (Page 532 [19].)

"When a logarithmic spiral rolls on a straight line the pole traces a straight line which cuts the first line at the same angle as the spiral cuts the radius vector." (Page 535 [23].) (Often attributed to Catalan.)

Among many other results the following may be noted: Haton de la Goupillière proved[8] that the logarithmic spiral is the only curve whose pedal with respect to a given pole is an equal curve which can be brought into coincidence with the first by a rotation about the pole—Cesàro

[1] For example: D. C. Jackson and J. P. Jackson, *Alternating Currents and Alternating Current Machinery*, New edition, New York, 1917, pp. 13–15. The discussion in this connection seems to have originated with C. P. Steinmetz, *Trans. Amer. Inst. Electrical Engs.*, vol. 10, p. 527; *Elektrotechnische Zeitschrift*, June 20, 1890.

[2] I. Stringham, "A classification of logarithmic systems," *American Journal of Mathematics*, vol. 14, pp. 187–194.

[3] *Bulletin of the New York Mathematical Society*, vol. 2, pp. 164–170, 1893. See also I. Stringham, *Uniplanar Algebra*, San Francisco, 1893.

[4] L. Cremona, *Graphical Statics*. Translated by T. H. Beare, Oxford, Clarendon Press, 1890, pp. 59–64. Italian edition, Torino, 1874, pp. 39–42. The xylonite logarithmic spiral curve (eight inches in width) sold by Keuffel & Esser Co., New York, furnishes the means for accurately and rapidly drawing the curve. The curvature gradually changing it is peculiarly adapted for fitting to any part of a given curve. It assists in the rapid determination of the center of curvature of a given part of the curve, and, hence, in drawing evolutes and equidistant curves. An eight-page pamphlet by W. Cox (*The logarithmic spiral curve and description of its uses*, 1891) accompanies the instrument. Eugene Dietzgen & Co., Chicago, manufactured a similar celluloid instrument and a ten-page pamphlet descriptive of its use was written by E. M. Scofield, and entitled *The logarithmic spiral curve* (Chicago, 1892).

[5] Wien, 1885; especially pp. 40–75.

[6] London, 1887, p. 322.

[7] "On the Theory of Rolling Curves," *Transactions of the Royal Society of Edinburgh*, vol. 16, part V, 1849, pp. 519–40. [*The Scientific Papers of J. C. Maxwell*, edited by W. D. Niven, vol. 1, Cambridge, 1890, pp. 4–29.] Loria, Gomes Teixeira, and Wieleitner seem to be equally ignorant of this paper.

[8] *Journal de mathématique pures et appliquées*, tome 11 (2), 1866, pp. 329–336.

discussed the tractrix and logarithmic spiral as correlative figures[1]—From logarithmic spirals H. Dittrich derived[2] (according to Loria, *l. c.*) sum and difference spirals which he used for geometrical exposition of hyperbolic functions—If a logarithmic spiral roll on a straight line the locus of its center of curvature at the point of contact is another straight line (A. Mannheim, 1859)—The involutes of a logarithmic spiral are equal spirals (which is really the same as Bernoulli's result for evolutes)—The inverse of a logarithmic spiral with respect to its pole is an equal spiral with the same pole—Coplanar logarithmic spirals and their orthogonal trajectories, which are again coplanar logarithmic spirals, come up (1) in the discussion of loxodromic substitutions[3] and (2) in conformal representations.[4] As a consequence of a general theory relative to linear transformations F. Klein and S. Lie obtained the following result:[5] The logarithmic spiral is its own polar reciprocal with respect to any equilateral hyperbola which has its center at the pole and is tangent to the spiral.

In 1833 T. Olivier described to the Société Philomathique, Paris, "un compass simple permettant de traces toutes les spirales logarithmiques,"[6] and in a letter written by Collins for Tschirnhaus, Sept. 30, 1675,[7] reference is made to "an instrument invented by M. Tschirnhaus" and its connection with the logarithmic spiral.

The most practical form of a ship's anchor was discussed in 1796 by F. H. Chapman, vice-admiral in the Swedish Marine.[8] He found that the best form for each of the barbed arms would be an arc of a logarithmic spiral cutting the shank of the anchor at an angle of 67° 30'.

[1] *Mathesis*, tome 2, 1882, pp. 217–219.

[2] H. Dittrich, *Die logarithmische Spirale*, Progr. Breslau, 1872.

[3] F. Klein and R. Fricke, *Vorlesungen über die Theorie der elliptischen Modulfunctionen*, Band I, Leipzig, Teubner, 1890, p. 168.

[4] G. Holzmüller, *Einführung in die Theorie der isogonalen Verwandtschaften und der conformen Abbildung*, Leipzig, Teubner, 1882, pp. 65, 238–241; and "Ueber die logarithmische Abbildung und die aus ihr entspringenden Curvensysteme," *Zeitschrift für Mathematik und Physik*, Band 16, 1871, pp. 269–289.

[5] *Mathematische Annalen*, Band 4, 1871, p. 77. *Cf. Encyklopädie der mathematischen Wissenschaften*, Band III₃, Leipzig, 1903, pp. 210, 212; also Clebsch-Lindemann, *Vorlesungen über Geometrie*, Band I, Leipzig, Teubner, 1876, p. 995.

[6] This description may be found in T. Olivier, *Compléments de géométrie descriptive*, Paris, 1845, p. 445. See also T. Olivier, *Mémoires de géométrie descriptive*, Paris, 1851, p. 284.

[7] This letter is printed in *Correspondence of Scientific Men of the Seventeenth Century*, vol. 1, Oxford, 1841. The paragraphs of special interest in this connection are as follows: "As to the instrument invented by M. Tschirnhaus for dividing an angle in ratione data, we suppose he gives an angle as geometers do, ready drawn by accident or at pleasure, and then I conceive it an instrument worthy the author: whereas here (so far as I know) we have nothing but the old mechanism, viz. to measure the angle in degrees first, by aid of a sector or opening joint, and then set off the part proportional by aid of an arch or line of chords, which one of the legs may draw after it, which part proportional may be attained by a sliding scale with log[cal] lines upon it, which may be annexed to the other leg; but here I will a little enlarge on the use of M. Tschirnhaus's invention.

"We have an instrument called the serpentine line, or, as Oughtred terms it the circles of proportion, in the use whereof, in relation to compound interest, it is often required to divide an angle in ratione data, or an angle being given to enlarge it in ratione data. Moreover, conceive the eye at the south pole, projecting the loxodromia or rumb of a ship's course on the earth, on a plane touching the sphere at the north pole, the projected curve will be a spiral line, in which, if the polar rays PE, PD, PC, PÆ, [the figure of the letter is omitted] make equal angles at the pole P, those rays will be in continual geometrical proportion; and conceiving a circle described upon P as a centre, the equal segments of the arch in the circumference, made by the polar rays, will be an arithmetical progression, suited to a geometrical one; consequently the spiral line is a logarithmic curve and from hence the meridian line of the true sea chart may be demonstrated to be a line of logarithmic tangents, and the spiral line with M. Tschirnhaus's angular instrument, makes the mesolabe [an instrument for finding mean proportionals between two numbers], which our late learned Oughtred said was hitherto tenebris obvolutum.

"To rectify or straighten this spiral, or part of it, as EÆ, is all one effect as to draw a touch-line to it, or to find the rumb between two places whose latitudes and difference of longitude are given which to perform in lines is a proposition of great use, and hitherto wanting in navigation, and depends on the quadrature of the hyperbola, as Dr. Barrow, at my instance, proved in his Geometrical Lectures. Moreover such a spiral, being once well described, may serve to take away the use of compasses in Galileus or our Gunter's sector or joint for proportions, all which I thought not impertinent to hint."

[8] "Om rätta Formen på Skepps-Ankrar," *Svensk. Vetensk. Academ. nya Handl.*, 1796, Vol. 17, pp. 1–24.

The distinctive properties of the logarithmic spiral which permit it to be used for lines of pitch of cams and non-circular wheels[1] are: (a) that the difference of radii vectores of the ends of equal arcs is constant; (b) the curve cuts radii vectores under a constant angle. For these reasons two equal logarithmic spirals may roll together with fixed poles and a fixed distance between the poles. Two arcs (not necessarily equal) of logarithmic are required for the complete line of pitch of a wheel, but any even number of arcs may be used. A wheel with three lobes may act on a wheel with two, which in turn may act on a unilobe wheel. Even with two reacting wheels with the same number of lobes there are varying velocity ratios having maximum and minimum values for the rates of rotation of the shafts.

The first definite suggestion connecting the logarithmic spiral with organic spirals seems to have been made by Sir John Leslie in his *Geometrical Analysis and Geometry of Curve Lines*.[2] After proving that the involutes of a logarithmic spiral are logarithmic spirals he remarks: "The figure thus produced by a succession of coalescent arcs described from a series of interior centers exactly resembles the general form and the elegant *septa* of the *Nautilus*."[3] The aptness of this remark has been long since established. One of the earliest mathematical discussions of organic logarithmic spirals was by Canon Moseley, "On the Geometrical Forms of Turbinated and Discoid Shells"[4]—a paper written more than eighty years ago which is one of the classics of natural history. In "turbinate" shells we are no longer dealing with a plane spiral as in the nautilus but with a gauche spiral on a right circular cone cutting the generators at a constant angle and such that along a generator the line-segments between successive whorls form a geometric progression.[5] For mathematical and other details of Moseley's work as well as of that of many others, on univalve and bivalve shells, Thompson's book, with its many exact references to the literature of the subject, should be consulted. One notable work which Thompson appears to have overlooked is Haton de la Goupillière, "Surfaces Nautiloïdes."[6]

In the field of leaf arrangement or phyllotaxis discussion of the theories of A. H. Church[7] and Cook evolved from observations of arrangements in logarithmic spirals of florets of sunflowers, pine cones, and other growths, should be read in connection with Thompson's criticisms. The fine sunflower photograph by H. Brocard[8] ought to be compared with those by Church.

Abridged and translated in *Annalen der Physik* (Gilbert), Band 6, Halle, 1800: "Von der richtigen Form der Schiffsanker," pp. 81–95.

[1] W. J. M. Rankine, *Manual of Machinery and Millwork*, London, 1869, pp. 99–102;

C. W. MacCord, *Kinematics*, New York, 1883, pp. 47–50;

F. Reuleaux, *Lehrbuch der Kinematik*, Band 2: *Die praktischen Beziehungen der Kinematik zu Geometrie und Mechanik*, Braunschweig, 1900, pp. 473, 542–544;

P. Schwamb and A. L. Merrill, *Elements of Mechanism*, New York, 1913, pp. 32–36;

R. F. McKay, *The Theory of Machines*, London, 1915, pp. 218–222.

F. DeR. Furman, "Cam design and construction," *American Machinist*, vol. 51, pp. 695–698, Oct. 9, 1919.

[2] Edinburgh, 1821, p. 438.

[3] For pictures of the nautilus pompilius see pp. 494, 581, 582 of D. W. Thompson, *On Growth and Form*, Cambridge University Press, 1917, and also pp. 57, 457 of T. A. Cook, *The Curves of Life*, London, Constable, 1914. This latter work contains many beautiful illustrations and logarithmic spiral forms are specially discussed on pages 60–63, 413–421; another work by the same author, *Spirals in Nature and Art*, London, Murray, 1903, has some good illustrations.

[4] *Philosophical Transactions of the Royal Society*, London, Vol. 128, 1838, pp. 351–370.

[5] As early as 1701 Guido Grandi showed, *l. c.*, as already noted, that the orthogonal projection of this spiral on a plane perpendicular to the axis of the cone is a logarithmic spiral. The gauche spiral has been studied by Th. Olivier (who called it the conical logarithmic spiral), *Développements de géométrie descriptive*, 1843, pp. 56–76; by P. Serret, *Théorie nouvelle géométrique et mécanique des lignes à double courbure*, 1860, p. 101; etc. A number of results are collected by Gomes Teixiera, *l. c.*, pp. 396–400.

For other surfaces involving the logarithmic spirals reference should be given to the very interesting pages 232–313 of G. Holzmüller, *Elemente der Stereometrie*, Dritter Teil, Leipzig, Göschen, 1902, on logarithmic spiral tubular surfaces and their inverses.

[6] This occupies almost the whole of the third volume of *Annaes scientificos da academia polytechnica do Porto*, Coïmbra, 1908. Cf. *L'Intermédiaire des mathématiciens*, 1900, tome 7, p. 40; 1901, tome 8, pp. 167, 314; 1910, tome 17, p. 155.

[7] A. H. Church, *On the Relation of Phyllotaxis to Mechanical Law*, London, Williams and Norgate, 1904.

[8] In *L'Intermédiaire des mathématiciens*, 1909, and in H. A. Naber, *Das Theorem des Pythagoras*, Haarlem, Visser, 1908, opposite p. 80.

II. Golden Section.

In the "Elements" of Euclid (who flourished about 300 B. C.), the following propositions occur: (1) "To cut a given straight line so that the rectangle contained by the whole and one of the segments is equal to the square on the remaining segment" (Book II, proposition 11); (2) "To cut a given finite line in extreme and mean ratio" (Book VI, proposition 30).[1] While these propositions are equivalent in statement the methods of construction given by Euclid are quite different. There can be little doubt that the construction in the second is due to Euclid and in the first to the Pythagoreans (fifth century B. C.). The result is used "To construct an isosceles triangle having each of the angles at the base double of the remaining one" (Elements, Book IV, 10) and this leads to the construction of a regular pentagon (Book IV, 11).

In the Elements, book XIII, the first five propositions, which are preliminary to the construction and comparison of the five regular solids, and deal with properties of a line segment divided in extreme and mean ratio, are usually attributed to Eudoxus, who flourished about 365 B. C. Proclus tells us that Eudoxus "greatly added to the number of the theorems which Plato originated regarding the section"; scholars agree that "the section" refers to the division in extreme and mean ratio.

The so-called book XIV of Euclid's Elements, written by Hypsicles of Alexandria between 200 and 100 B. C., contains some results concerning "the section."

In recent times the name golden section has been applied to the division of a line segment as above[2] in the ratio $(\sqrt{5} - 1) : 2$. Terquem believed that the expression "extreme and mean ratio" (which is an exact translation of Euclid's Greek phrase) is "une réunion de mots ne présentant aucun sens,"[3] and following J. F. Lorenz (1781) employed the term "continued section." Terquem has also suggested:[4] "diviser une droite décagonalement." Leslie introduced the term "medial section."[5] "Divine proportion" was used by Fra Luca Pacioli in 1509[6] and possibly earlier by Pier della Francesca;[7] "sectio divina" and "proportio divina" occur in the writings of Kepler.

[1] These enunciations are taken from *The Thirteen Books of Euclid's Elements* translated with introduction and commentary by T. L. Heath, 3 vols., Cambridge, at the University Press, 1908. For statements in connection with our discussion see particularly, Vol. 1, pp. 137, 403; Vol. 2, p. 99; Vol. 3, p. 441.

[2] The earliest instances which I find of the use of the term golden section are in J. Helmes, "Eine einfachere, auf einer neuen Analyse beruhende Auflösung der sectio aurea, nebst einer kritischen Beleuchtung der gewöhnlichen Auflösung und der Betrachtung ihres pädagogischen Werthes." *Archiv der Mathematik*, Grunert, Band 4, 1844, pp. 15–22; in A. Wiegand, *Geometrische Lehrsätze und Aufgaben*, Band 2, 1. Abtheilung, Halle, 1847, p. 142; and also in A. Wiegand, *Der allgemeine goldene Schnitt und sein Zusammenhang mit der harmonischen Theilung*. . . Halle, 1849.

Much negative evidence seems to indicate that the term 'golden section' was originated within the thirty years 1815–1844. For example, it is not mentioned in Klügel–Mollweide's *Mathematisches Wörterbuch*, which contains so many references to the literature of different topics. We do, however, find the following (Erste Abtheilung, vierter Theil, Leipzig, 1823, p. 363): "Die Aufgabe bey Eukleides II, 11, oder VI. 30, ist sonst auch bisweilen *sectio divina* genannt."

[3] *Nouvelles annales de mathématiques*, Paris, tome 12, 1853, p. 38.

[4] *Journal de mathématiques pures et appliquées*, Paris, tome 3, 1838, p. 98.

[5] J. Leslie, *Elements of Geometry, geometrical Analysis and plane Trigonometry*, Edinburgh, 1809, p. 66.

[6] *Divina Proportione opera a tutti gli ingegni perspicaci e curiosi necessaria que ciaseum studioso di philosophia: prospettiva, pictura, sculptura, architectura: musica: e altre matematice . . . Venetiis . . . 1509*. Although not printed till 1509 the manuscript of this work was completed in 1497. The geometrical drawings were made by Leonardo da Vinci; *cf.* G. Libri, *Histoire des Sciences math. en Italie*, tome 3, Paris, 1840, p. 144; note 2. Another edition of the Latin text "herausgegeben, übersetzt und erläutert von C. Winterberg" appeared at Vienna (Gräser) 1889. Another edition 1896, 6 + 367 pp. A full analysis of Pacioli's work is to be found in A. G. Kästner, *Geschichte der Mathematik* . . . Band I, Göttingern, 1796, pp. 417–449. See also M. Cantor, *Vorlesungen über Geschichte der Mathematik*, Band 2, 2. Auflage, Leipzig, 1900, pp. 341 ff., 347.

[7] It has been shown by G. Mancini that parts of Pacioli's *Divina Proportione* were taken from a Vatican manuscript by Pier della Francesca. See (1) G. Pittarelli, *Atti del IV. congresso dei matematici*, tomo 3, Roma, 1909; (2) G. Mancini, "L'opera 'De Corporibus Regularibus' di Pietro Franceschi detto Francesca usurpata da Fra Luca Pacioli" (con dodici tavole) *Reale accademia dei Lincei*, 1915. See review by F. Cajori in the *American Mathematical Monthly*, Vol. 23, 1916, p. 384. (3) G. B. de Toni, "Intorno al codice sforzesco 'De divina proportione' di Luca Pacioli e i disegni geometrici di qust' opera attribuiti a Leonardo da Vinci," *Modena soc. dei naturalistic e matematici, atti*, 13₄, 1911, pp. 52–79.

Pacioli's work was doubtless influential in inspiring a certain amount of mysticism in the consideration of golden section by later writers. In a work published in 1569, P. Ramus associates the Trinity with the three parts of golden section. A little later Clavius wrote of its "godlike proportions." As noted above Kepler declared himself similarly. He said also: "Geometry has two great treasures, one is the Theorem of Pythagoras, the other the division of a line into extreme and mean ratio; the first we may compare to a measure of gold, the second we may name a precious jewel."[1]

In the Thirteenth Century Campanus proved (in his edition of Euclid's Elements, bk. IX, prop. 16) that golden section was irrational. His argument (by mathematical induction) was reproduced in algebraic notation by Genocchi and by Cantor.[2]

There is an interesting passage on golden section by Albert Girard in his edition of Stevin's works.[3] Girard gives a method of expressing the ratio of the segments of a line (cut in golden section) in rational numbers that converge to the true ratio. For this purpose he takes the sequence

(1)
$$0, 1, 1, 2, 3, 5, 8, 13, 21, \ldots,$$

every term of which (after the second) is equal to the sum of the two terms that precede it, and says, after Kepler, any number in this progression has to the following the same ratios (nearly) that any other has to that which follows it. Thus 5 has to 8 nearly the same ratio that 8 has to 13; consequently any three consecutive numbers such as 8, 13, 21 nearly express the segments of a line cut in golden section. Since the fractions

(2)
$$\tfrac{1}{1}, \tfrac{1}{2}, \tfrac{2}{3}, \tfrac{3}{5}, \tfrac{5}{8}, \tfrac{8}{13}, \tfrac{13}{21}, \ldots$$

are the various convergents of the continued fraction

$$\frac{\sqrt{5}-1}{2} = \cfrac{1}{1 + \cfrac{1}{1 + \cfrac{1}{1 \ldots}}},$$

Maupin reasons with force (after taking into account all which follows in the note) that Girard was probably familiar with the elements of continued fractions. Simson interprets Girard's reasoning differently.

For mathematical treatment of problems in golden section, in ordinary or generalized form, see also the papers by C. Thiry[4] and R. E. Anderson,[5] E. Catalan's "*Théorèmes et Problèmes de*

[1] Exact references to sources, and some quotations from originals, are given in (1) J. Tropfke, *Geschichte der Elementar-Mathematik*, Band 2, Leipzig, Veit, 1903; (2) F. Sonnenburg, *Der goldne Schnitt. Beitrag zur Geschichte der Mathematik und ihre Anwendung.* (Progr.), Bonn, 1881. (Not always reliable.) *Cf.* ftn. 4, p. 155.

[2] *Annali di scienze matematiche e fisiche* (Tortolini), vol. 6, 1855, pp. 307–308; also M. Cantor, *Vorlesungen über Geschichte der Mathematik*, vol. 2, 2. ed., 1900, pp. 105–106; see also *American Mathematical Monthly*, vol. 25, 1918, p. 197, and *Bulletin of the American Mathematical Society*, vol. 15, 1909, p. 408.

[3] *Les œuvres mathématiques de Simon Stevin* ... le tout revu, corrigé et augmenté par A. Girard. Leyde, 1634, pp. 169–170. The passage in question is reprinted with commentary in G. Maupin, *Opinions et Curiostés touchant la Mathématique* (deuxième série), Paris, 1902, pp. 203–209. It has been discussed also by R. Simson, *Philosophical Transactions*, 1753, vol. 48, pp. 368–377; see "Reflexions sur la préface d'un mémoire de Lagrange intitulé: 'Solution d'un problème d'arithmétique'" by J. Plana, *Memoire della r. accademia d. scienze di Torino*, series 2, vol. 20, Torino, 1863, especially pp. 89–92.

[4] C. Thiry, "Quelques propriétés d'une droite partagée en moyenne et extrême raison," *Mathesis*, 1894, vol. 14, pp. 22–24.

[5] "Extension of the medial section problem and derivation of a hyperbolic graph," *Proceedings of the Edinburgh Mathematical Society*, 1897, Vol. 15, pp. 65–69.

géométrie élémentaire"[1] and Emsmann's program[2] containing more than 350 relations and problems.

In the nineteenth century the literature of golden section is by no means inconsiderable. It includes at least a score of separate pamphlets and books and many times that number of papers. In numerous, voluminous and rather unscientific writings A. Zeising[3] finds golden section the key to all morphology and contends, among other things, that it dominates both architecture and music. A distinctly new line was set under way by Fechner who applied scientific experimental methods to the study of aesthetic objects.[4] He was led to the conclusion that the rectangle of most pleasing proportions was one in which the adjacent sides are in the ratio of parts of a line segment divided in golden section.[5] There are some paragraphs on "Golden Section," by J. S. Ames in *Dictionary of Philosophy and Psychology*[6] edited by J. M. Baldwin. In his article on "The aesthetics of unequal division"[7] P. A. Angier discusses earlier contributions to the aesthetics of golden section, including those by L. Witmer[8] (the chief investigator in the aesthetics of simple forms after Fechner), W. Wundt,[9] and O. Külpe.[10] The subject has been treated still more recently by M. Dessoir[11] and J. Volkelt.[12]

Sir Theodore Cook discusses[13] golden section from some new points of view in connection with art and anatomy, and the writings of F. X. Pfeifer[14] remind one both in subject matter and style of treatment of Zeising's publications.

Neikes defined the term golden section for different units (areas, volumes—not alone line-segments) such that the smaller part is to the larger as the larger is to the whole. With Piazzi Smyth's work as a basis he applied golden section to an unscientific study of the architecture of the Cheops pyramid.[15]

[1] 6e éd., Paris, 1879, pp. 261–263. Some of these properties are given in the first edition of this work, which was really written by H. C. de La Frémoire, Paris, 1844.

[2] D. H. Emsmann, *Zur sectio aurea. Materialien zu elementaren namentlich durch die Sectio aurea löslichen Constructions-aufgaben* etc., Progr. Stettin, 1874 (*Cf. Zeitschrift f. math. und naturw. Unterricht*, vol. 5, pp. 289–291)

[3] For example (1) *Neue Lehre von den Proportionen des menschlichen Körpers aus einem bisher unerkannt gebliebenen, die ganze Natur und Kunst durchdringenden morphologischen Grundgesetze entwickelt*, Leipzig, 1854, 457 pp.; particularly pages 133–174; (2) *Aesthetische Forschungen*, Frankfort, 1855, pp. 179f. (3) *Das Normalverhältnis der chemischen und morphologischen Proportionen*, Leipzig, 1856, 114 pp. and the posthumous work: (4) *Der goldene Schnitt*, Leipzig, 1884, 28 pp. *Cf.* S. Günther, "Adolph Zeising als Mathematiker," *Zeitschrift für Mathematik und Physik*, Historisch-literarische Abtheilung, Band 21, 1876, pp. 157–165.

[4] G. T. Fechner, *Zur experimentalen Aesthetik*, Leipzig, 1871; also *Vorschule der Aesthetik*, Leipzig, 1876, pp. 185f.

[5] C. L. A. Kunze speaks of "Rechteck der schönsten Form" in his *Lehrbuch der Planimetrie*, Weimar, 1839, p. 124. A reference may be given to a recent discussion of "printer's oblong" and "golden oblong" in H. L. Koopman, "Printing page problems with geometric solutions," *The Printing Art*, Cambridge, Mass., 1911, vol. 16, pp. 353–356.

[6] New York, vol. 1, 1901, p. 416.

[7] *Harvard Psychological Studies*, vol. 1, 1903, pp. 541–561.

[8] L. Witmer, "Zur experimental Aesthetik einfacher räumlicher Formverhältnisse" *Philosophische Studien*, Leipzig, vol. 9, 1893, pp. 96-144, 209–263.

[9] W. Wundt, *Grundzüge der physiologischen Psychologie*, Band 2, 4. Auflage, 1893, pp. 240f. (See also Band 3, 6. Auflage, 1911, pp. 136f.).

[10] O. Külpe, *Outlines of Psychology*, translated into English by E. P. Titchener, London, 1895, pp. 253–255.

[11] M. Dessoir, *Aesthetik und allgemeine Kunstwissenschaft in den Grundzügen dargestellt*, Stuttgart, 1906, pp. 124f, 176–177.

[12] J. Volkelt, *System der Aesthetik*, Band 2, Munchen, 1910, pp. 33f.

[13] T. A. Cook, *The Curves of Life*, London, Constable, 1914.

[14] (a) "Die Proportion des goldenen Schnittes an den Blättern und Stengeln der Pflanzen," *Zeitschrift für mathematischen und naturwissenschaftlichen Unterricht*, 1885, vol. 15, pp. 325–338; (b) *Der goldene Schnitt und dessen Erscheinungsformen in Mathematik Natur und Kunst*, Augsburg, [1885], 3 + 232 pp. + 13 plates. A résumé of this work given by O. Willman in *Lehrproben und Lehrgänge aus der Praxis der Gymnasien und Realschulen*, 1892 was the basis of E. C. Ackermann, "The Golden Section," *American Mathematical Monthly*, 1895, vol. 2, pp. 260–264. *Cf. Zeitschrift f. math. und naturwiss. Unterricht*, 1887, vol. 18, pp. 44–47, 605–612.

[15] H. Neikes, *Der goldene Schnitt und ihre Geheimnisse der Cheops Pyramide*, Cöln, 1907; (reviewed in *Jahrbuch über die Fortschritte der Mathematik*, 1907, p. 526). Pages 3–10: "der goldene Schnitt"; pages 11–20: "die Geheimnisse der Cheops Pyramide." C. Piazzi Smyth, *Life and Work at the great Pyramids*, 1867.

III. The Fibonacci Series.

Foremost among mathematicians of his time was Leonardo Pisano (also known as Fibonacci), who flourished in the early part of the thirteenth century. His greatest work is Liber abbaci "a Leonardo filio Bonacci compositus, anno 1202 et correctus ab eodem anno 1228." It was first printed in 1857.[1]

Among miscellaneous arithmetical problems of the twelfth section is one entitled "How many pairs of rabbits can be produced from a single pair in a year."[2] It is supposed (1) that every month each pair begets a new pair which, from the second month on, becomes productive; and (2) that deaths do not occur. From these data it is found that the number of pairs in successive months would be as follows:

(3) $$1, 2, 3, 5, 8, 13, 21, 34, 55, 89, 144, 233, 377.$$

These numbers follow the law that every term after the second is equal to the sum of the two preceding and form, according to Cantor, the first known recurring series in a mathematical work. The doubtful accuracy of this latter statement has been pointed out by Günther.[3]

The series (3) was well known to Kepler, who discusses and connects it with golden section and growth, in a passage of his "De nive sexangula," 1611.[4] Commentaries of Girard and Simson, and the relation of the series to a certain continued fraction, have been noted above. But the literature of the subject is very extensive and reaches out in a number of directions. In what follows u_n will be regarded as the $(n + 1)$st term of what we shall call the Fibonacci series (1); so that $u_0 = 0, u_1 = u_2 = 1, u_3 = 2, \quad . \quad . \quad .$ For reasons which shall appear later the names Lamé series, and Braun or Schimper-Braun series, have been also employed in this connection. Girard observed, l. c., that the three numbers u_n, u_{n+1}, u_{n+1}[5] may be regarded as corresponding to lengths which form an isosceles triangle of which the angle at the vertex is very nearly equal to the angle at the center of the regular pentagon.

The relation $u_{n-1}u_{n+1} - u_n^2 = (-1)^n$ was stated in 1753 by Simson (l. c.). It was to this relation, and hence to the Fibonacci series that Schlegel[6] was led when he sought to generalize the well-known geometrical paradox of dividing a square 8×8 into four parts which fitted together form a rectangle 5×13.[7] Catalan found (1879) the more general relation[8] $u_{n+1-p}u_{n+1+p} - u_{n+1}^2 = (-1)^{n-p}(u_p)^2$, from which may be derived $u_{n+1}^2 + u_n^2 = u_{2n+1}$ first given, along with

[1] Il liber Abbaci di Leonardo Pisano pubblicato da Baldassare Boncompagni, Roma, MDCCCLVII. For an analysis of this work see M. Cantor, *Vorlesungen über Geschichte der Mathematik*, Band II, 3. Auflage, Leipzig, Teubner, 1900, pp. 5-35.

[2] Pages 283-284.

[3] S. Günther, *Geschichte der Mathematik*, 1. Teil, Leipzig, Göschen, 1908, p. 137.

[4] J. Kepler, *Opera*, ed. Frisch, tome 7, pp. 722-3. After discussions of the form of the bees' cells and of the rhombo-dodecahedral form of the seeds of the pomegranite (caused by equalizing pressure) he turns to the structure of flowers whose peculiarities, especially in connection with quincuncial arrangement he looks upon as an emanation of sense of form, and feeling for beauty, from the soul of the plant. He then "unfolds some other reflections" on two regular solids the dodecagon and icosahedron "the former of which is made up entirely of pentagons, the latter of triangles arranged in pentagonal form. The structure of these solids in a form so strikingly pentagonal could not come to pass apart from that proportion which geometers to-day pronounce divine." In discussing this divine proportion he arrives at the series of numbers 1, 1, 2, 3, 5, 8, 13, 21 and concludes: "For we will always have as 5 is to 8 so is 8 to 13, practically, and as 8 is to 13, so is 13 to 21 almost. I think that the seminal faculty is developed in a way analogous to this proportion which perpetuates itself, and so in the flower is displayed a pentagonal standard, so to speak. I let pass all other considerations which might be adduced by the most delightful study to establish this truth."

[5] There is a typographical error (13 for 21) in Girard's discussion in this connection.

[6] V. Schlegel, "Verallgemeinerung eines geometrischen Paradoxons," *Zeitschrift für Mathematik und Physik*, 24. Jahrgang, 1879, pp. 123-128.

[7] This paradox was given at least as early as 1868 in *Zeitschrift für Mathematik und Physik*, Vol. 13, p. 162. Cf. W. W. R. Ball, *Mathematical Recreations and Essays*, 5th edition, London, Macmillan, 1911, p. 53; and E. B. Escott, "Geometric Puzzles," *Open Court Magazine*, vol. 21, 1907, pp. 502-5.

[8] E. Catalan, *Mélanges Mathématiques*, tome 2, [Liège, 1887], p. 319.

many other properties, by Lucas,[1] in a paper showing the relation between the Fibonacci series and Pascal's arithmetical triangle. Daniel Bernoulli showed[2] that

$$u_n = \left[\left(\frac{1 + \sqrt{5}}{2} \right)^n - \left(\frac{1 - \sqrt{5}}{2} \right)^n \right] : \sqrt{5};$$

from this a result given by Catalan readily follows:[3]

$$2^{n-1} u_n = \frac{n}{1} + 5 \frac{n(n-1)(n-2)}{1.2.3} + 5^2 \frac{n(n-1)(n-2)(n-3)(n-4)}{1.2.3.4.5} + \cdots.$$

A very similar series occurs in a letter written by Euler in 1726.

Lucas showed the importance of the Fibonacci series in discussions of (a) the decomposition of large numbers into factors and (b) the law of distribution of prime numbers.[4] Binet was led to the series in his memoir on linear difference equations (l. c.), and Leger[5] and Finck[6] (and later Lamé[7]) indicated its application in determining an upper limit to the number of operations made in seeking the greatest common divisor of two integers. Landau evaluated the series $\Sigma(1/u_{2n}$ and $\Sigma(1/u_{2n+1})$, and found that the first was related to Lambert's series and the second to the theta series.[8]

The solution of the problem of determining the convex polyhedra, the number of whose vertices, faces, and edges are in geometrical progression, leads to the Fibonacci series.[9]

For further references and mathematical discussions one may consult (1) *L'Intermédiaire des mathématiciens*, 1899, p. 242; 1900, pp. 172–7, 251; 1901, 92; 1902, p. 43; 1913, pp. 50, 51,

[1] E. Lucas, "Note sur la triangle arithmétique de Pascal et sur la série de Lamé," *Nouvelle correspondance mathématique*, tome 2, 1876, p. 74.

[2] D. Bernoulli, "Observationes de seriebus quae formantur ex additione vel subtractione quacunque terminorum se mutus consequentium," *Commentarii academiae scientiarum imperialis Petropolitanae*, vol. 3, 1732, p. 90. This memoir was read in September, 1728, but it appears that Bernoulli had the formula in his possession as early as 1724 (*Cf.* Fuss, *Correspondance mathématique et physique*, St. Petersburg, 1843, vol. 2, pp. 189, 193–4, 200–202, 209, 239, 251, 271, 277; see also p. 710). The formula was given also by Euler in 1726 (in an unpublished letter to Daniel Bernoulli). For most of these facts I am indebted to Mr. G. Eneström. The formula seems to have been discovered independently by J. P. M. Binet, "Mémoire sur l'intégration des equations linéaires aux différences finies d'un ordre quelconque, à coefficients variables," *Comptes rendus de l'académie des sciences de Paris*, tome 17, 1843, p. 563.

[3] *Manuel des Candidats a l'École Polytechnique*, tome 1, Paris, 1857, p. 86.

[4] E. Lucas, (a) "Recherches sur plusieurs ouvrages de Léonard de Pise et sur divers es questions d'arithmétique supérieure. Chapter 1. Sur les séries recurrentes," *Bullettino di bibliografia e di storia delle scienze matematiche e fisiche*, tome 10, pp. 129–170, Marzo, 1877; (b) Théorie des fonctions numériques simplement périodiques," *American Journal of Mathematics*, vol. 1, 1878, pp. 184–229, 289–321 [on p. 299 are given the first 61 terms of the Fibonacci series and the factors of every term]; (c) "Sur la théorie des nombres premiers" [dated mai 1876], *Atti della r. accademia delle scienze di Torino*, vol. 11, 1875–76, pp. 928–937; (d) "Note sur l'application des séries recurrentes a la recherche de la loi de distribution des nombres premiers," *Comptes rendus de l'académie des sciences*, vol. 82, 1876, pp. 165–167. See also A. Aubry, "Sur divers procédés de factorisation," *L'Enseignement mathématique*, 1913, especially §§ 11, 16 and 17, pp. 219–223.

[5] "Note sur le partage d'une droite en moyenne et extrême, et sur un problème d'arithmétique," *Correspondance mathématique et physique*, vol. 9, 1837, pp. 483–484.

[6] *Traité Elémentaire d'Arithmétique*, Paris, 1841; also *Nouvelles annales de mathématiques*, vol. 1, 1842, p. 354.

[7] G. Lamé, "Note sur la limite du nombre des divisions dans la recherche du plus grand commun diviseur entre deux nombres entiers." *Comptes rendus de l'académie des sciences*, tome 19, 1844, pp. 867–870. See also J. P. M. Binet, idem, pp. 939–941.

Because of results obtained in the above-mentioned memoir the Fibonacci series is frequently called the Lamé series. Thompson's statement (*On Growth and Form*, p. 643) that the series 2/3, 3/5, 5/8, 8/13, 13/21, ... "is called Lami's series by some, after Father Bernard Lami, a contemporary of Newton's, and one of the co-discoverers of the parallelogram of forces," is incorrect.

[8] E. Landau, "Sur la série des inverses des nombres de Fibonacci," *Bulletin de la Société Mathématique de France*, tome 27, 1899, pp. 298–300.

[9] *Archiv der Mathematik und Physik* Band 28, 1919, pp. 77–79.

147; 1915, pp. 39–40 (see also question 4171, 1915, p. 277); (2) "Sur une généralisation des progressions géométriques," *L'Education mathématique*, 1914, pp. 149–151, 157–158; (3) V. Schlegel, "Séries de Lamé supérieurs," *El progreso matematico*, 1894, año 4, pp. 171–174; (4) T. H. Eagles, *Constructive Geometry of Plane Curves*, London, 1885, pp. 293–299, 303–304; and (5) L. E. Dickson, *History of the Theory of Numbers*, vol. 1, Washington, 1919, Chapter XVII: "Recurring series; Lucas' u_n, v_n."

As to growths it is particularly in connection with older chapters on leaf arrangement or phyllotaxis that the Fibonacci series comes up. Among the earliest and most important of these are the memoirs of Braun (based on researches of Schimper and himself),[1] and L. et A. Bravais.[2] Of later papers there are those by Ellis,[3] Dickson,[4] Wright,[5] Airy,[6] Günther,[7] and Ludwig.[8] Much that was fanciful and mysterious was swept away by the publication of P. G. Tait's note "On Phyllotaxis."[9] Of recent books on the subject the most notable are those by Church,[10] Cook,[11] and Thompson.[12] The first two are beautifully illustrated. The third is a scholarly work, written in an attractive style; it reproduces Tait's discussion in an appreciative manner.

NOTE VI.

THIS idea of commensurability or measurability in square is geometrically explained in the tenth book of Euclid's "Elements." The artistic use of this fact became lost. This loss was a calamity. We must either blame the Romans for this catastrophe or ascribe it to a general deterioration of intelligence. If this knowledge had not become lost artists today would, undoubtedly, have been creating masterpieces of statuary, painting and architecture equalling or surpassing the masterpieces of the Greek classic age.

Since the material for this book was obtained the writer has continued the work of analyses of other phases of Greek design such as that furnished by the temples, bronzes, stele heads and general decoration. To this has been added a close inspection of the architecture of man, both in the skeleton and in the living example; and the human figure has been compared with Greek statuary. The results of this more recent work show quite clearly that the symmetry of man, as well as the symmetry of Greek statuary, is dynamic. The symmetry of the human figure in art since the first century B. C. is undoubtedly static. From the fact that we do not find this type

[1] A. Braun, "Vergleichende Untersuchung über die Ordnung der Schuppen an den Tannenzapfen als Einleitung zur Untersuchung der Blätterstellung überhaupt," *Nova acta acad. Caes Leopoldina*, vol. 15, 1830, pp. 199–401.

[2] L. et A. Bravais, (1) "Sur la disposition des feuilles curviseriées," *Ann. des sc. nat.*, 2e série, vol. 7, 1837, pp. 42–110; (2) *Mémoire sur la Disposition géométrique des Feuilles et des Inflorescenses*, Paris, 1838.

[3] R. L. Ellis, *Mathematical and Other Writings*, Cambridge, 1863; "On the theory of vegetable spirals," pp. 358–372.

[4] A. Dickson, "On some abnormal cases of pinus pinaster," *Transactions of the Royal Society of Edinburgh*, vol. 26, 1871, pp. 505–520.

[5] C. Wright, "The uses and origin of the arrangements of leaves in plants" (read 1871), *Memoirs of the American Academy*, vol. 9, part 2, Cambridge, Mass., p. 384f.

[6] H. Airy, "On leaf arrangement," *Proceedings of the Royal Society of London*, vol. 21, 1873, pp. 176–179.

[7] S. Günther, "Das mathematische Grundgesetz im Bau des Pflanzenkörpers," *Kosmos*, II. Jahrgang, Band 4, 1879, pp. 270–284.

[8] F. Ludwig, "Einige wichtige Abschnitte aus der mathematischen Botanik," *Zeitschrift für mathematischen und naturwiss. Unterricht*, Band 14, 1883, p. 161f.

[9] P. G. Tait, *Proc. Royal Society Edinburgh*, vol. 7, 1872, pp. 391–4.

[10] A. H. Church, *On the Relation of Phyllotaxis to Mechanical Laws*, London, Williams and Norgate, 1904. On page 5 Church writes: "The properties of the Schimper-Braun series 1, 2, 3, 5, 8, 13, . . ., had long been recognized by mathematicians (Gerhardt, Lamé). . . ." In *Botanisches Centralblatt*, Band 68, 1896, F. Ludwig writes (on p. 7) that the numbers of this series "werden vielfach von Botanikern als Braun'sche, von Mathematikern als Gerhardt'sche oder Lamé'sche Reihe bezeichnet." I have not been able to verify that any mathematician used the term Gerhardt series in this connection, or that anyone by the name of Gerhardt wrote about the Fibonacci series. From what has been indicated above it seems certain that "Gerhardt'sche" should be "Girard'sche."

[11] T. A. Cook, *The Curves of Life*, London, Constable, 1914.

[12] D'A. W. Thompson, *On Growth and Form*, Cambridge: at the University Press, 1917.

of symmetry in the living example it seems fair to assume that static man could not function and, therefore, the human figure in art of the past two thousand years is not true to nature.

Since the publication of Darwin's "Origin of Species," an enormous amount of human measurement material or data has been produced. During the American Civil War measurements were obtained of over a million recruits and drafted men. To add to this we have the results of the activities of the anthropologists the world over during the past generation. All this data confirms the dynamic hypothesis. Since the first century B. C. many treatises have been written upon the proportions of the human figure by artists and others. Bertram Windle, an English lecturer on art, has prepared a table of some eighty-eight names. To this we may add the canons of proportion used in the continental studios during the past hundred years. If human figures were made according to the principles enunciated in these treatises and canons, the result would, automatically, be static. If artists made human figures in accordance with the measurements obtained by anthropologists and by the different governments, of men in the armies and navies, the result would also be static; though the latter would be truer to nature than the figures made according to the artistic canons, because men of science have found that the members of the human body are incommensurate; to meet this difficulty they use a decimal system. This is nearer nature than the artists' schemes of commensurate length units used by artists.

One reason why we seem to have failed to construct the human figure true to nature appears to be due to Roman misinterpretation of a Greek tradition and the persistence of this misinterpretation through the ages since. The tradition, according to the Roman architectural writer Vitruvius, was that the Greeks based the symmetry they were so careful to apply to works of art, upon the commensurate relationship of the members of the human body to the structure as a whole. The Romans assumed that this commensuration or measurableness was that of line. The members of the body are, indeed, commensurable or measurable with the structure as a whole, but in *area*, not in *line*.

Greek scientists clearly understood that lines incommensurable or unmeasurable, one by the other, as lengths, were not necessarily irrational; they might be commensurable in square. Greek design shows that Greek artists also understood this fact.

If a projection is made of the living model, or the skeleton, and the members, such as the hands, feet, arms, legs, head, trunk, etc., be compared with the whole in terms of area a theme will be disclosed and this theme will be recognized as dynamic exactly as are the area themes we obtain from a Greek temple or, indeed, from almost any example of good Greek design. And such themes of area show also that the architecture of the plant and that of man are essentially the same.

NOTE VII.

THE reciprocal idea, especially in connection with design, is quite unknown to modern artists. It was, however, well understood by the Greek masters as their design creations abundantly prove. The modern mathematician understands the value of the reciprocal of a number and uses it to shorten certain mathematical operations. For example; if it is desired to divide one number by another the same result is obtained if that number be multiplied by the reciprocal of the other number. A reciprocal is obtained by dividing a number into unity. .5 is the reciprocal of 2. and any number multiplied by .5 produces a result equivalent to dividing that number by 2. In this example simple numbers are employed, but it will be apparent that a problem might involve a very complicated and unwieldy number and in that case the operation would be much simplified if multiplication by a reciprocal were done instead of division by the original number. This valuable property of the reciprocal forms part of the machinery of dynamic symmetry, and its chief use is that of determining similar figures for purposes of design. The rectangular shapes derived from animal or plant growth may all be expressed by a ratio. This fact enables us to perform most extraordinary feats of design analysis by simple arithmetic. If we measure a Greek design, for example, and find that it is contained in a rectangle and that the short end of this rectangle divided into its long side produces, say, the ratio 2.236,

we know that we have found an example of Greek design in a root-five rectangle, because 2.236 is the square root of five. We also know that there is another number which expresses this same fact and that number is the reciprocal of 2.236. To obtain this reciprocal we divide 2.236 into unity: the answer is .4472. Because a reciprocal shape is a similar shape to the whole we know that .4472 also represents a root-five rectangle. In root rectangles the reciprocal is always an even multiple of the whole. .4472 multiplied by 5 equals 2.2360. Consequently, the area of a root-five rectangle is composed of five reciprocal areas. As a labor-saver the property of the reciprocal is as great in design as it is in mathematics. Also, it should be remembered that reciprocal ratios are always less than unity. Because of this we know that any ratio less than unity is the reciprocal of some ratio greater than unity. Diagonals to reciprocals always cut the diagonals of the whole at right angles.

NOTE VIII.

ROOT-TWO and root-three rectangles never appear in connection with root-five and the rectangle of the whirling squares. For this reason it may be that the root-two and root-three shapes constitute a type of symmetry intermediate between static and dynamic or constitute a minor phase of the dynamic type. They are not found in the plant or the human figure or in Greek statuary.

NOTE IX.

THE summation series of numbers represents an extreme and mean ratio series approximately, or as nearly as may be by whole numbers. For an exact representation we must use a substitute series. A suggestion for such a substitute series is furnished by the human figure and Greek design. Such a series would be: 118 . 191 . 309 . 500 . 809 . 1309 . 2118 . 3427 . 5545 . 6854 . 8972 . 14517., etc.

Any member of the series divided into any succeeding member produces the ratio 1.618. Members divided into alternate members, as 5 into 1309 produce the ratio 2.618.

2.618 is the square of 1.618, that is 1.618 multiplied by itself. Also 1.618 plus 1 equals 1.618 squared. Every member divided into every fourth member produces the ratio 4.236. This ratio equals 1.618 raised to the third power. Also, 2.618 plus 1.618 equals 4.236. Also 1.618 multiplied by two and one added equals 4.236 and so on.

NOTE X.

THE root rectangles are constructed by a simple geometrical process. The instrument for the purpose need not be more complicated than that of a string the ends of which are held in the two hands. The constructions depend upon the Greek method of determining multiple squares. The ancient surveyor being called a "rope stretcher," the craftsman, using the same method, might be termed a "string stretcher."

"In the determination of a square, which shall be any multiple of the square on the linear unit, a problem which can be easily solved by successive applications of the 'theorem of Pythagoras'—the first right-angled triangle, in the construction, being isosceles, whose equal sides are the linear unit; the second having for sides about the right angle the hypotenuse of the first (root 2) and the linear unit; the third having for sides about the right angle (root 3) and 1, and for hypotenuse 2, and so on." Allman, Greek Geometry, p. 24.

"Theaetetus relates how his master Theodorus, who was subsequently the mathematical teacher of Plato, had been writing out for him and the younger Socrates something about squares; about the squares whose areas are three feet and five feet (these squares would be those on the sides of a root-three and a root-five rectangle), showing that in length they are not commensurable with the square whose area is one foot (that the sides of the square whose areas are three superficial feet and five superficial feet are incommensurable with the side of the square whose area is the unit of surface, *i. e.*, are incommensurable with the unit of length) and that Theodorus had taken up separately each square as far as that whose area is seventeen

square feet, and, somehow, stopped there. Theaetetus continues:—'Then this sort of thing occurred to us, since the squares appear to be infinite in number, to try and comprise them in one term, by which to designate all these squares.'

"*Socrates.* 'Did you discover anything of the kind?'

"*Theaetetus.* 'In my opinion we did. Attend, and see whether you agree.'

"*Socrates.* 'Go on.'

"*Theaetetus.* 'We divided all number into two classes; comparing that number which can be produced by the multiplication of equal numbers to a square in form, we called it quadrilateral and equilateral.'

"*Socrates.* 'Very good.'

"*Theaetetus.* 'The numbers which lie between these, such as three and five, and every number which cannot be produced by the multiplication of equal numbers, but becomes either a larger number taken a lesser number of times, or a lesser taken a greater number of times (for a greater factor and a less always compose its sides); this we likened to an oblong figure, and called it an oblong number.'

"*Socrates.* 'Capital! What next?'

"*Theaetetus.* 'The lines which form as their squares an equilateral plane (square) number, we defined as length, *i. e.*, containing a certain number of linear units, and the lines which form as their squares an oblong number, we defined as dunameis, inasmuch as they have no common measure with the former in length, but in the surfaces of the squares, which are equivalent to these oblong numbers. And in like manner with solid numbers.'

"*Socrates.* 'The best thing you could do, my boys; no one could do better.'" Allman, 201-210. (These boys were working out root-rectangles, which seem to have been familiar to the elder Socrates, who, before he became a philosopher, was a stone-cutter.)

NOTE XI.

SEE the "Thirteen Books of Euclid's Elements" by Thomas L. Heath and his reference to Proclus.

NOTE XII.

THE terms "ellipse," "parabola" and "hyperbola" were first used in connection with this process of the "Application of Areas." They were afterwards applied to conic sections. See Heath.

NOTE XIII.

THE Parthenon at Athens has been analyzed by dynamic symmetry and the proportions of the building determined to the minutest detail. The theme throughout is that of square and root five. This building, and other Greek temples, are examined exhaustively in monographs now in preparation.

NOTE XIV.

THE connection between the geometry of art and the geometry of science in Greece is shown by the history of the "Duplication of the cube problem." In Greece, as in India, the geometry of art was used in architecture very early. In the former it is the Delian or duplication problem, in the latter "the rules of the chord," both ideas being involved in altar ritual. The Greeks reduced the duplication problem to one of finding two mean proportionals between two lines. The artist uses the inverse of this idea in dynamic symmetry; he is constantly dealing with two mean proportionals between two lines. Allman's suggestion that the problem arose in the needs of architecture is undoubtedly correct. The duplication of the cube problem arose naturally from the duplication of the square.

"The Pythagoreans, as we have seen, had shown how to determine a square whose area was

any multiple of a given square. The question now was to extend this to the cube, and, in particular, to solve the problem of the duplication of the cube." Allman, "History of Greek Geometry from Thales to Euclid," pp. 83-84.

THE DUPLICATION OF THE CUBE

PROCLUS (after Eudemus) and Eratosthenes tell us that Hippocrates reduced this question ('the duplication of the cube') to one of plane geometry, namely, the finding of two mean proportionals between two given straight lines, the greater of which is double the less. Hippocrates, therefore, must have known that if four straight lines are in continued proportion, the first has the same ratio to the fourth that the cube described on the first, as side, has to the cube described in like manner on the second. He must then have pursued the following train of reasoning:—Suppose the problem solved, and that a cube is found which is double the given cube; find a third proportional to the sides of the two cubes, and then find a fourth proportional to these three lines; the fourth proportional must be double the side of the given cube; if, then, two mean proportionals can be found between the side of the given cube and a line whose length is double of that side, the problem will be solved. As the Pythagoreans had already solved the problem of finding a mean proportional between two given lines,—or, which comes to the same, to construct a square which shall be equal to a given rectangle—it was not unreasonable for Hippocrates to suppose that he had put the problem of the duplication of the cube in a fair way of solution. Thus arose the famous problem of finding two mean proportionals between two given lines—a problem which occupied the attention of geometers for many centuries." Allman, p. 84.

We must not forget that conic sections were discovered while a great Greek geometer was trying to solve this problem of two mean proportionals.

Plutarch, Life of Marcellus: " 'The first who gave an impulse to the study of mechanics, a branch of knowledge so prepossessing and celebrated, were Eudoxus and Archytas, who embellish geometry by means of an element of easy elegance, and underprop, by actual experiments and the use of instruments, some problems which are not well supplied with proof by means of abstract reasonings and diagrams; that problem, for example, of two mean proportional lines, *which is also an indispensable element in many drawings.*' " Allman p. 159.

"Eratosthenes, in his letter to Ptolemy III, relates that one of the old tragic poets introduced Minos on the stage erecting a tomb for his son Glaucus; and then, deeming the structure too mean for a royal tomb, he said; 'double it but preserve the cubical form.' Eratosthenes then relates the part taken by Hippocrates of Chios towards the solution of this problem and continues 'Later (in the time of Plato), so the story goes, the Delians, who were suffering from a pestilence, being ordered by the oracle to double one of their altars, were thus placed in the same difficulty. They sent, therefore, to the geometers of the Academy, entreating them to solve the question.' This problem of the duplication of the cube, henceforth known as the Delian Problem, may have been originally suggested by the practical needs of architecture, as indicated in the legend, and have arisen in Theocratic times; it may subsequently have engaged the attention of the Pythagoreans as an object of theoretic interest and scientific enquiry, as suggested above." Allman, p. 85.